D0938638

NEO-DADA

NEO-DADA
REDEFINING ART
1958-62

By Susan Hapgood

with essays by Maurice Berger and Jill Johnston

WITHDRAWN
ALBANY, NEW YORK

The American Federation of Arts

in association with Universe Publishing

700.9048
H352n

This catalogue has been published in conjunction with *Neo-Dada: Redefining Art, 1958-62*, an exhibition organized by the American Federation of Arts. It is a project of ART ACCESS, a program of the AFA with major support from the Lila Wallace-Reader's Digest Fund. Additional support has been provided by the National Patrons of the AFA.

Exhibition Itinerary

Scottsdale Center for the Arts
Scottsdale, Arizona
November 4, 1994-January 1, 1995

The Equitable Gallery
New York, New York
January 27-March 26, 1995

Sarah Campbell Blaffer Gallery
University of Houston
Houston, Texas
June 2-July 30, 1995

Tufts University Art Gallery
Medford, Massachusetts
October 6-December 3, 1995

Florida International University Art Museum
Miami, Florida
January 5-March 3, 1996

The American Federation of Arts, founded in 1909 to broaden the public's knowledge and appreciation of the visual arts, organizes traveling exhibitions of fine arts and media arts and provides museum members nationwide with specialized services that help reduce operating costs.

© 1994 by The American Federation of Arts.
All rights reserved.

John Cage's "26 Statements Re Duchamp" was originally published in *Art and Literature* (Autumn-Winter 1964) and is reprinted here with permission from the John Cage Estate.

Jasper Johns's "Marcel Duchamp [1887-1968], An Appreciation" was originally published in *Artforum* (November 1968) and is reprinted here with permission from the publisher.

Scores published in this catalogue may not be performed without the permission of the copyright holder.

Published by The American Federation of Arts, 41 East 65th Street, New York, New York 10021, and Universe Publishing, 300 Park Avenue South, New York, New York 10010

Library of Congress Cataloging-in-Publication Data
Hapgood, Susan.
 Neo-Dada: redefining art, 1958–62 / Susan Hapgood.
 p. cm.
 Catalog of an exhibition to be held at the Scottsdale Center for the Arts, Scottsdale, Ariz., beginning Nov. 4, 1994, and at other museums.
 Includes bibliographical references and index.
 ISBN 0-87663-629-6 ISBN 0-917418-98-0 (pbk.)
 1. Art, Modern—20th century—Exhibitions.
2. Dadaism—Influence—Exhibitions. I. Scottsdale Center for the Arts. II. Title.
 N6487.S36S375 1994 94-7388
 700'.9'04807473—dc20 CIP

Publication Coordinator: Michaelyn Mitchell
Design and typography: Russell Hassell
Editor: Brian Wallis
Printed in Hong Kong

Front cover: Dick Higgins performing his *Danger Music Number Seventeen,* ca. 1962. (figure 13)

Contents

Lenders to the Exhibition

Indiana University Art Museum

The Metropolitan Museum of Art

The Museum of Modern Art, New York

The Museum of Modern Art Library

National Gallery of Art, Washington, D.C.

Rose Art Museum, Brandeis University,
 Waltham, Massachusetts

Virginia Museum of Fine Arts, Richmond

Yale University Art Gallery

Ulla Ahrenberg, Vevey, Switzerland

Stephen S. Alpert, Boston

Anderson Gallery, Buffalo, New York

Arman, New York

Estate of Wallace Berman and
 L.A. Louver, Inc., Venice, California

George Brecht

Jeanne-Claude and Christo, New York

Paul Cornwall-Jones

Galerie Karsten Greve, Cologne-Paris

Jon and Joanne Hendricks

Hirschl & Adler Modern

Jasper Johns

Allan Kaprow

Edward Kienholz

Estate of Yves Klein

Phyllis Lambert, Montreal

Laura and Philip Mathews

Larry Miller and Sara Seagull

Robert Morris

Yoko Ono

Nam June Paik

Carolee Schneemann

The Gilbert and Lila Silverman Fluxus Collection

Sonnabend Collection

Daniel Spoerri

Ben Vautier

La Monte Young and Marian Zazeela

Zabriskie Gallery

Acknowledgments

"Neo-Dada" is a term that is no longer in currency: for many, in fact, the term may not conjure up a specific kind of art or art work. In the late 1950s and early '60s, however, "Neo-Dada" was understood to describe the creative efforts of numerous artists now associated with different and much more limiting labels— labels that virtually preclude their works being considered together. The investigation undertaken by Susan Hapgood to present this group of artists as united on a fundamental level is a fascinating and rewarding one, and the American Federation of Arts is proud to have served as the organizing institution.

To the lenders of the works in the exhibition we extend our deepest gratitude, for surely without their generosity there would be no show. We want to applaud the intelligence and tenacity of Susan Hapgood, who curated the exhibition and wrote the principal essay of this publication. We are also grateful to Maurice Berger and Jill Johnston, for their important contributions to the book, as well as to artists Arman, Allan Kaprow, Claes Oldenburg, and Daniel Spoerri, who agreed to be interviewed for the publication. We offer our thanks to Niki de Saint Phalle for allowing us to publish her intriguing text "A Letter to Bloum."

The ephemeral nature of a number of Neo-Dada works has in some cases necessitated their recreation for the traveling exhibition, as can be noted from the checklist. For George Brecht's *Chair Events*, for example, a recreation will be carried out by each museum on the tour. For Daniel Spoerri's *Les Lunettes noires*, the curators at the AFA have recreated the work that will travel. In all cases, the recreation involved a dialogue with the artist that not only assures its accuracy but adds a provocative and dynamic dimension to the show. To those artists who have generously given of their time in this way, we extend our sincere thanks.

At the American Federation of Arts, this project has required the considerable efforts of Rachel Granholm, curator of education; Sarah Higby, exhibitions assistant; Alex Mairs, publications assistant; Michaelyn Mitchell, head of publications; Maria Gabriela Mizes, registrar; and Andrew Spahr, curator of exhibitions, who oversaw the organization of the exhibition. Jillian Slonim, director of public information; Bob Workman, director of exhibitions; and Tom Padon, curator of exhibitions, also contributed their time.

At Universe Books, the AFA's copublisher, Manuela Soares has been a pleasure to work with. Brian Wallis has done a wonderful editing job, and Russell Hassell has provided a handsome design.

We are pleased also to recognize the participation of the presenting museums: the Scottsdale Center for the Arts, the Equitable Gallery, the Sarah Campbell Blaffer Gallery, Tufts University Art Gallery, and the Florida International Art Museum.

Finally, our thanks go to the National Patrons of the AFA, whose contributions helped to make this project possible.

Serena Rattazzi
Director, The American Federation of Arts

7

Acknowledgments

This exhibition was developed over a long period with sustained encouragement from friends, colleagues, and family. My first inkling of Neo-Dada arose while I was doing research at the Guggenheim Museum for Diane Waldman, who for several years generously fostered a far deeper understanding of the art preceding Pop than I had previously had. My subsequent organization, with Cornelia Lauf, of an exhibition on Fluxus brought many Dada themes to mind once again, at which point I became determined to investigate Neo-Dada and find out what it had or had not been.

While I was thinking over how to approach the topic, my friend and colleague Tom Padon, curator of exhibitions at the American Federation of Arts, suggested that I pitch the exhibition proposal to his organization. I thank him for the encouragement, and for his subsequent supervision of the project's beginnings.

Andrew Spahr, curator of exhibitions, has patiently overseen the bulk of the exhibition organization, and to him I offer my deep gratitude for his level-headed, steadfast support. I am indebted as well to Michaelyn Mitchell, head of publications, for her devoted attention to the catalogue's organization and production. Serena Rattazzi, director, and Bob Workman, director of exhibitions, have shown unswerving commitment to the project, for which I am extremely grateful. Among the kind, professional staff of the AFA with whom it has been my privilege to work are Sarah Higby, exhibitions assistant, Evie Klein, exhibitions scheduler, Alexandra Mairs, publications assistant, and Maria Gabriela Mizes, associate registrar, all of whom have shown ingenuity and perseverance.

I am so pleased to have had the collaboration of Maurice Berger and Jill Johnston, who wrote such stimulating and insightful essays for the catalogue. Niki de Saint Phalle's willingness to publish the very personal text "A Letter to Bloum" is much appreciated, as was her cooperation with various requests for time and information. I am extremely grateful to Arman, Allan Kaprow, Claes Oldenburg, and Daniel Spoerri, who graciously endured not only their interviews but the production process as well. In so doing, they have made new contributions to the history of the late 1950s and early 1960s. Finally, Brian Wallis deserves sustained applause for his patient, adept, and painstaking editing of the manuscripts.

Many colleagues have provided extensive support to my research. I wish to acknowledge Bruce Altshuler, director of the Noguchi Museum, who openly shared his knowledge of this era with me, and pointed me in several crucial directions; Julia Blaut, who generously assisted me in locating published sources; Nan Rosenthal, curator at the Metropolitan Museum of Art, who took my cold telephone calls and spoke with keen insight of the Neo-Dada period; and David Platzker, who aided my search for specific photographs. My deep thanks go to Pierre Restany, who allowed me to record a long interview with him in Paris during the early stages of my research, and to Phyllis Stigliano and Janice Parente of Niki de Saint Phalle's archives in Paris, who showed me many articles and rare catalogues from the early sixties. Additional individuals who provided support during the organization of this show include Roland Augustine,

Timothy Baum, Clare Bell, Amanda Demersky, Daniel Faust, Stephen Foster, Emily Harvey, Jon Hendricks, Billy Klüver, Michael Kohn, Cornelia Lauf, Loïc Malle, Jacqueline Matisse Monnier, Christie Ray, Monica Regas, Joseph Rickards, Sara Seagull, Jeanne Stanford, Kristine Stiles, Leslie Tonkonow, Liliane Vincy, Jeffrey Wasserman, and Winnie Wechsler.

Numerous artists and dealers were extremely forthcoming with their time and recollections. In particular, I am indebted to Ben Vautier, Dick Bellamy, and Shirley Berman for submitting to my many questions with aplomb. Others whose informative discussions contributed to my understanding of the Neo-Dada period include John Baldessari, William Copley, Raymond Hains, and Ed Ruscha. Thanks are due Betty Asher, Virginia Dwan, and Jean Larcade, who were involved in the art scene of the era and likewise aided me by digging in their memory banks and sharing their time.

In parting with their works of art for an extended tour, the lenders deserve deep acknowledgment for their generosity.

Finally, I extend my most heartfelt gratitude to those who helped see me through the project from its inception. I thank Anne and Robert Louttit for their willingness to drop everything and help out when I asked. I am grateful to my son, Sam, for helping me keep it all in proper perspective. Most of all, I thank my husband, Aaron Schwarz, for his patience, his encourage-ment, and his enthusiasm, and for providing love and support through every phase of *Neo-Dada*.

Susan Hapgood

9

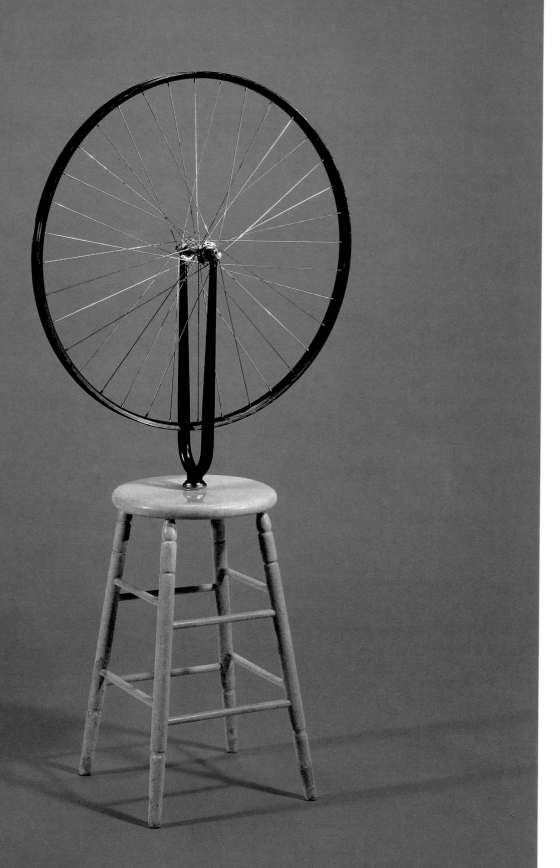

1 MARCEL DUCHAMP

Roue de bicyclette (Bicycle Wheel), 1913/1964.

Neo-Dada

Susan Hapgood

Fundamental changes in the art of the late 1950s and early 1960s were brought about by a new generation of artists in the United States and Europe. The primary source of inspiration during this fluid, experimental period was Dada. "Neo-Dada" quickly became the principal term used to describe the art made between Abstract Expressionism and Pop art. Escaping from the stifling conventions of abstract painting, younger artists were empowered by their newfound knowledge of the methods and manifestations of the Dada movement. Their embrace of any material or format, their display of raw trash, and their attraction to assemblage and collage techniques was bolstered by this growing historical awareness. The full impact of Marcel Duchamp's notion of the readymade—manufactured products designated as art objects—was registered and amplified in the work of younger artists. Finally, and most important, attitudes toward art changed on the most elemental levels. Artists' use of chance as a compositional method, their interest in performance and other ephemeral manifestations, and their challenges to the conventional exhibition, distribution, and commodification of art all reflect major shifts effected by Dada. During this brief, fertile period, Dada was the most important influence, spawning a host of new directions by the mid-1960s.

Coined in the late 1950s as a pejorative slap, the term "Neo-Dada" endured in the critical literature for at least seven years, although it was rejected by many artists and was never applied consistently.[1] Use of the term varied considerably depending on who was using it and on how they felt about Dada itself. In 1958, *Art News* claimed that "Neo-Dada" defined an approach that was "pyrotechnic or lyric, earnest but slyly unaggressive ideologically but covered with esthetic spikes."[2] By 1960, the phenomenon had

grown so strong that Irving Sandler called it "an avant-garde fad," a "craze"; two years later, it was referred to as "the most talked-about art movement of the moment."[3] Artists in Japan took up the name briefly in 1959; and in 1962, a group of artists performing in Germany used the term to characterize their activities.[4] Most artists and critics spurned the term, however. Critics often tossed it about in reviews or articles, but rarely with any degree of commitment or conviction. And for artists, resistance to the label was part of a quite reasonable hesitancy to be identified with a movement dating back forty years. As one artist put it recently, "Neo-Dada" had the allure of reheated coffee.

On the simplest level, Neo-Dada described art that rebelled against formal conventions by reintroducing everyday materials into painting and sculpture. In general, it was an affront to expectations of what art should look like. Sometimes Neo-Dadaists intended a broader challenge to the rules about what art should be, both conceptually and visually. Such iconoclastic attitudes were often discussed by critics, who compared such intentions to the confrontational nonsense and anti-art impulses of the original Dada movement.

Dada, a nihilist literary and art movement that flourished from 1916 until 1922 in several cities, was founded by German and French artists who had fled to Switzerland to avoid being drafted into World War I. Appalled by the brutality of war, and by the complacent conservatism of the bourgeoisie, Dada artists found subversive, irreverent means to outrage their staid audiences, while at the same time overthrowing the artistic status quo. At the Cabaret Voltaire music hall in Zurich, the earliest Dada activity manifested itself in performances—simultaneous readings of poems written using chance methods of composition, or concerts of *bruitist* music, comprised of noise. Other

Dada groups quickly appeared in Paris and New York. While Parisian Dadaists adhered to more literary formats, a small New York contingent made objects from miscellaneous found items, most notably Marcel Duchamp's singular manufactured products known as readymades. At the end of the war, Dada spread to Berlin, Hannover, and Cologne. In Berlin, production was largely photographic and propagandistic: artists openly opposed the political establishment with scathing imagery and dramatic photomontage juxtapositions.

Forty years later, Neo-Dada was occasionally described as a cultural or social protest, and this point was briefly debated in the art journals. But more often, perceptions of Dada as having been an almost exclusively political movement led critics to dismiss the relative lack of engagement shown in the new art. Where the Neo-Dada moniker did seem to fit was in the revived use of irony and metaphysical cynicism (derived from the work of Marcel Duchamp) and in the implementation of various liberating creative methods.[5] Some critics simply regarded the Neo-Dadaists as satirical rather than for or against anything.[6] While these and many other characteristics were evident in the art referred to as Neo-Dada, the strongest Dadaist impulses informing younger American and European artists of the 1950s were Duchamp's notion of the readymade and Schwitters's collage technique.[7]

The first artists to be designated Neo-Dadaists were Jasper Johns, Robert Rauschenberg, and Allan Kaprow in 1958.[8] Slightly later, the term was also applied to Richard Stankiewicz and John Chamberlain. But throughout the fifties, the most influential promoter of Dadaist—and, more specifically, Duchampian—ideas was the avant-garde composer John Cage. By the early 1960s, a wide circle of artists in New York was fre-

quently compared to Dada, often unfavorably. Their art is now better known under the rubrics Pop, Fluxus, and Happenings.

In Paris, around 1960, art critic Pierre Restany was one of the first to fully understand the relevance of the blossoming historical comparison between Dada and Neo-Dada, particularly with respect to the emerging Nouveaux Réalistes group. Since many of the Nouveaux Réalistes were not only interested in Dada but also well-informed about it, Restany's comparison of their work to Dada and to the Duchampian readymade was most appropriate, though it met with resistance from some of the artists early on and was subsequently downplayed.[9] In Los Angeles around the same time, a strong infusion of Dada was imparted to many young artists by artist-poet Wallace Berman and curator Walter Hopps.[10] Pockets of interest in Dada could also be found in many other cities, including San Francisco, Milan, Cologne, Nice, Düsseldorf, and London. But it was the artistic environments of New York, Paris, and Los Angeles that were the hotbeds of Neo-Dada fervor between 1958 and 1962.[11]

In all these cities during this period, webs of friendship were established among artists interested in the rather obscure subject of Dada. Throughout the fifties, few artists or critics had pursued information about Dada, since Surrealism was regarded as the main art-historical precedent for avant-garde painting in New York and Paris. Ironically, it was one of the leading Abstract Expressionists, Robert Motherwell, who was the principal force in reviving Dada. In 1951, Motherwell edited an enormously important book, *The Dada Painters and Poets: An Anthology*, the most comprehensive Dada anthology in any language at that time. For years it served as a rich source of ideas for younger artists.[12] As this new generation became disenchanted with Abstract Expressionism, attention was diverted from Surrealist

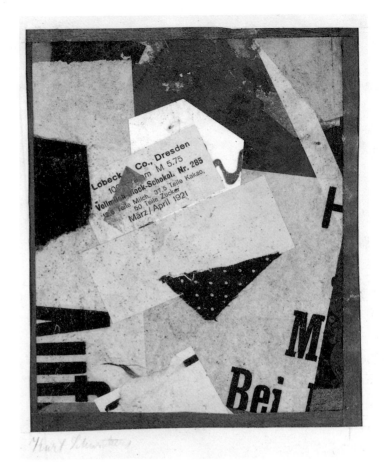

2 KURT SCHWITTERS

Collage: Lobeck and Co., n.d. Pasted paper, fabric, feather, 5½ × 4½". Yale University Art Gallery; bequest of Josephine Setze (1982.61.2). Photo Joseph Szaszfai.

abstraction to its nearly forgotten and far more radical predecessor. Dada provided a means of escape from the increasingly stifling hegemony of abstraction.

At the same time, galleries, museums, and publishers showed increasing interest in Dada. Solo exhibitions of Marcel Duchamp's work were held at Sidney Janis in New York in 1952, 1953, 1956, and 1959; Janis also showed Kurt Schwitters's work in 1952, 1953, and 1956.[13] Duchamp's oeuvre became far more visible with the opening of the Arensberg Collection (including forty-three

3 KURT SCHWITTERS

White - Blue, 1946.

Duchamps) at the Philadelphia Museum of Art in 1954, and with the major show of work by the three Duchamp brothers that was held at the Solomon R. Guggenheim Museum in 1957.[14] A collection of Duchamp's writings, *Marchand du Sel: Ecrits de Marcel Duchamp*, was published in French in 1958; Robert Lebel's monograph on Duchamp was published in French and English in 1959;[15] and the *Green Box*, an English translation of Duchamp's notes for the *Large Glass*, appeared in 1960. A major Dada exhibition, including eight hundred items, traveled through Europe in 1958 and 1959,[16] and a Schwitters retrospective was mounted at the Venice Biennale in 1960. Schwitters and Duchamp were featured in the highly influential

Museum of Modern Art exhibition *The Art of Assemblage* in 1961. Large retrospectives of these two crucial figures were organized by the Pasadena Art Museum in 1962 and 1963.

Much of this new attention to Dada centered on Marcel Duchamp, whose work exerted a particularly strong influence on younger artists. Art dealer Richard Bellamy recalls that "everybody had studied Duchamp" at that time.[17] What is more, Duchamp lived in New York from 1954 until his death in 1968, and he knew many of the younger artists, went to see their exhibitions and performances, and occasionally commented on their art.[18]

For these younger artists, Duchamp's principal artistic contribution was the readymade, manufactured objects that Duchamp selected and exhibited as art works. Of these, the most notorious was *Fountain*, a common urinal exhibited in 1917 in New York. The organizers, the Society of Independent Artists, rejected the urinal after they claimed they would accept and exhibit any work submitted. The urinal defied "good taste," that bourgeois phenomenon Duchamp loved so much to hate. As he later wrote to a friend, "I threw . . . the urinal into their faces as a challenge."[19] Without this sense of defiance, the charge of all of the readymades dies, the shock is neutralized. The readymade thrives on its uneasy position both outside and within the arbitrarily defined realm of art.

The multivalence of the readymades makes them adaptable to many interpretations, yet they splendidly elude specific meaning. Despite the small mountain of texts written on these works, Duchamp's own comments about the readymades remain the most revealing. He once stated that in 1913 he was visually indifferent when he attached a bicycle wheel to a kitchen stool; it was "a distraction,"[20] "a pleasure, something to have in my room . . . as one watches a fire in a fireplace."[21] But this simple distraction/pleasure motive apparently faded later in favor of a shrewd, multifaceted layering of meaning demonstrated by Duchamp's designation of many subsequent readymades and his authorization of

their fabrication in editions. Duchamp said simply that he wanted to "reduce the idea of aesthetic consideration to the choice of the mind, not to the ability or cleverness of the hand."[22]

Shortly after the urinal was rejected by the hanging committee, Duchamp wrote a brief, anonymous essay about the event in which he claimed that the importance of the urinal was the artist's act of selection. "He CHOSE it," Duchamp wrote. "He took an ordinary article of life, placed it so that its useful significance disappeared under the new title and point of view—created a new thought for that object."[23] This aspect of the readymade is ambiguous and troubling, however, because it is often interpreted as the artist *elevating* a common object to the sanctified status of art, an attitude that only buttresses and perpetuates the elitism of fine art.[24] Duchamp himself claimed that with the readymades he wanted to lower the status of the artist in society, to de-deify the artist, and even to eliminate art entirely.[25] Late in his life, with much fame and significant hindsight, Duchamp downplayed the chooser/appropriator role, announcing that he was "accepting" the readymade objects,[26] and saying that they were not *objets trouvés* but "canned chance."[27]

The readymades were also an attempt to eliminate the "aura" of the masterpiece, and, in general, to foil the commodification of art. By nature, readymades are not unique; they are manufactured objects. As Duchamp said later, "I never intended to sell them . . . The readymades were a way of getting out of the exchangeability, the monetarization of the work of art, which was just beginning about then [in the 1910s]. In art, and only in art, the original work is sold, and it acquires a sort of aura that way. But with my readymades a replica will do just as well."[28] Duchamp even said that he preferred playing chess to making art because chess, a purer conceptual activity, escaped the danger of being corrupted by money.[29] But he could never really alter the trade value of art objects or overturn commodity fetishism.[30] The invincible capitalist art system eventually engulfed his

readymades and transformed them into precious collectibles.

Duchamp commented on this capitalist hegemony with characteristic wit in his *Box in a Valise* (1941/1959), a traveling salesman's case of miniature replicas of his own work. Duchamp said he didn't really know what his intentions had been in creating this work, but that perhaps "it was regret that I hadn't made a Saint-Etienne [Sears and Roebuck] sort of catalogue."[31] But such ironic gestures toward the market fell on deaf ears until the early 1960s, when a number of artists began to pick up on their relevance and cynical humor. For these artists, Duchamp's art was a kind of open door through which they passed; his activities, and especially the implications of the readymades gave them permission to pursue many iconoclastic directions.

A second Dada artist whose work strongly affected the Neo-Dadaists was Kurt Schwitters, whose oeuvre was comprised chiefly of colorful, brilliantly composed collages incorporating scraps and bits of everyday materials. Schwitters's 1920 essay "Merz," advocating the combination of any and all materials to make composite art works, was included in Motherwell's Dada anthology and was widely circulated in the late fifties.[32] Also, Schwitters's *Merzbau*, a sculptural environment he created in Hannover and later refashioned in England, was known in New York through photographs, as were his performances. But mostly what was seen were his collages. Sidney Janis reportedly had "dozens" of them, which he exhibited regularly throughout the fifties.[33] Some sense of the rising interest in Schwitters's art during this period is reflected by the fact that the price of his collages quadrupled between 1954 and 1957.[34] By the late sixties, the Museum of Modern Art owned forty-eight Schwitters collages.[35]

Schwitters and Duchamp occupy opposite ends of a spectrum of influence that is relevant to the Neo-Dadaists. This continuum ranges from Schwitters's more formalist, aestheticized style, with ample evidence of the artist's touch and persona, to Duchamp's more conceptual approach, which veers away from a crafted

appearance toward irony and wit.[36] Nearly all of the artists characterized as Neo-Dadaists fall to one extreme or the other, and the appearance of their work differs significantly.

Although Robert Rauschenberg is the artist most often called a Neo-Dadaist, comparisons of his art with Dada are generally repudiated as false and misleading. Yet several of his most noteworthy works from the early 1950s show clear affinities to Dada. In particular, his erased de Kooning drawing of 1953 seems to take the same mischievous approach to venerated art as Duchamp's addition of a mustache to the Mona Lisa or André Breton's erasure of a blackboard drawing by Francis Picabia in 1919.[37] Perhaps even more subversive and Dadaist in spirit were Rauschenberg's twin paintings of 1957, *Factum I* and *Factum II* (figs. 4, 5). These nearly identical paintings, with similar drips and smears, offered a wry, Duchampian commentary on the vaunted originality and spontaneity of Abstract Expressionism's painterly gestures.[38]

Rauschenberg's first knowledge of Dada apparently came from John Cage, whom he met in 1951; Cage had known about Duchamp since the thirties.[39] Rauschenberg may also have learned about Dada at Black Mountain College in August 1951, when Motherwell visited the school for one month just after completing his Dada anthology.[40] But Rauschenberg's "first real exposure" to Duchamp came in 1953, when he saw twelve of his works in an exhibition at Sidney Janis (though he had seen Duchamp's *Bicycle Wheel* [fig. 1] at the Museum of Modern Art several years earlier).[41] Although Rauschenberg has said that Duchamp's life and work are a constant inspiration to him,[42] elsewhere he claims that Duchamp was not a direct influence since he only fully understood Duchamp's art after his own approach was developed.[43]

Jasper Johns has noted that in 1958, after reading Motherwell's Dada anthology, he and Rauschenberg were prompted to go to Philadelphia to see the concentration of Duchamp's art at the museum.[44] While there, Rauschenberg found the galleries momentarily empty and tried to snatch one of the marble pieces from Duchamp's sculpture *Why Not Sneeze?*, a birdcage filled with marble cubes of the size and appearance of sugar, a thermometer, and a cuttlebone.[45] Rauschenberg's impulse to possess something by Duchamp was satisfied in 1959, when he bought a replica of the first unassisted readymade, the *Bottlerack*, and had it signed by Duchamp.[46] Rauschenberg made one final Duchampian gesture in 1961, when he was invited to participate in a group exhibition honoring the avant-garde Parisian gallery owner Iris Clert. When he realized he had forgotten to make the portrait of her that he had promised, he sent off a telegram that read, "This is a portrait of Iris Clert if I say so—Robert Rauschenberg" (fig. 6).[47]

Rauschenberg's unfettered approach to art making led him to employ almost any method or material that seemed right, including various types of performance, dance, or musical composition. His paintings of the early 1950s incorporated sheets of newsprint and other collaged papers, and soon grew out into the viewer's space with the addition of ever-larger found objects. Eventually, Rauschenberg coined the term "Combines" to describe these new hybrid works. Regarding the inclusion of collaged papers and large everyday objects in his art, Rauschenberg said, "I don't want a picture to look like something it isn't. I want it to look like something it is. And I think a picture is more like the real world when it's made out of the real world."[48] By 1959, Rauschenberg was even including working radios and, later, electric fans in his Combines, pushing one step further into the "real world" he was exploring.

Whenever Rauschenberg's work is compared to Dada, it is linked to the collages of Kurt Schwitters. But this analogy is spurious. Schwitters's use of collaged fragments is nostalgic, mementolike, and somewhat narrational, while Rauschenberg's choice of everyday elements is impersonal, reflecting his surroundings rather than his own taste. And Schwitters's compositions are

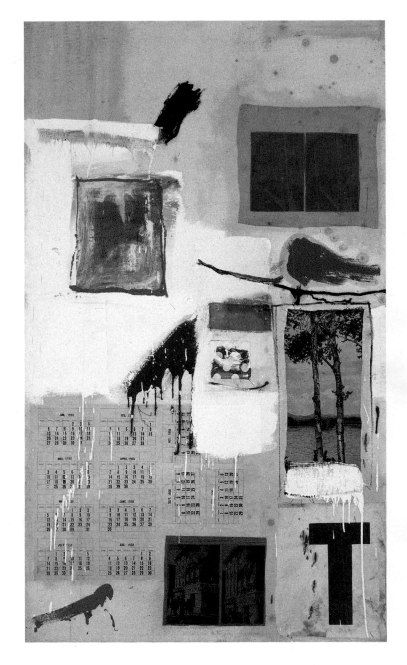

4 ROBERT RAUSCHENBERG

Factum I, 1957. Combine painting, 61½ × 35¾". The Museum of
Contemporary Art, Los Angeles; The Panza Collection. Photo Squidds
& Nunns. © Robert Rauschenberg/VAGA, New York 1994

5 ROBERT RAUSCHENBERG

Factum II, 1957. Combine painting, 61½ × 35¾". Morton G.
Neumann Family Collection, Chicago. Photo courtesy Leo Castelli.
© Robert Rauschenberg/VAGA, New York 1994

tightly controlled and formal, whereas Rauschenberg's are more spontaneous, allowing the content of collaged elements to show through, and reproducing the non-order of the artist's environment.[49] Nevertheless, there are some striking similarities between the two artists: elegant formal balances between the real items and the painted or drawn areas; an attraction to discarded, worn bits of detritus; and a blunt denial of "appropriate" ways to make art. Rauschenberg's statement in 1959 that "a pair of socks is no less suitable to make a painting with than wood, nails, turpentine, oil and fabric" neatly echoes Schwitters's 1920 declaration, "I take any material whatsoever if the picture demands it."[50] In fact, when Rauschenberg first saw a show of Schwitters's work, he said he felt as if the whole exhibition had been made just for him.[51]

One month after Duchamp's death in 1968, Jasper Johns wrote an "appreciation" of him for *Artforum*. In it, Johns acknowledges a far greater debt to Duchamp than has Rauschenberg (although, since Johns and Rauschenberg were in frequent contact during the years 1958 to 1962, it might be safe to assume that whatever one knew the other knew). The seeds of Johns's appreciation may be glimpsed even earlier in a text he wrote about Duchamp in 1960, two years after he and Rauschenberg first saw the Arensberg Collection.[52] In 1969, Johns published more of his thoughts on Duchamp in a special issue of *Art in America*.[53] These brief essays demonstrate Johns's acute understanding of Duchamp, particularly his wit, his plays with language, his attempts to destroy art, his use of the readymade, his refusal to be pinned down about meaning, and his views on the importance of the viewer's role. Johns wrote, "It may be a great work of his to have brought doubt into the air that surrounds art . . . attacking the ideas of object, artist and spectator with equal force."[54]

Johns's own works, though often spoken of as Neo-Dadaist,

are actually a reversal of Duchamp's readymade gesture. In his flag and target paintings of the mid-fifties, Johns appropriated widely known emblems and painted them with dabs of encaustic. Adopting images that are readymade, that is, compositions that he chose rather than conceived, he then reverted to an extremely traditional method—in fact one used by ancient Greek painters—a technique that ironically leaves all of his gestural strokes evident, strokes that have no correspondence to the predetermined graphic composition. His attitude toward these works was as indifferent as his choice of subjects; he said, "A picture ought to be looked at the same way you look at a radiator."[55]

In 1956, Johns began to attach actual objects to the surfaces of his paintings, as in *Drawer* (fig. 7), which makes punning reference to underwear and draughtsmanship, while ironically imitating the front of a dresser with its non-functioning drawer. Likewise, in 1960, Johns made two *Painted Bronze* sculptures, one representing a couple of beer cans (fig. 8), the other resembling a coffee can filled with paintbrushes. Cast from life, and then painstakingly painted by the artist, these witty objects flip back and forth between being perceived as readymades and being viewed as traditional sculpture. Additional Duchampian motifs and themes appear in Johns's works of the late 1950s and early '60s, as well, particularly in his repeated use of rulers and other measuring devices, his love of witty paradoxes, and his play with visual puns.[56]

Three other artists who were often called Neo-Dadaists are Richard Stankiewicz, Jean Follett, and John Chamberlain; their daring use of junk materials and unconventional sculptural techniques cast them as renegades of their era. Stankiewicz was a prominent member of the group of artists who had studied under Hans Hofmann in the late forties and which went on to found one of the more progressive New York galleries in 1951,

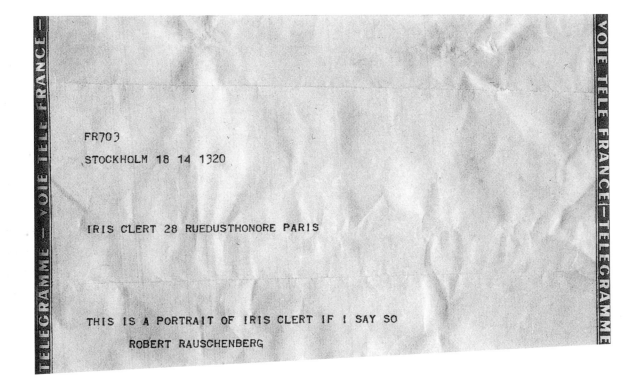

6 ROBERT RAUSCHENBERG

This is a Portrait of Iris Clert If I Say So, 1961.

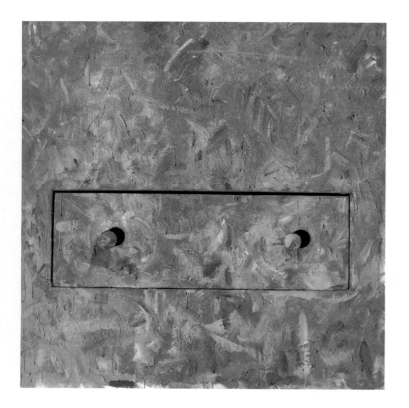

7 JASPER JOHNS

Drawer, 1957. Encaustic and assemblage on canvas,
30¾ × 30¾". Rose Art Museum, Brandeis University,
Waltham, Massachusetts; Gevirtz-Mnuchin Purchase
Fund (1962.133). © Jasper Johns/VAGA, New York 1994

the Hansa Gallery, where he showed throughout the decade. In
1952, Stankiewicz introduced sculpture made from cast-off mate-
rials. Gradually, in shows throughout the decade, his welded
accumulations of mundane remnants of machinery and plumb-
ing found many adherents in New York and in Europe as well.
Celebrating the industrial decay that accumulates in our urban
and suburban environments, he said that Duchamp's ready-
mades were crucial to his realization that art derived not from
materials but from how they were used.[57]

While Stankiewicz was a pioneer of junk sculpture, his work
in this area was probably preceded by that of his girlfriend, Jean
Follett. Unfortunately, published information about Follett is
scanty, but several artists of the period have referred to the high
level of respect she enjoyed, and to her precedence in introduc-
ing junk in her works.[58] Follett, too, studied with Hans Hofmann
in the 1940s, and her sculptures show the *spannung*, or pictorial
tension, that he praised. In both Stankiewicz's and Follett's more
figurative works, there is always a visual play between abstraction
and figuration. In Follett's case, it seems she was experimenting
with only the slightest hints of anthropomorphic reference—
the figures seem so elusive and abstracted. Of the few works by
Follett that survive (see fig. 59), all focus on assorted pieces of
iron and steel hardware affixed to two-dimensional supports,
often with bodily connotations.

During the late 1950s, John Chamberlain's use of discarded
materials classified him as a Neo-Dadaist. His sculptures, made
by welding together contorted sheets of painted steel left over
from automobile bodies, adhere to the junk aesthetic that takes
found detritus as readymade fodder to be reconfigured into
something else (see fig. 9). Yet at the same time, his works have
also been compared to action painting with their broad swaths
of color and all-over compositions. His interest in the process of
his art, in "the idea of the squeeze, the compression and the fit,"
clearly echos the aims of the New York School.[59]

All of the artists associated with Neo-Dada were deeply indebted to Abstract Expressionist painting, even though they challenged it at every turn. Theirs was not an about-face or an open revolt, it was a paradigm shift from an old set of values to a new one. Among the earliest artists to be called Neo-Dadaists, most were educated in an Abstract Expressionist milieu and retained many of its attributes in their work. As one of the original Dadaists once said, "Dada was born of what it hated. It had a hard time clearing its throat."[60]

In an influential article called "The Legacy of Jackson Pollock" (published in *Art News* in 1958), Allan Kaprow described some of the links between Abstract Expressionist painting and subsequent Neo-Dadaist forays into assemblage, environments, and performance.[61] By 1956, Kaprow argues, advanced art had become dull and repetitive, even futile. But Pollock, he claims, opened new avenues for the younger generation of artists. Pollock's mural-size paintings and their extension into the viewer's space had a dramatic effect on Kaprow's perception of his environment and the life in it. He writes,

> Pollock, as I see him, left us at the point where we must become preoccupied with and even dazzled by the space and objects of our everyday life, either our bodies, clothes, rooms, or, if need be, the vastness of Forty-Second Street. Not satisfied with the *suggestion* through paint of our other senses, we shall utilize the specific substances of sight, sound, movements, people, odors, touch.

Further inspired by a recent visit to Rauschenberg's studio, Kaprow concludes, "Objects of every sort are materials for the new art: paint, chairs, food, electric and neon lights, smoke, water, old socks, a dog, movies, a thousand other things which will be discovered by the present generation."[62]

Kaprow's own environments (see fig. 58), which he began to make in 1957 from large hanging pieces of paper, lights, junk,

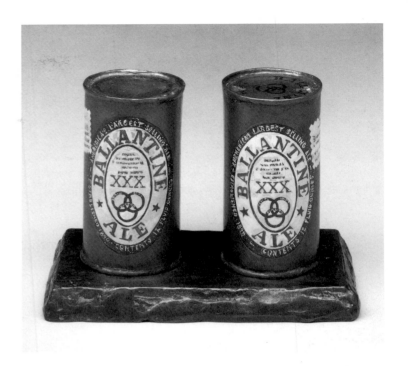

8 JASPER JOHNS

Painted Bronze (ale cans), 1964 (first version 1960). Painted bronze, 5½ × 8 × 4½". Philadelphia Museum of Art; Lent by the artist (103.1979.6). © Jasper Johns/VAGA, New York 1994

and recorded noises, derived from Abstract Expressionism. Using compositional units made from ubiquitous common items instead of oil paint, and a room instead of a stretcher, Kaprow composed environments that enveloped the viewer in sensory stimulation. Instead of noticing, for instance, the way a brash stroke of ochre might visually resonate against a field of blue wash, a viewer might consider how a curtain of chicken wire affects the perception of the textured papers behind it, or walk along a wall of undulating pieces of plastic while listening to recorded sounds.

Kaprow's democratic, unfettered approach to materials and methods pointed in a new direction, as evidenced by an untitled work recreated for the current exhibition (fig. 10). It is a mound of newspaper balls that was displayed in the 1959 exhibition

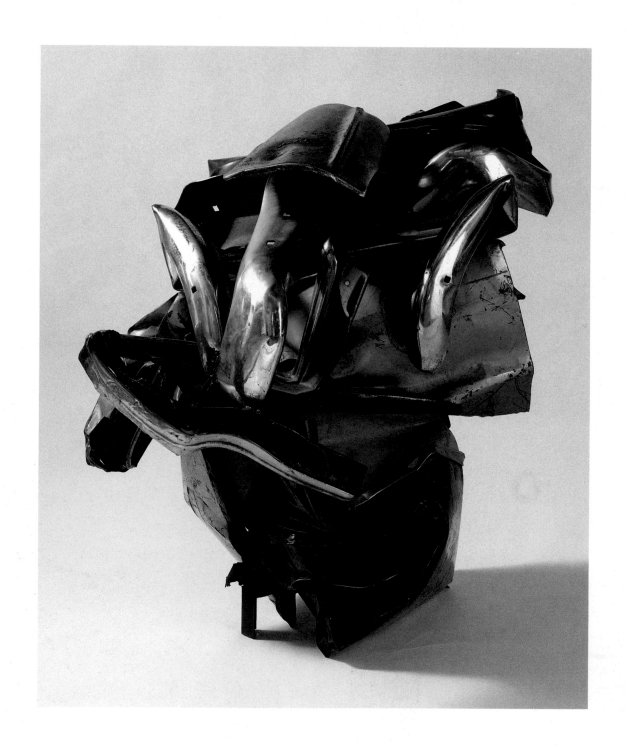

9 JOHN CHAMBERLAIN

Butternut, 1963.

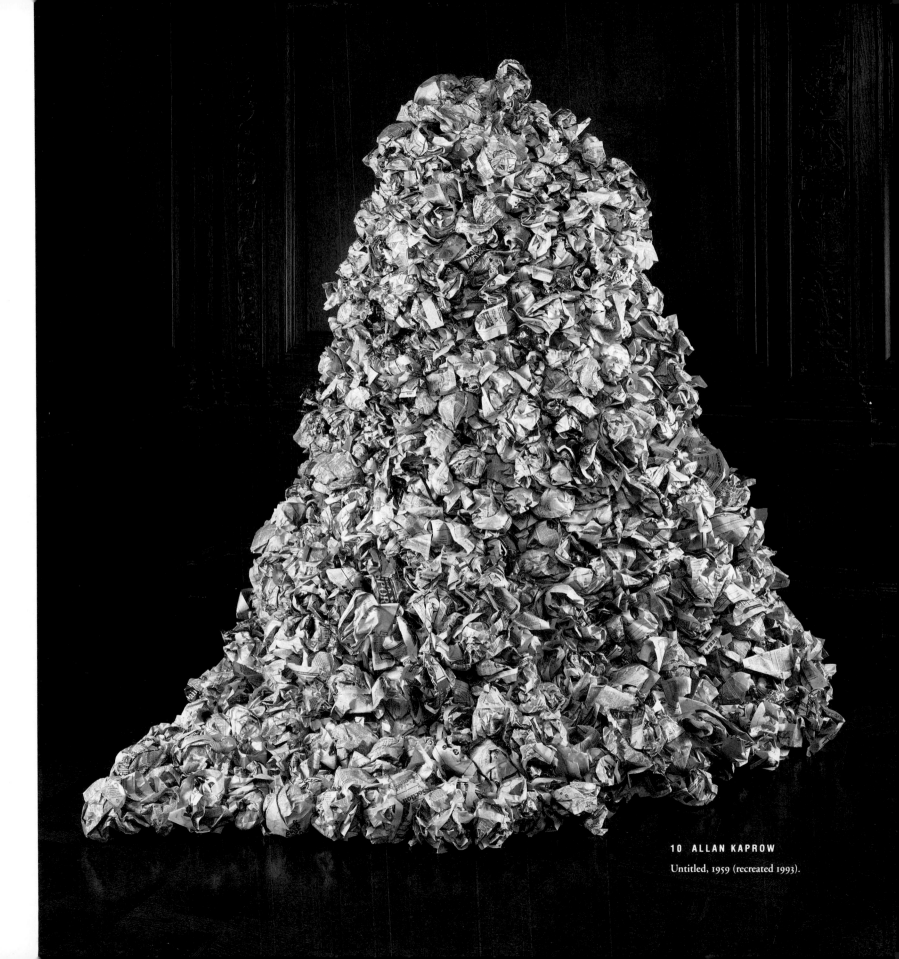

10 ALLAN KAPROW

Untitled, 1959 (recreated 1993).

Below Zero at the Reuben Gallery. One of the few smaller-scaled works that Kaprow made during this period, it nonetheless imparts a sense of his general approach at the time—his use of readily available sheets of newspaper, and his compositional method of assembling these balled-up sheets into a mountain shape, a method achievable by virtually anyone. The repetition of haphazardly positioned circular forms in this small work brings to mind Kaprow's best-known environment, *Yard* (1961), a small urban courtyard filled with hundreds of automobile tires that viewers were allowed to explore.

But perhaps the most experimental American art works to emerge from the Abstract Expressionist milieu were Kaprow's Happenings. In another text from 1958, Kaprow wrote, "This idea of a total art has paradoxically grown from attempts to extend the possibilities of one of the forms of painting, collage, but unknowingly this led to the rejection of 'painting' in any form . . . What has been worked out instead is a form which is as open and fluid as the shapes of our everyday experience, without simply imitating some part of it."[63] Claes Oldenburg, who began to experiment with performance in 1959, also noted that "Happenings came about when painters and sculptors crossed into Theatre taking with them their way of looking and doing things."[64] The shift toward performing the physical act of action painting, and the subsequent media attention to the artists themselves accentuated the performative qualities of art making.[65]

During the late 1950s, Kaprow also became intrigued by Dada and the ideas of Duchamp, whom he called one of his most important influences. He said, Duchamp "hints to the effect that you could pick up art anywhere if that's what you wanted. In other words, he implied that the whole business of art is quite arbitrary."[66] Kaprow also prized Motherwell's Dada anthology, which documented in lengthy descriptions and photographs the readings, noise-music, and provocations of the Dadaists. In particular, Kaprow was inspired by Schwitters's ideas for Merz theater, fantastic passages that called for "objects [that] move and revolve, and lines . . . allowed to broaden into surfaces . . . Materials for the score are all tones and noises capable of being produced by violin, drum, trombone, sewing machine, grandfather clock, stream of water, etc. Materials for the text are all experiences that provoke the intelligence and emotions . . . Take a dentist's drill, a meat grinder, a car-track scraper, take buses and pleasure cars, bicycles, tandems and their tires, also war-time ersatz tires and deform them."[67] Kaprow said Schwitters "actually conceived Happenings but never did them. His writings about possible activities are almost like pre-Happenings."[68]

Another strong influence on the Neo-Dadaists was John Cage, the primary figure to inspire Happenings and the performative works called events. From 1957 to 1959, Kaprow attended Cage's musical composition classes at the New School for Social Research in New York, and was one of the most active participants. Cage described to his students Dada performances and suggested that they should experiment with chance and indeterminacy when carrying out their class assignments. His teachings interwove Duchampian attitudes[69] with Zen Buddhist philosophy, returning again and again to three themes: the importance of environmental sounds and immediate occurrences; audience participation (particularly the viewer's role in making the meaning of the work); and chance methods of composition (which

derived from Duchamp as well as the *I Ching*, and were intend-
ed to imitate nature). For artists such as Allan Kaprow, George
Brecht, Dick Higgins, Jim Dine, and many others, Cage was
both a mentor and an escape hatch, pointing a way out from the
"heavy shadow of Abstract Expressionism."[70]

Happenings took place in New York from about 1958, when
they were known to few, until 1962, when they were attended by
overflowing audiences. For Kaprow, Oldenburg, Dine, and
Robert Whitman, some of the chief practitioners, Happenings
were an extension of their object-oriented assemblages that
included everyday detritus. Like the assemblages, these frag-
mented, non-narrational performances were put together with-
out meaningful connections between parts. Happenings were
related to the contemporaneous collagelike environments, but
they were not static; Happenings were theatrical and temporal, if
short-lived. Impermanence was more than a formal attribute; it
reflected American "throwaway culture," according to Kaprow,
and kept the line between art and life as fluid and as indistinct as
possible.[71]

Claes Oldenburg was especially struck by Kaprow's Pollock
article and attended Kaprow's first New York performance, *18
Happenings in Six Parts* in 1959. The following year, Oldenburg
organized a series of Happenings. Oldenburg's own perfor-
mances represented the grittiness of New York's Lower East Side,
and tended to be more spontaneous and emotionally inflected
than Kaprow's, which have been described as detached, con-
trolled, and precise. Oldenburg said he wanted his performances
to be "normal, natural experience[s]," like "simply sitting and
watching something that's *very familiar*."[72] Oldenburg was ambiva-

lent about the commodified art object, and felt that publicity-
seeking and media attention would impinge upon one's creativi-
ty.[73] Beyond his use of everyday objects, this ambivalence, which
at times was rather political and distinctly anti-bourgeois, was
Oldenburg's closest connection to Dada. In fact, a 1961 notebook
entry by him alludes to Duchamp as a true revolutionary because
he formulated an ethical position through his art.[74] Oldenburg
supposedly enjoyed selling art made from worthless materials,
pieces of junk, to collectors; he said he always tried to inconve-
nience the people who were buying his art.[75]

Oldenburg's most ironic, critical performance of all was an
exhibition titled *The Store* (fig. 61), which opened in December
1961 on New York's Lower East Side. Echoing Daniel Spoerri's
L'Epicerie (fig. 64), which was staged in Copenhagen just a few
months earlier, Oldenburg's show consisted of handmade paint-
ed plaster foods and clothes that he sold out of a storefront.[76]
For two months, Oldenburg made, displayed, and marketed
slices of frosted cake, gloppy overstuffed pastries, giant ham-
burgers, fake TV dinners, and plaster underwear. In a humorous
metacritique on the art system, he claimed to be disguising art in
order to protect it from destructive forces like the bourgeoisie
and commercialism.[77]

"Junk culture" was proposed as an alternate label for Neo-
Dada by Lawrence Alloway in 1960. He used these words to
describe the art of Oldenburg, Rauschenberg, and other artists
who sought to reflect the urban milieu in their work by directly
integrating its obsolescent materials and popular imagery. In his
catalogue essay for the landmark exhibitions *New Media—New
Forms* and *New Forms—New Media* at Martha Jackson Gallery,

11 GEORGE BRECHT

Chair Events, 1961. Chair placed on sidewalk as part of George
Brecht's *Chair Events*, included in *Environments, Situations,
Spaces*, Martha Jackson Gallery, New York, 1961.

Alloway traced a tradition of junk culture, linking the new art to
Dada collage and the readymade. Kaprow's essay for the same
catalogue curiously disavows any comparison to Dada, saying
such analogies reflect a lack of understanding of the new art. He
strongly advocates ephemeral art works, the temporary rather
than the permanent, and the rejection of art works as valuable
possessions. Kaprow was a principal influence on collaborative
projects involving performance and dance pieces at Judson
Church and elsewhere in New York.

Another prominent influence on performance and Happen-
ings of the late 1950s and early 1960s, was the Japanese Gutai Art
Association, whose most experimental period ran from 1954 to

about 1957. Although Western knowledge of their activities has
been scanty in recent years, the group was well-known during
the mid- to late 1950s by a host of artists, including Klein,
Arman, Vautier, Pollock, Kaprow, Oldenburg, and Ed Ruscha.
By 1957, they were prominent enough to prompt a long article
in the arts section of the Sunday *New York Times*, and to exhibit
at Martha Jackson Gallery the following year.[78] By around 1960,
"there was just talk, talk, talk about the Gutai and Gutai ideas,"
according to Ruscha.[79] Jiro Yoshihara, the Gutai artists' leader,
responded to Pollock's large allover paintings in much the same
way as Kaprow did; he discussed their "impact not so much on
the purely visual perception, but rather directly on ourselves."[80]
His group's art took off from there, pushing the action of paint-
ing into the sphere of performance, challenging the status of the
art work altogether, and investigating the concrete aspects of
painting. They heavily promoted their own activities by sending
issues of their journal abroad, with texts and names translated
into English.[81] The Gutai group was well aware of Dada and
even considered themselves a sort of "Dada without the packag-
ing and with the simplest of aids."[82] The Gutai Group's perfor-
mance works involved the body and environment, often making
use of highly unconventional materials and exhibition sites.
Their first "actions," as they called them, were presented in 1955
in conjunction with an exhibition of their art. Kazuo Shiraga
thrashed around for nearly half an hour in a ton of clay out-
doors, and Saburo Murakami violently thrust his body through
layers of packing paper stretched across frames. Inside the exhi-
bition, viewers were invited to walk on Shozo Shimamoto's
wooden paths mounted on springs, which wiggled under their
weight. During this same exhibition, a series of electric bells was
installed throughout the show by Atsuko Tanaka, to be activated
by her audience. In the following year, Shimamoto presented an
action outdoors that consisted of him firing rounds of enamel
from a homemade cannon at a huge piece of plastic hanging

between the trees. In the focus on simple, and sometimes violent or abrupt action using unusual "props" and outdoor settings, the Gutai performances were a contributing factor to the burgeoning performance scene in the United States.[83]

One of the lesser known, but extremely influential artists working in the middle of the American Happenings and environment milieu is George Brecht. His performance works are so simple that they are often not easy to distinguish as art. Now known chiefly as a member of Fluxus, Brecht was a friend of Kaprow's in the 1950s, and a fellow student in Cage's classes. But Brecht's interest in the art/life distinction and in using chance methods predated his participation in Cage's class. In his 1957 essay "Chance Imagery," Brecht discusses chance as a means to avoid cultural and personal biases, citing Jackson Pollock's painterly methods as an example. Interestingly, Brecht also details at some length various Dada themes and approaches that informed his generation, but often went undisclosed.[84]

Brecht's earliest performances were comparable in some respects to Kaprow's, but he soon diverged from conventional Happenings and began to stage what he called "events." Brecht's events were shorter, involved the audience more radically in creating the work, and didn't even need to be performed—Brecht insisted that they could be "realized mentally."[85] Brecht's events focused on the most mundane everyday activities, such as sitting in a chair or exiting from a room. In the latter case (fig. 49), the score is typewritten on a small card titled "Word Event." Below this the text reads "Exit." What could be more direct and simple than this mundane daily activity, or more open-ended, even absurd? This work has been consciously performed during numerous Fluxus festivals, as when Fluxus artists walked off the stage, but it can likewise be thought about instead of acted out, according to the artist. This hyper-banality recalls Duchamp's notion of "infra-mince," or the virtually unnoticeable: for example, the faint sound of velvet pants brushing together.[86]

Yet, whereas Duchamp placed such things in the context of art, Brecht merely drew attention to them. As he said, "The difference between a chair by Duchamp and one of my chairs could be that Duchamp's chair is on a pedestal and mine can still be used."[87]

Brecht fully understood the importance of contexts that defined works of art, and he frequently played with the dissolution of such boundaries. An unobtrusive example of this Duchampian trope was devised for the important 1961 group exhibition *Environments, Situations, Spaces* at Martha Jackson Gallery. Brecht placed one chair under spotlights in the gallery, one in the bathroom, and one outside on the sidewalk (fig. 11). Increasingly in the early 1960s, Brecht drew attention to or rather awakened the audience's awareness of such contextualizing effects in everyday experience. In a 1961 essay, he quotes from a 1922 lecture by Dada poet Tristan Tzara: "Art is not the most precious manifestation of life . . . Life is far more interesting."[88]

For Brecht, chance was always a means rather than an end; as he said, it is "not what Duchamp's and Cage's work is about. After the stream is crossed the raft must be abandoned . . . the work is not 'done' (by anyone), but simply occurs."[89] Veering away from the role of creator, Brecht held an exhibition in 1959 titled *Toward Events* in which he invited the spectators to participate by touching, unpacking, and playing with the works on display. He even set up a card game for viewers to play.[90] Shifting the viewer's role to player rather than a reader or observer extended Duchamp's stress on the spectator's role in creating meaning, while adding some refreshing levity. George Maciunas, the Fluxus organizer, later wrote enthusiastically to Brecht, "WORK ON GAMES! This is good idea!"[91]

Of the many groups that have been called "Neo-Dada" at one time or another, Fluxus is the one that most appropriately fits the description. In September 1962, Maciunas discussed the renewed interest in Dada among Fluxus artists in his lecture "Neo-Dada in Music, Theater, Poetry, Art." In the same year, Nam June Paik

```
                        Composition 1960 #5

Turn a butterfly (or any number of butterflies) loose in the
performance area.

When the composition is over, be sure to allow the butterfly to
fly away outside.

The composition may be any length, but if an unlimited amount of
time is available, the doors and windows may be opened before the
butterfly is turned loose and the composition may be considered
finished when the butterfly flies away.

                                    La Monte Young
                                    6·8·60
```

12 LA MONTE YOUNG

Score for *Composition 1960 #5*, 1960.

organized a series of performances, similarly titled *Neo-Dada in der Musik*. Among the parallels to the earlier movement that Maciunas noted were a nihilistic anti-art attitude, a preference for concreteness, and a tendency toward indeterminacy. Maciunas coined terms like "Fluxfest," "Fluxmanifesto," and "Fluxamusement" to echo earlier Dada titles such as "Propagandada," "Dadadiplomat," or "Dadaoz." According to one artist, Maciunas looked like a "reincarnation" of Tzara; according to another, the Fluxus concerts were "revivals of the Dadaist performances of Hugo Ball and Tristan Tzara."[92] And, given the atmosphere of ridiculousness around Fluxus, it is no surprise to find an overriding emphasis on humor in Maciunas's scanty notes on Dada from graduate school in the late 1950s.[93] As with Dada, Maciunas wanted "art amusement" to be unpretentious, without commodity value, funny, simple, and require no skill.

Ann Halprin's workshop near San Francisco during these years, with its emphasis on routine activities and tasks, exerted an impact indirectly on New York when several of its participants, including La Monte Young and Robert Morris, came east in 1960 and 1961, respectively. La Monte Young had learned about Cage's ideas while still a graduate student at Berkeley, and then in Darmstadt, Germany, in 1959, and had moved to New York in the fall of 1960 to study composition with Cage's successor at The New School, Richard Maxfield.[94] Upon arriving, Young quickly became immersed in various projects, including the guest editing of a New York version of the West Coast magazine *Beatitude* (which eventually appeared as the proto-Fluxus publication *An Anthology*), as well as the organization of a series of performances at Yoko Ono's Chambers Street loft from December 1960 through June 30, 1961. As the originator of what

he termed "the short form," a brief text that conceptually described a performance, event, or work of art (see figs. 12, 52, and 53), Young evinced a simplicity and directness unparalleled among his New York contemporaries, with the possible exception of George Brecht. Young's more conceptual short form, as well as the San Francisco artists' detached use of everyday activities infused a new approach to performances that diverged from the more complex, collage-like Happenings predominating in New York. The presentations at Ono's loft preceded and coincided with performances by many of the same individuals at the brief-lived AG Gallery uptown in 1961, run by George Maciunas, who would soon take over publication of Young's magazine and lead Fluxus.

The individuals who formed Fluxus came from various groups—the circle around La Monte Young; Cage's students from the New School, including Brecht, Higgins, and Mac Low; and a few Gutai-influenced Japanese artists such as Toshi Ichiyanagi and Yoko Ono.[95] These groups were gathered together in a series of concerts, festivals, publications, and editioned sets of objects and ephemera from 1962 onwards by Maciunas, who functioned as the ringleader of Fluxus. Maciunas occasionally created works of his own. Among his more interesting pieces is *In Memoriam to Adriano Olivetti, Revised* (fig. 45), a performance for ten individuals who carry out brief mundane and somewhat absurd activities (lifting a bowler hat from the head, for example). Each activity corresponds to a number in the score, which is any used tape from an Olivetti adding machine. Absurd humor also informs the performances of Dick Higgins and Alison Knowles from this era, such as Higgins's score for *Danger Music Number Seventeen* (see figs. 13, 14): "Scream! Scream! Scream! Scream! Scream! Scream!" On a less frantic note, Alison Knowles's *Proposition* (see fig. 50) simply reads, "Make a salad." While a preference for absurdity in performance certainly recalls Dada, the Fluxus artists' use of performance as a

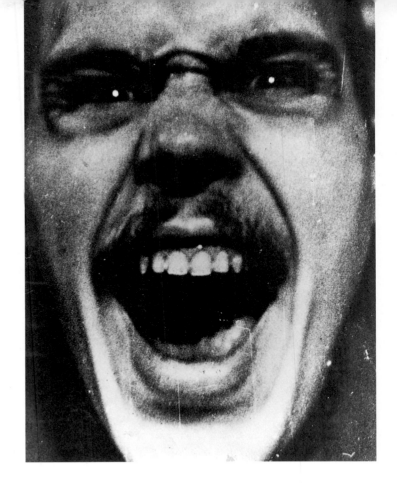

13 DICK HIGGINS performing his *Danger Music Number Seventeen*, ca. 1962. Photo Mercedes Vostell, courtesy Gilbert and Lila Silverman Fluxus Collection.

```
Danger Music Number Seventeen

   Scream!  !  Scream!   !  Scream!   !
Scream!  !  Scream!  !  Scream!  !
```

14 DICK HIGGINS

Score for *Danger Music Number Seventeen*, ca. 1960.

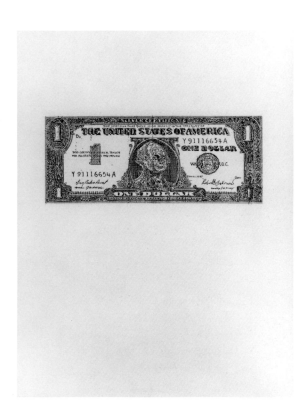

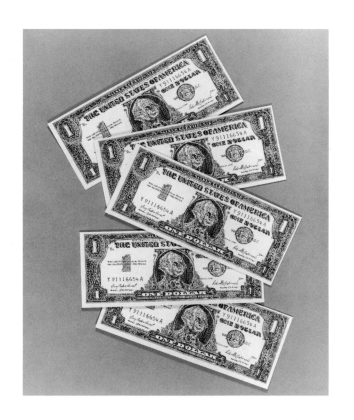

15 ROBERT WATTS

Dollar Bill, 1961–62.

means of expression reflected the broader artistic environment of the early 1960s. "Intermedia," a term devised by Higgins to describe the melding of traditionally distinct artistic formats, was already thriving in the United States by the late 1950s.

Although Fluxus existed outside the conventional art gallery system, the sale of small art objects was encouraged. The obsessive boxed accumulations of Flux objects, with packaging and graphic design by Maciunas, were not conventional commodities since they were often inexpensive and ephemeral. One obvious precedent for Maciunas's Fluxus boxes was Duchamp's *Box in a Valise*. But Maciunas was probably also influenced by Brecht's boxlike works from the late '50s, especially *The Case (Suitcase)* (1959); and several works by Spoerri, including the MAT

series of multiples of 1959, and *Der Koffer* (The Trunk, 1961), which gathered small works by numerous artists in one suitcase. The scale and format of the Fluxus boxes implied private use rather than public exhibition, and their multiplicity denied the preciousness connected with unique objects. Robert Watts's stamps and money (see figs. 15, 16) took a similar tack by embodying nonart formats, ironically identifying themes such as art's functionlessness (or subversive role as counterfeit currency) and its limited audience.

Among the more violent anti-art manifestations of Fluxus were pieces by Yoko Ono, Nam June Paik, and Ben Vautier. Paik became extremely interested in Dada after seeing a major exhibition in Düsseldorf in 1958, and seems to have been drawn to its

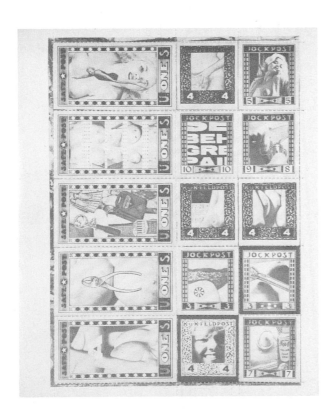 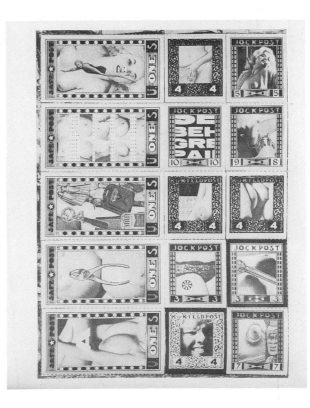

16 ROBERT WATTS

Safe Post/K.U.K. Feldpost/Jockpost, 1962.

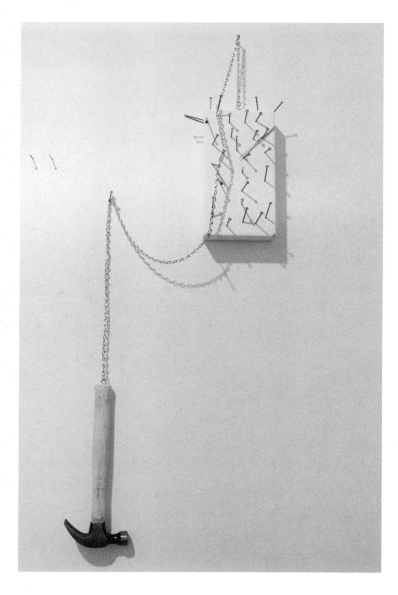

destructive impulses. In his six-minute performance in 1959, Paik overturned a piano, and in a later piece from 1962, he very slowly raised a violin over his head and then violently smashed it down.[96] Ono's series of works titled *Painting to Hammer a Nail* (fig. 17) also portrays the physical destruction of a traditional form, though she invites the audience to partake in the destruction rather than sit idly by.[97] In her various works of this title, Ono provides a hammer, a bucket of nails, and a painted white panel into which viewers may hammer the nails. One of the European members of Fluxus, Ben Vautier, recalls his own excitement about the shock value of the Dadas, whom he learned about from flyers published during the 1950s.[98] One of Vautier's more outrageous early pieces was his contribution to "The Festival of Misfits" in London (fig. 18), organized by Daniel Spoerri in 1962—he lived in the window of the gallery and signed people as living sculptures, presenting himself and all of his activities as art.

Numerous artists who show Neo-Dada traits were tangentially affiliated with Fluxus. Such independent artists as Robert Morris and Carolee Schneemann were immersed in intersecting spheres of activity in New York, including visual artists, performance artists, dancers, and musicians. Among Schneemann's earliest and least-known works are a series of assemblages dating from 1962 onward made from gathered bits of found elements. Schneemann's *Fur Wheel* (fig. 20), for instance, while punning

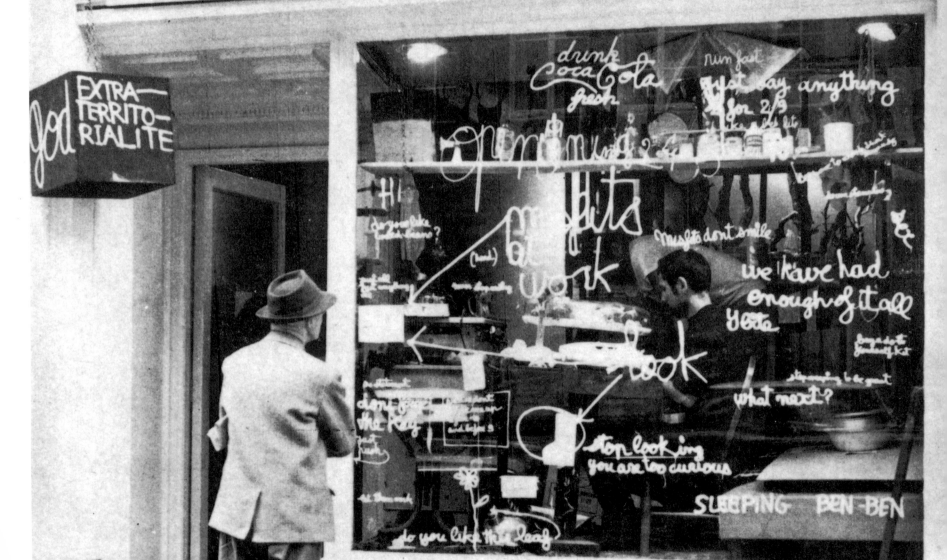

MOI, BEN JE SIGNE

19 BEN VAUTIER

Two sheets from *Ben dieu* (Ben God), 1962–63.

APPENDICE 1964 A LA REIMPRESSION DE MON MA-NIFESTE DE 1961 .

Mes meilleurs textes de 1961 sont sur la necessité de tout
" conquérir en art . Je préconise un tout illimité ainsi j'écrivais
"il faut que dans l'esprit d'une minorité d'abord et d'une majorité
ensuite , le beau soit partout même dans le pastiche et la
reproduction . Je vais jusqu'à réclamer une transformation de
l'individu par voie médica-le pour lui ouvrir de plus grandes
possibilités de création .

Un homme X ne creera pas comme un homme Z .

Depuis 1958 je crois que l'art est un geste essssentielllement
égoiste. L'essence d'un tableau , d'une sculpture , d'un
poeme est " Regardez moi X, c'est moi X qui l'ait crée .
C'est pour cela que le principe de tout art est dans la dif-
-férence entre un créa-teur et un autre .
Cet égoisme qu'on appelle personnalité interdit tout retour en
arriére . L'a-rtiste ne peut pas refaire ce qui a été fait .
Donc parce que il fa-ut du nouveau tout doit être conquis .
A partir de:cette reflexion à laquelle je reste fidéle , j'ai
cherché depuis ___ quelles sera-ient les nouvelles voies
possibles à l'a-rt . Non pas de nouvelles variantes à une
vielle pensée mais de nouvelles pensées .

EnI958 j'ai signé la notion du tout .
EN I959 j'ai signé la mort .
EN: I960 j'ai signé l'histoire de l'artetc.
EN. I962 je préconise l'art dans la prétention " Regar-
-dez moi cela suffit "

EnI962 je déclare que la destruction de l'art est art .
EN I963 je m'arrete de signer .
EN I963 je déclere qu'il n'y a plus de bonne ou mauvaise
peinture .

TOUTES CES NOUVELLES NOTION SERONT DEVELOPPEES
DANS MON PROCHAIN OUVRAGE "TOUT "

on Duchamp's bicycle wheel, adds a tactile and aural dimension with fur and tin cans attached to a lampshade structure that the viewer was invited to touch and spin. This sculpture was first exhibited in 1962 at a show in Schneemann's New York studio titled *Mink Paw's Turret*, and featuring fur and assemblage objects installed throughout. Schneemann would soon use her body as a "collage environment," becoming increasingly involved with the Judson Dance Theater and specifically with the exploration of sensuous and sexual themes involving the body.

Like Schneemann, Morris was exploring performance, dance, and the creation of art objects during the early 1960s. His work from these years shows strong links to Dada as in *Box with the Sound of Its Own Making* (fig. 21), *Litanies* (1961), *Document* (1963), *Three Rulers* (1963), or *Fountain* (1963). These works examine the artist's role as maker or designator of art objects, and refer directly to the art of Marcel Duchamp, who Morris felt was one of the artists with the biggest, most incisive ideas.[99] Morris's *Box with the Sound of Its Own Making*, for instance, recalls Duchamp's sculpture *With a Hidden Noise* of 1916 (fig. 22); the former contains a three-hour tape of the box being made, while Duchamp's contains an unidentified object inserted by Walter Arensberg. Both are conceptually based on a kind of deadpan circular logic that humorously alludes to art's hermeticism and self-referentiality. There is no doubt that Morris felt strong affinities to Duchamp during this period, a time when he was affiliated with composer La Monte Young, dancer Simone Forti (who was his wife until 1961), and various Fluxus artists.

In 1962, a new aesthetic swept through the New York galleries, one that no longer rebelled against traditional art forms or the commodity status of the art object, but strategically played into the media and institutional apparatus of contemporary culture. By October 1962, this new phenomenon was acceptable enough to warrant a show titled *New Realists* at the established Sidney Janis gallery. Juxtaposing the art of the Nouveaux Réalistes with many lesser-known Americans who would soon be the stars of Pop art, this exhibition gave a false impression that survives today, that the French artists were contemporaneous to the younger American Pop artists. Notably absent from this show were Rauschenberg, Johns, Chamberlain, and Stankiewicz, who had previously paralleled the French artists in such exhibitions.[100] In the catalogue for the show, Dada and Duchamp were raised as precedents in both of the brief texts by John Ashbery and Sidney Janis. They discuss the heavy indebtedness of the "new realists" to Duchamp, citing a common Duchampian approach that employs the readymade and a distinct sense of irony and indifference. But Janis dismisses the Neo-Dada label, citing a lack of nihilism or anti-art impulses in the new art.

The majority of American art included in the Janis show—which was variously labeled Neo-Dada, Commonism, New Realism, Factualism, and a host of other names—came to be called Pop art by early 1963.[101] Although Dada undoubtedly exerted an influence on the Pop artists, they were looking more closely at Rauschenberg and Johns than anyone else and generally did not like being compared to a much earlier art movement. The experimental works immediately preceding Pop—sloppy assemblages of junk, room-sized environments, evanescent manifestations, or intimately scaled multiples—gave way to the cleaner, more traditional format of painted canvases in New York and

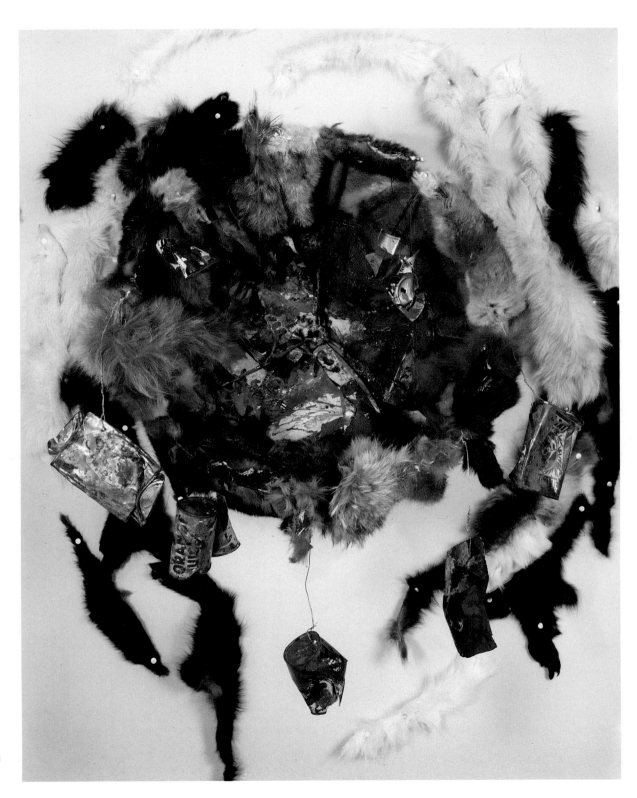

20 CAROLEE SCHNEEMANN

Fur Wheel, 1962.

21 ROBERT MORRIS

Box with the Sound of Its Own Making, 1961 (recreated 1993).

22 MARCEL DUCHAMP

With a Hidden Noise (Ball of Twine), 1916. Metal and twine, 5 × 5 × 5⅛". Philadelphia

Museum of Art; Louise and Walter Arensberg Collection (1950-134-71)

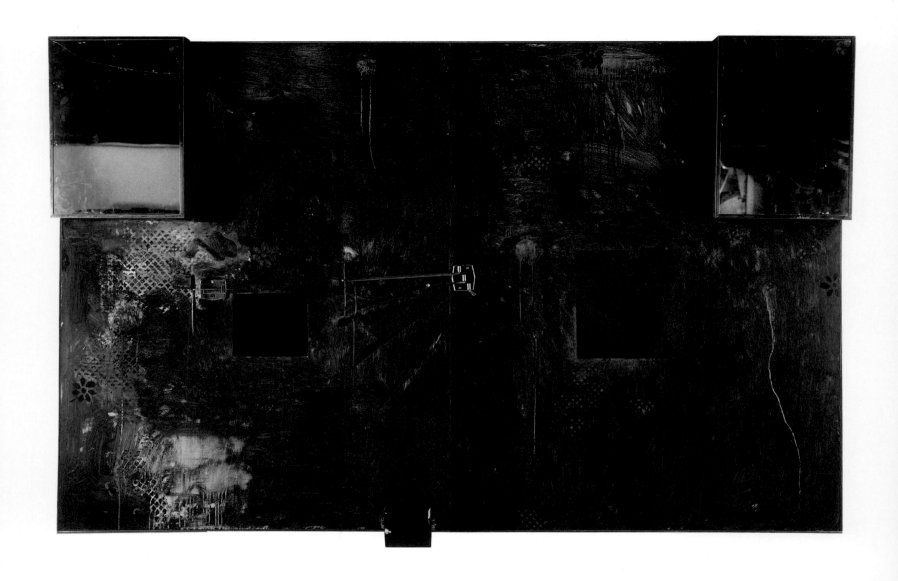

23 JIM DINE

Double Red Bathroom, 1962.

Los Angeles. Dine and Oldenburg took new approaches; the former no longer painted his images but rather attached his industrial objects and manufactured tools directly to the canvas (see fig. 23), while the latter began to make soft sculptures out of smooth vinyl rather than drippy plaster.

In the works of the most famous Pop artist, Andy Warhol (or of his studio assistants), immediately recognizable advertising and news images and ubiquitous supermarket products obviously echo the Duchampian readymade. Already by 1961, Warhol had started to adopt the front pages of daily newspapers (see fig. 24) as a subject for his art, along the lines of Johns's flag paintings and Rauschenberg's use of newspapers—deadpan, Dadalike subject matter that defied traditional "interpretation." Warhol acknowledged that without Rauschenberg's use of objects, he would not have made works depicting soup cans, stamps, paint-by-number diagrams, or dollar bills.[102] Less obvious sources for Warhol are Arman and Yves Klein, who seem to have inspired the radical impetus to repeat images in series, or within a single painting.[103] (During the summer of 1962, one year after these Nouveaux Réalistes had solo shows in New York, Warhol's first series of repeated images, the famous soup cans, were exhibited at the Ferus Gallery in Los Angeles.)

Like the everyday images that were proliferating in Pop art, Warhol's newspaper pictures subverted the radical gesture of the unmodified readymade and redelivered it in a palatable, painted format. In the following year, his use of paint-by-numbers compositions (see fig. 25) more pointedly conflated art's elite status with popular hobbies. His ironic strategies—multiplying uniqueness, challenging originality and authorship while seeking superstardom, denying the impropriety of any subject matter, and mythologizing his own life—had strong, perhaps unwitting, parallels to the devices of Duchamp. Warhol acknowledged the existence of a relationship when he said, "As my work began to evolve I realized, not consciously, it was like a surprise—

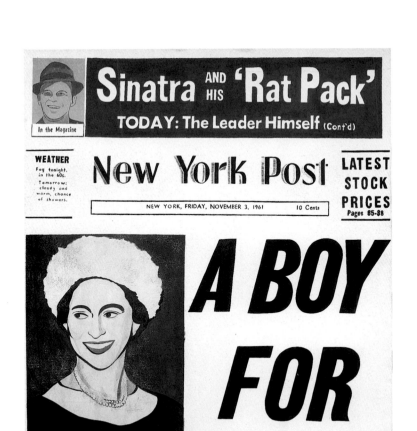

24 ANDY WARHOL

A Boy for Meg, 1961.

that maybe [Dada] had something to do with my work."[104]

Dada was a guiding light for the artists of the late 1950s and early '60s. The use of the term "Neo-Dada" probably muddied issues by leading critics to suppose that all aspects of Dada could be found in the new art. But the prevalence of collage methods and of the Duchampian readymade in the 1950s unquestionably bear extended comparison to Dada. Less distinguishable themes of Dada and Neo-Dada pertain to negative or critical attitudes toward the institutions of art, and more generally, social and political protest. Since Dada was, in part, a nihilist reaction to the horrors of World War I, intent upon eradicating the entrenched conventions of art and shocking the complacent bourgeoisie, the term "Neo-Dada" led critics to see in that movement a similar social and cultural critique. Among the early reviews of "Pop art," for instance, were numerous passages along these lines: "the spectator's nose is practically rubbed into the whole pointless cajolery of our hardsell, sign dominated culture," or "Pop . . . is of course, founded on the premise that mass culture is bad, an expression of spiritual poverty. So perhaps this is the old story of the avant-garde given the opportunity to seize on the bourgeois again, this time through their packaged products."[105]

Typical of the tendency to disavow Dada as nihilistic was Rauschenberg's statement from 1961, "Dada was anti; I am pro."[106] But his far-better-known quote about "acting in the gap between art and life" definitely did echo Dada, whether he knew it or not. Both Tzara and Breton had discussed the same subject forty years before.[107] Gradually at first, and then increasingly in late

1962 and early 1963, critics contended that the so-called Neo-Dadaists were not against anything; at most they were indifferent. Yet here again, exceptions include some of the leading Nouveaux Réalistes, most Fluxus artists, many of the California assemblagists, and some artists involved in performance. Kienholz openly declared that his art and that of his contemporaries was about social protest, and he characterized Warhol's Campbell's Soup cans as obvious commentary on extreme commercialism.[108] California critics repeatedly cited the cultural criticism implicit in the discarded materials of West Coast assemblage, intended to criticize the affluent wasteland around them.[109] Among the European artists, nihilist and social impulses informed, for instance, Arman's commentary on the quantity of commercial products and garbage, Tinguely's machines made to destroy themselves, Klein's creation of identical uninflected monochrome paintings, and Manzoni's canned excrement. Fluxus was nothing if not an anti-art movement.

Several of the aging original Dadaists reacted to the supposed revival of their movement in the early 1960s, pointing to distinctions between the two moments. Raoul Hausmann, Richard Huelsenbeck, and Marcel Duchamp all had their say on the matter. Hausmann impugned the younger artists' reliance on art objects, declaring, "Neo-Dada is stillborn, its birth is so concrete."[110] Duchamp wrote in confidence to another artist, presumably after seeing the *New Realists* exhibition at Sidney Janis Gallery, "This Neo-Dada, which they call New Realism, Pop Art, Assemblage, etc., is an easy way out, and lives on what

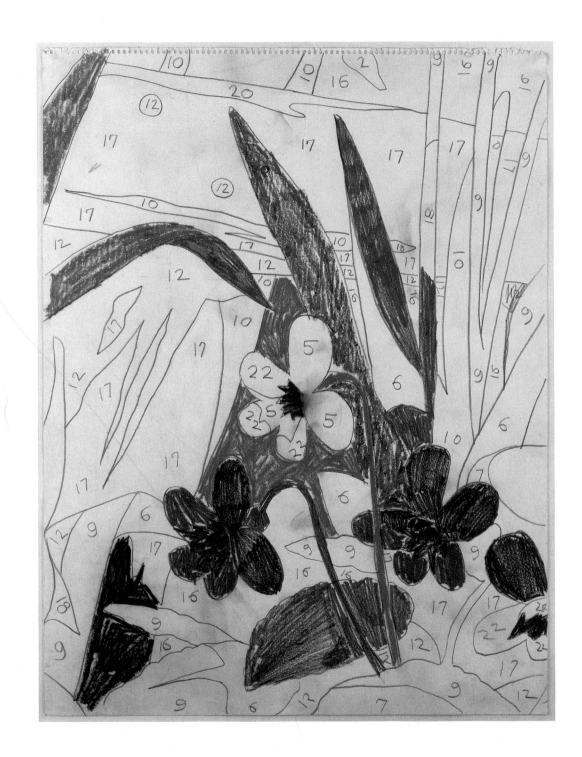

25 ANDY WARHOL

Do It Yourself (Flowers), 1962.

Dada did. When I discovered readymades I thought to discourage aesthetics. In Neo-Dada they have taken my ready-mades and found aesthetic beauty in them. I threw the bottle-rack and the urinal into their faces as a challenge and now they admire them for their aesthetic beauty."[111]

In France, as in the United States, the fifties were a time of deep attitudinal shifts, moving further and further away from the hermeticism of abstract painting, known there as *tachisme* or *l'art informel*. It is difficult to discern who knew about Dada and who did not. While the older Nouveaux Réalistes, such as Raymond Hains and Yves Klein, probably knew of Dadaist ideas from abstract painters, other artists, such as Arman, Daniel Spoerri, and Ben Vautier, only learned about Dada from books and pamphlets in the mid- to late 1950s, in part because it simply was not shown in most art museums.[112] According to Spoerri, Duchamp was at that time "unknown, long-forgotten," and people "had managed to forget about Dada, too."[113] As a result of this "climate of under-information,"[114] French artists had to teach themselves about Dada, and this gave them a more thorough historical knowledge of the movement than was available to most American artists. Some Dada ideas were also promulgated in Paris by the Lettristes, a literary group active from the mid-1940s to the early 1950s, who experimented with concrete poetry and Dadaist phonetic wordplay. Several of the Lettristes, including Guy Debord, formed the Situationist International in 1957. The Situationists also had links to Dada, stressing the activist, political side of art to a degree that apparently alienated the artists who later formed the Nouveaux Réalistes.

The Nouveaux Réalistes was a group of artists who were exploring various alternatives to abstract painting, approaches that often derived from Dada. According to their chief organizer, art critic Pierre Restany, the group expressed a new reality, a sense of nature as urban, industrial, and public, and available to everyone directly, without recourse to painterly or illusive means. Among the principal artists associated with Nouveau Réalisme were Yves Klein, Jean Tinguely, Raymond Hains, Arman, Ben Vautier, Daniel Spoerri, and Niki de Saint Phalle. One of the first important exhibitions juxtaposing many Neo-Dada artists, *Le Nouveau Réalisme à Paris et à New York*, was organized by Restany in Paris for the Galerie Rive Droite in June 1961. Strong ties of friendship had formed during this period between Rauschenberg, Johns, Tinguely, and Saint Phalle, who collaborated on Happening-type performances in Paris and New York.[115] In October, many Nouveaux Réalistes participated in the Museum of Modern Art's influential show *The Art of Assemblage*, where they were seen en masse for the first time in the United States. And in 1962, the Stedelijk Museum hosted a thematic exhibition, in which each of seven artists, including Rauschenberg, Tinguely, Saint Phalle, and Spoerri, were invited to create individual environments that together formed a labyrinth.

From the start, Restany drew distinctions between the American artists who had begun to show in Europe, and the Nouveaux Réalistes. Several months after he compared Nouveau Réalisme to Dada, he extended his discussion of Dada to the "Neo-Dadaists," by which he meant Rauschenberg, Johns, Stankiewicz, and Chamberlain, among others. Restany felt that the French

Nouveaux Réalistes had evolved beyond the Americans. While the (American) Neo-Dadaists deserved credit for integrating the Duchampian readymade into their creations, Restany argued that they were held back by certain affinities for tradition and a lingering attraction to action painting.[116] This "baroque" quality, as Restany called it, has been noted by others in reference to Kaprow and Chamberlain.[117] But notwithstanding his nationalistic competitiveness, Restany's point is noteworthy. There was a smoother transition out of abstract painting in the United States than there was in France, where the paint medium quickly took on more negative associations.

By 1954, Klein had begun to push the limits of abstraction with his monochrome paintings. Against the automatic painting techniques and lyrical brushwork of *l'art informel*, Klein applied his paint with a roller to achieve a uniform surface of color. He mocked the pretensions of contemporaneous abstract painting by setting different prices for works of the exact same hue and format.[118] Such extreme challenges to tradition and to the commodification of art do bear comparison to Duchamp, even if Klein did "violently protest" comparisons of his art to Dada.

Klein must have been aware of Duchamp at least as early as 1948, when he lent his friend Arman a copy of the book *Prière de Toucher* (Please Touch), with its foam-rubber breast cover designed by Duchamp.[119] Klein may have learned much more about Dada in the early 1950s through his connections to the Lettristes.[120] And his notorious exhibition of an empty gallery in 1958, *Le Vide* (The Void) surely parallels Duchamp's stringing a web of twine throughout the International Surrealist Exhibition in 1942 in

New York, or hanging sacks of coal over spectators' heads during the International Surrealist Exhibition of 1938 in Paris. By 1959, Klein even dared to sell air, offering four *Zones of Immaterial Pictorial Sensibility* (see fig. 26) for one kilogram of gold each, perhaps in response to Duchamp's famous *Ready-Made, 50cc of Paris Air* (fig. 27). In this work, Klein drew attention to the monetary value attached to art objects, insisting that if the purchaser wanted a receipt it took away "all authentic immaterial value from the work." For intrinsic ownership of the work, the purchaser had to burn the receipt, and Klein himself threw half of the gold into a river. A final, Dadaistic challenge was Klein's assault on authorship. In 1960, Klein founded the International Klein Bureau and empowered a group of individuals to make and sign paintings as his own. Undoubtedly, Klein's relationship to Dada might have been made clearer if he had not died at the age of thirty-four in 1962.

One of the lesser-known Nouveaux Réalistes, Raymond Hains is recognized chiefly for his *affichiste* works, begun in 1949. Hains initially photographed the walls of posters that appeared throughout Paris, but then he took actual segments of torn, layered posters and presented them as art. Appropriating these found collages from the street, Hains insidiously undercut prevailing art practices, though his torn-poster art looked very much like chance-generated cousins of abstraction's deliberate brushstrokes (see fig. 28). Fellow *affichistes* François Dufrêne and Jacques Villeglé also went out into the streets, finding art in their urban environment rather than creating it in their studios. This shift in artists' practices reflects Duchamp's preference for choices

26 **YVES KLEIN** (left) selling a *Zone of Immaterial Pictorial Sensibility* to Dino Buzzatti, Paris, January 26, 1962. Photo Harry Shunk.

27 MARCEL DUCHAMP

Ready-Made, 50cc of Paris Air, 1919.
Glass ampulla, 5½" high. Philadelphia
Museum of Art; Louise and Walter
Arensberg Collection (50.134.78)

28 RAYMOND HAINS

Composition, 1959.

of the mind and for the artist's act of selection. Hains was indeed knowledgeable about Dada and Duchamp by the late 1940s and early 1950s. Many of the younger Parisian artists also visited the studio of Man Ray in the 1950s, where presumably they saw his small Dada sculptures made from everyday objects.[121]

Klein and Hains were sensitive to Dada comparisons, however, and both vehemently rejected Restany's later intimations that the Nouveaux Réalistes descended from Dada. The disputed affinity was discussed in an essay written for the 1961 exhibition *A 40° au-dessus de Dada* (Forty Degrees Above Dada). Restany pointed to the readymade as the key precedent for appropriating the exterior reality of the modern world, and he traced the Dadaist anti-art spirit through the late forties and fifties in the Ecole de Paris, to a less nihilistic position of the Nouveaux Réalistes, who used the readymade as a positive means of expression.[122] Not surprisingly, such direct linkage did not go over well with artists like Hains, Klein, or Martial Raysse, who subsequently declared the dissolution of the Nouveaux Réalistes.[123]

Jean Tinguely's reaction to this historical connection could not have been more different. Tinguely knew about Duchamp by 1957, and openly was flattered to have his art compared to Dada.[124] The vast majority of his works hardly recall Dada at all, yet some of his best-known art, as well as his abiding interest in movement, chance, and debunking the preciousness of art echo Duchamp's concerns. Tinguely's *Métamatics*, begun in 1955 (see fig. 36), are more amusing than the many severely anti-art Dada pieces, yet they do bear comparison.[125] Like Rauschenberg's *Factum* paintings (figs. 4, 5), Tinguely's motorized art-making contraptions (which accepted tokens as payment for three minutes of drawing action) openly ridiculed the gestures and automatic markings of the Ecole de Paris. Their first public display attracted wide attention, including visits from many of the original Dadaists, including Tristan Tzara, Jean Arp, and Man Ray.[126] Even Duchamp came to play with the *Métamatics* at

29 **MARCEL DUCHAMP** at Galerie Iris Clert, Paris, 1959, making a drawing with one of Jean Tinguely's *Métamatics*. With him are Tinguely and Iris Clert. Photo Vera Spoerri, courtesy Documentation du Musée National d'art Moderne—Centre Georges Pompidou—Paris.

Galerie Iris Clert (fig. 29), where Tinguely first met him.

The theatricality of early Dada was not lost on Tinguely, who once had 150,000 leaflets dropped from an airplane over Düsseldorf during a show there in May 1959. At the same show, he also staged a series of simultaneous and incomprehensible readings during his opening reception. But Tinguely's most radical work was the one that annihilated itself spectacularly, the *Homage to New York*. On a cold, slushy evening in February 1960, this twenty-seven-foot-high white contraption made from eighty bicycle wheels, a piano, an addressograph machine, and numerous other components scavenged from junkyards, performed a variety of spectacular stunts before a moderate-sized audience of cognoscenti in the garden of New York's Museum of Modern Art. Playing the same three piano notes over and over

again, it spewed stink gas into the air, propelled a moving cart trailing flames and smoke straight into the audience, and ironically, finally had to be put to rest by ax-wielding firemen due to the potential explosion of a fire extinguisher in its midst. Coinciding with this demonstration of anti-art par excellence, a pamphlet was printed that included texts by two Dadaists, Marcel Duchamp and Richard Huelsenbeck, who called Tinguely a meta-Dadaist, and the work "a giant step toward *la realité nouvelle*."

Arman, a Nouveau Réaliste and a close friend of Tinguely's, once exhibited actual garbage. For his 1960 exhibition titled *Le Plein* (roughly translated as "Full Up"), Arman filled a section of the Iris Clert gallery from floor to ceiling with garbage as a sequel to Yves Klein's empty gallery *Le Vide*. For collectors interested in owning trash, there were Arman's *poubelles* (trashcans), begun in 1959: transparent containers packed with waste (see fig. 57). Occasionally created as portraits of the people who discarded their contents, these *poubelles* recall the bits of cast-off detritus lovingly gathered by Schwitters, whom Arman has acknowledged as an influence.[127] Sometime in 1959, Arman also started to make another, far larger series of sculptures for which he is best known, his "accumulations." These assemblages, made up of many of the same or similar everyday objects, are clearly indebted to Duchamp's readymades.

Arman's invitations to *Le Plein* (fig. 65) were sardine cans containing bits of garbage. These humorous mementoes were given an outrageous turn by Arman's contemporary, Italian artist Piero Manzoni, who adapted the idea for his 1961 series *Merda d'artista* (fig. 39). Just what they purport to be, these cans of Manzoni's excrement were offered for the price of their weight in gold (recalling the form of payment for Yves Klein's *Zones of Immaterial Pictorial Sensibility*). Manzoni cared little for conventional notions of authorship—many of his best-known works from the late 1950s and early '60s resemble, and often improve upon, art by others.[128] Among the imitative Neo-Dada works by Manzoni

are his 1959 breaths of air (fig. 66), recalling both Klein's zones of sensibility and Duchamp's Paris air; his 1959 lines drawn with a marker on unrolling spools of paper, which resemble Rauschenberg's tire print and Tinguely's *métamatic* drawings; and his 1961 designation-by-signature of various people as "living sculptures," an idea that had been tried by Ben Vautier during the same period.[129] The alacrity of Manzoni's creative pinching is noteworthy, and indicates how fast ideas were traveling. Often more effectively and consistently than his sources, Manzoni acted as an *agent provocateur*, staging visual events to expose bourgeois limitations.

Manzoni may have discussed Dada with his Nouveau Réaliste friend Daniel Spoerri. In the 1950s, Spoerri had access to a great Dada library, and before 1960, he had already met Marcel Duchamp, Tristan Tzara, André Breton, and Max Ernst. The aggression and anarchistic revolutionary spirit of Dada were most attractive to Spoerri and his friend Tinguely.[130] Among Spoerri's earliest projects in the Dadaist vein were several performances of simultaneous readings held in 1959 and a series of multiples of various artists' works that he produced during the same year. These multiples, collectively titled MAT (Multiplication d'Art Transformable), were predicated on the defiant Duchampian concepts that art need not show the artist's hand, that it need not be unique, and that it need not be produced in a limited edition. In 1960 Spoerri began to create the works for which he is best known, his "snare-pictures" (*tableaux pièges*), which were made by permanently affixing the remains from meals or meetings to the tabletops where the events occurred. Next, he would tip such a tableau on its side for wall display—as a sort of readymade still life, arranged by chance (see fig. 38).

Readymades apparently also inspired Spoerri's 1961 show *L'Epicerie* (see fig. 64) at the Koepcke Gallery in Copenhagen. Canned groceries and preserves, each stamped with the phrase "Attention: Work of Art, Daniel Spoerri," were sold for their normal prices—and they nearly sold out at the opening.[131] In

another room of the gallery, Spoerri's *Les Lunettes noires* (fig. 37) hung from the ceiling, inviting spectators to pierce their eyeballs with folding needles attached to everyday glasses. Eventually adopted as a Fluxus piece, these spectacles offered to destroy retinal art once and for all.

"For everyone . . . at that time, it was Duchamp YES, Picasso NO," recalls Niki de Saint Phalle, the Nouveau Réaliste artist who was a close friend of Spoerri's, and was Tinguely's lover during this period.[132] Her principal contributions to Nouveau Réalisme were the *tir* paintings, works designed to be "completed" using rifle fire. Though initially a *succès de scandale*, these works have been surprisingly neglected by art history. Saint Phalle began to incorporate found objects in her work in 1959, sometimes including targets at which viewers were invited to throw darts (see figs. 42 and 69). This led to the first *tir* paintings of 1961, works made of plaster embedded with plastic bags of paint that exploded when shot with a .22 rifle. Saint Phalle later characterized these paintings as "a fundamental criticism of abstract expressionism, an alternative to action painting, a demonstration of the Dripping Ready-Made."[133] As such, they were typical of the nihilist, anti-art gestures of Neo-Dada. Yet, recently, the artist revealed that the *tirs* had a far more disturbing motivation—they were exorcisms of childhood sexual abuse by her father: "In 1961, daddy, I would revenge myself by shooting at my paintings with a REAL GUN. Embedded in the plastic were bags of paint. I shot you green and red and blue and yellow. YOU BASTARD YOU!"[134]

In 1962, Saint Phalle's first *tir* event in the United States was held in a parking lot on Sunset Strip in Los Angeles. Her technical assistant for this shootout was Ed Kienholz, who loaded cartridge after cartridge into his "little .22" and handed it up to her on the ladder.[135] Staged just prior to Jean Tinguely's gallery opening, the shootout was attended by a crowd of about 150 gallery goers who then proceeded up the block to visit Tinguely's

30 PIERO MANZONI holding his *Merda d'artista* (Artist's Shit) of 1961. Photo copyright Ole Bjørndal Bagger.

viewer-activated show of moving sculpture at the Everett Ellin Gallery. In the weeks surrounding this opening, a flurry of events had catalyzed the art scene in Los Angeles: Ellin Gallery sponsored dances by Merce Cunningham with music by Cage and sets by Rauschenberg, as well as separate concerts and lectures by John Cage; Rauschenberg presented Combines and drawings at Dwan Gallery; and on the evening following the Ellin opening, Kienholz's bordello environment titled *Roxy's* was unveiled at the Ferus Gallery.

31 EDWARD KIENHOLZ

O'er the Ramparts We Watched, Fascinated, 1959.

For many of the French artists, Los Angeles in the early 1960s offered a more receptive environment than New York. Yves Klein's first New York show in April 1961 at the Leo Castelli Gallery was considered a failure by all accounts, whereas a similar show one month later at the Dwan Gallery in Los Angeles was warmly received.[136] Exhibitions of many of the other Nouveaux Réalistes were held subsequently at the Dwan Gallery (which had been founded by Virginia Dwan in 1959 and was directed by John Weber starting in 1962—with Ed Kienholz as his gallery assistant). Klein felt so comfortable in Los Angeles that he repeatedly talked about forming "l'école de Nice/Los Angeles."[137] The art scene in Los Angeles was still relatively small by 1962, revolving around a committed nexus of artists, dealers, and curators with an "indigenous dada sensibility,"[138] and connections to the Beat culture of San Francisco.

One locus of avant-garde activity in Los Angeles was the Ferus Gallery, which showed work by many of the young California assemblagists. The gallery was founded in 1957 by Walter Hopps and Ed Kienholz, who sold his share to Irving Blum the following year. The atmosphere there was heavily infused with Dadaist overtones, since Hopps's whole outlook on art was formed during his early, prolonged exposure to art by Marcel Duchamp. At the green age of sixteen, Hopps learned about Dada firsthand when he was taken under the wing of Walter Arensberg while visiting his collection as part of an extra-curricular high school enrichment program.[139] Although Hopps has claimed that Lebel's 1959 monograph was of crucial importance in disseminating information about Duchamp, his own part in spreading the Dada word was significant in Los Angeles. As a curator at the Pasadena Art Museum, Hopps was responsible for organizing a Kurt Schwitters retrospective in 1962, and in the fol-lowing year, the first retrospective ever of Marcel Duchamp's art.[140]

While the young L.A. artists of this period have frequently been grouped together as "California assemblagists," they resist being labeled as a school, and disavow any connection to the term "Neo-Dada," which was commonly used in writing about their art.[141] But as Ed Ruscha has said, "Duchamp's art gave people permission to do a lot of things—it was dazzling."[142] The best known of the California assemblage sculptors was Ed Kienholz, who managed to produce his own art work while employed at various galleries from the late 1950s well into the '60s. Although he knew little about Duchamp's art until about 1960, he remembers seeing a book on Schwitters in 1957 and thinking, "Wow! What stuff!"[143] Another kindred spirit for Kienholz was Rauschenberg, whose art he had heard about from Hopps by 1955.[144]

Kienholz's attitude toward New York in those days was one of "envy, a long-distance chafing under New York's indifference and . . . snobbery."[145] This bitterness motivated the wickedly humor-ous work of 1960, *Odious to Robert Rauschenberg*. Kienholz initial-ly intended to send this booby-trapped work to Rauschenberg, rigged with its rotating deer head and some kind of signal that would interfere with power sources in its immediate vicinity.[146] Hopps has characterized Kienholz as an artist who was shaking up status-quo situations vis-a-vis "culture," a word that "would make him reach for a gun" if he heard it.[147] Kienholz claims that in the late 1950s, he didn't know what the aesthetic rules were, so he could hardly have set out to break them; he is less averse to being characterized as ethical.[148] Kienholz's approach has never been cool or removed; a work such as *O'er the Ramparts We Watched, Fascinated* (fig. 31) shows the strong emotional and moral overtones of his many tableaux and Combines. The use of

32 WALLACE BERMAN

Semina 4, San Francisco, 1959.

cast-off objects and junk in the assemblages of Kienholz and his California contemporaries was intended as pointed commentary on materialist postwar culture, on the systematized marketing of planned obsolescence.[149]

Another community that intersected with Los Angeles as well as New York was the Beat scene, a milieu of poets, performers, and filmmakers centered in San Francisco in the late fifties. One of the central figures of the West Coast counterculture was Wallace Berman, who, according to one historian, "established assemblage in California as a poetic art with strong moral and spiritual overtones."[150] His earliest assemblages date from 1949, but he did not show them publicly until 1957 at the Ferus Gallery, in his first and only exhibition. The show was officially closed and Berman was arrested when he refused to withdraw one supposedly obscene item. According to his wife, the general atmosphere during this period was "stifling"; to the art critics, Berman and his colleagues were "worse than communists. This was the atmosphere we were *living in*; there was no support."[151] After the arrest, Berman devoted his energy to a project begun in 1955, printing poems, photographs, collages, and drawings by himself and others on a handpress and assembling them in envelopes or containers. Titled *Semina*, these "periodicals" were given away to friends rather than sold (fig. 32). Berman created his own context and thwarted the conventional exhibition circuit, taking the only direction Duchamp eventually thought was possible—going underground, de-deifying the artist.[152] According to his friends, Berman admired Duchamp as a master; he exposed others to Duchamp's art and kept Motherwell's anthology among his small library of Dada books.[153]

George Herms and Bruce Conner were in Berman's circle of friends. Both developed their own strains of assemblage in the late 1950s and early '60s. While these artists were certainly informed about Dada, they were equally interested in Surrealism and Existentialism, which contributed to a more symbolic and

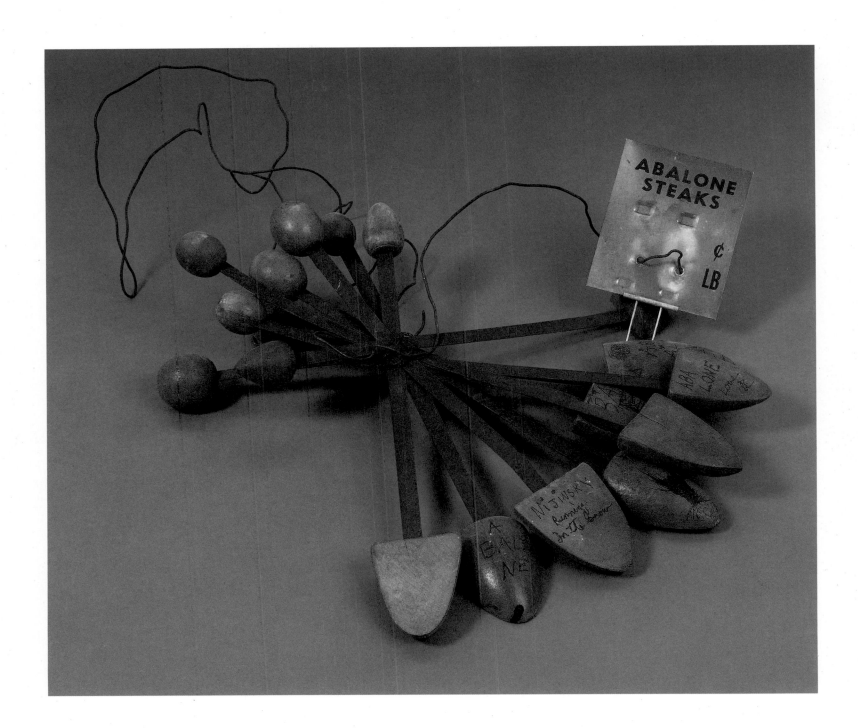

33 GEORGE HERMS

Nijinsky Running in the Snow, 1960.

spiritual use of found objects than that of their contemporaries in New York or Paris. Surrealist exhibitions were held regularly throughout 1948 at the short-lived Copley Galleries in Beverly Hills, and Man Ray, who resided in Los Angeles from 1940 to 1951, had three one-person shows in Los Angeles during that time. Hopps was perhaps the only person from the younger generation who went to the Copley Galleries, and no one paid much attention to Man Ray. Yet the subsequent interest in Surrealist themes and approaches must have stemmed partly from their proximity and existence.[154] Dada influences appeared intermittently, particularly in the relationship between George Herms's combinations of cast-off possessions (see fig. 34) and Schwitters's collages. Even stronger connections to Schwitters may be found in Herms's assemblage habitat at Hermosa Beach, which by 1957 had evolved into a total environment of found objects, covering every possible space, even the front yard.[155]

By the 1960s, the art establishment had imploded, and the most "successful" artists no longer wished to situate themselves in avant-garde or adversarial positions. As critic Barbara Rose has pointed out, the "bourgeoisie, that formerly worthy adversary, [became] the shock-proof patron of the new art."[156] By the early 1960s, there was plenty of money to be made. Oldenburg noted

a distinct shift toward commercialization by 1962.[157] Duchamp lamented the "terrific commercialization," the artist's integration into society. As he saw it, the only solution was for the artist to go underground.[158] Yet the individuals who continued on underground paths were correspondingly accorded less attention when they refused to play by the reinstated rule that artists had to produce collectible objects. By 1962, the term "Neo-Dada" and its attendant attributes were largely a thing of the past.

In New York, Paris, and Los Angeles, the artists who were labeled Neo-Dadaists over the years shrugged it off, because they did not form a homogeneous group or even an art movement, by their own or by institutional definitions. But the term has value as an atmosphere meter, as a sort of attitude index. It is clear that there was concentrated interest in Dada among avant-garde circles in New York, Paris, and Los Angeles. In locating points of contact between Dada art and the highly experimental work of the late 1950s and early 1960s, we gain insight into the roots of later art such as Pop, Minimalism, and conceptual art. Eclipsed from the 1920s to the 1950s, Dada emerged again in time to provide a way out, giving carte blanche to artists eager to try new approaches to artmaking. Neo-Dada was also buried, only coming to light in the past few years, as the late fifties and early sixties are being scrutinized again.

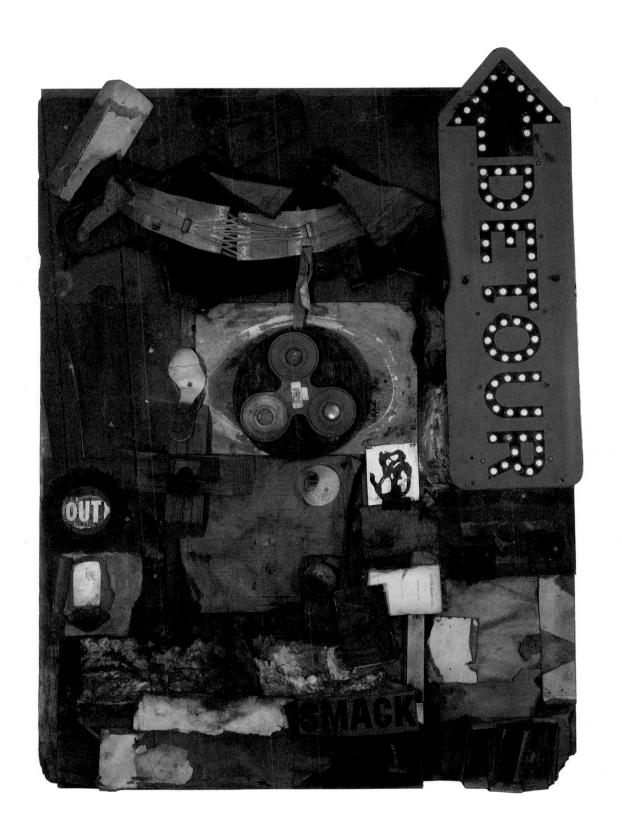

Notes

1 The term "Neo-Dada" first appears in 1958, in reference to Jasper Johns's target with plaster heads, in *Art News*, vol. 58, no. 9 (January 1958), pp. 1, 5. See Maria Müller, *Aspekte der Dada-Rezeption 1950–1966*, Essen, Verlag Die Blaue Eule, 1987, on a similar topic, which provides an outline of the term's appearances, and to which I am indebted for a few of the references in this study.

The following sources comment upon the pejorative use of the term "Neo-Dada": William Seitz, *The Art of Assemblage*, New York, Museum of Modern Art, 1961, p. 32; Max Kozloff, "'Pop' Culture, Metaphysical Disgust, and the New Vulgarians," *Art International*, vol. 6, no. 2 (March 1962), pp. 34–36; Peter Selz in "A Symposium on Pop Art," *Arts*, vol. 37, no. 7 (April 1963), p. 36; Barbara Rose, "Dada Then and Now," *Art International*, vol. 7, no. 1 (January 1963), p. 22. However, it was used without any negative associations increasingly frequently in the early 1960s. Roy Lichtenstein recalled no negative connotations for the term (conversation with the author, June 1991).

The prevalence of the term's usage is evident from the following partial list of articles, reviews, and printed materials, all of which use the word "Neo-Dada" or discuss contemporaneous art's relationship to Dada: "Trend to the 'Anti-Art,'" *Newsweek* (March 31, 1958), p. 94; "His [Johns's] Heart Belongs to Dada," *Time*, vol. 73, no. 18 (May 4, 1959), p. 58; Basil Taylor, "Art—anti-Art," *Listener* (London), November 12, 1959, pp. 819–22; Allan Kaprow, "Some Observations on Contemporary Art," in *New Forms — New Media 1*, New York, Martha Jackson Gallery, 1960; Emily Genauer, "Dada's the Disease, Geometry a Cure?" *New York Herald Tribune*, April 3, 1960, Section 4, p. 7; Robert M. Coates, "The Art Galleries: Exhibition at Leo Castelli," *New Yorker*, vol. 36, no. 8 (April 9, 1960), p. 158; John Canaday, "Art: A Wild, but Curious, End-of-Season Treat," *New York Times*, June 7, 1960, p. 32; Irving Sandler, "Ash Can Revisited, A New York Letter," *Art International*, vol. 4, no. 8 (October 25, 1960), pp. 28–30; Dore Ashton, "Rauschenberg's Illustrations for Dante's Inferno," *Arts and Architecture*, vol. 78, no. 2 (February 1961), p. 4; Pierre Restany, "Le Baptême de l'objet," *Ring des Arts*, no. 2 (Autumn 1961), pp. 31–35 (Restany writes about Neo-Dada in most of his early histories and accounts of the late fifties and early sixties); Françoise Choay, "Dada, Néo-Dada, et Rauschenberg," *Art International*, vol. 5, no. 8 (October 20, 1961), pp. 82–84, 88; Gerald Nordland, "Neo-Dada Goes West," *Arts*, vol. 36, no. 8/9 (May-June 1962), pp. 102–03; George Maciunas, "Neo-Dada in Music, Theater, Poetry, Art," read by Arthur C. Caspari in Wuppertal, Germany, June 9, 1962, reprinted in Clive Phillpot and Jon Hendricks, *Fluxus: Selections from the Gilbert and Lila Silverman Collection*, New York, Museum of Modern Art, 1988, pp. 25–26; *Neo-Dada in der Musik*, program of concert organized by Nam June Paik in Düsseldorf, June 16, 1962; Martha Jackson, letter to Andy Warhol, July 20,

1962, reprinted in Kynaston McShine, ed., *Andy Warhol: A Retrospective*, New York, Museum of Modern Art, 1989, p. 49; Herta Wescher, "Die 'Neuen Realisten' und ihre Vorläufer," *Werk*, vol. 49, no. 8 (August 1962), pp. 291–300; James R. McMahon, "A Comparative Analysis of the Dada and Neo-Dada Movements," Masters thesis, University of Florida, August 1962; John Ashbery and Sidney Janis, *New Realists*, New York, Sidney Janis Gallery, November 1962; Sidney Tillim, "New York Exhibitions: Month in Review," *Arts*, vol. 37, no. 2 (November 1962), p. 36; Donald Clark Hodges, "Junk Sculpture: What Does It Mean?," *Artforum*, vol. 1, no. 5 (November 1962), p. 34; Jules Langsner, "Los Angeles Letter, September 1962," *Art International*, vol. 6, no. 9 (November 25, 1962), p. 49–52; Dorothy Gees Seckler, "Folklore of the Banal," *Art in America*, vol. 50, no. 4 (Winter 1962), p. 60; Marcel Broodthaers, 1963 quote, in Benjamin Buchloh, ed., *Broodthaers: Writings, Interviews, Photographs*, Cambridge, Mass., MIT Press, 1988, p. 34; Brian O'Doherty, "Robert Rauschenberg I," *New York Times*, April 1963 (as repr. in *Object and Idea: An Art Critic's Journal 1961–1967*, New York, Simon and Schuster, 1967, pp. 113, 137); Raoul Hausmann, "Neorealismus, Dadaismus," *Das Kunstwerk*, vol. 17, no. 1 (July 1963), pp. 13–14; Dorothy Gees Seckler, "Folklore of the Banal," *Art in America*, vol. 51 (August 1963), pp. 45, 48; Alan R. Solomon, "The New Art," *Art International*, vol. 7, no. 7 (September 1963), p. 37; John Wulp, "Happening," *Esquire* (November 1963), p. 134; Alan Solomon, *Robert Rauschenberg*, New York, Jewish Museum, 1963; Gerald Nordland, "Marcel Duchamp and Common Object Art," *Art International*, vol. 8, no. 1 (February 1964), pp. 30–32; Alan Solomon, *Jasper Johns*, New York, Jewish Museum, 1964, p. 5; Allan Kaprow, *Assemblages, Environments & Happenings*, New York, Abrams, 1965, p. 154; Edward Lucie-Smith, *Late Modern: The Visual Arts Since 1945*, New York, Praeger, 1969, pp. 11, 128; Pierre Restany, "cologne 1981: le nouveau réalisme entre le néo-dada et le pop," *Art Press*, no. 48 (May 1981), pp. 11–12.

By 1964, there was "rather widespread opposition to the term 'Neo-Dada,'" according to Edward Kelly, "Neo-Dada: A Critique of Pop Art," *Art Journal*, vol. 23, no. 3 (Spring 1964), pp. 192–201.

2 "Cover," *Art News*, vol. 58, no. 9 (January 1958), p. 1.

3 Irving Sandler, "Ash Can Revisited," pp. 28–30; Sidney Tillim, "New York Exhibitions," p. 36.

4 From 1959 to 1961, Ahusaku Arakawa (who currently uses only his last name) and Genpei Akasegawa with nine artists were a group called the Neo-Dada Organizers, which took the anti-art direction of the *informel* painters to extremes, performing in various informal locations, "generally being more provocative and scandalous than the Gutai Group had been." In 1963, Akasegawa and others formed the Hi-Red Center group, which was sometimes involved in Fluxus activities. See

58

Neo-Dada

Reconstructions: Avant-Garde Art in Japan 1945–1965, Oxford, Museum of Modern Art, 1985, pp. 26, 83. See also *Neo-Dada in der Musik*.

5 Lucy Lippard, *Pop Art*, London, Thames and Hudson, 1966, p. 20; William Seitz, *The Art of Assemblage*, p. 39.

6 Henry Geldzahler in "A Symposium on Pop Art," p. 37.

7 Barbara Rose identifies these two aspects of Dada as common points in an article in which she disputes the aptness of the "Neo-Dada" label, yet extensively compares the art of the late fifties and early sixties to Dada. Rose, "Dada Then and Now," p. 22.

8 In *Art News* (January 1958), p. 5, "Neo-Dada" is used to describe "a movement among young American artists," specifically in relationship to Jasper Johns; and *Newsweek*, vol. 51 (March 31, 1958), p. 94, which discusses Neo-Dada as a trend among Johns, Rauschenberg, and Kaprow.

9 According to Jean Larcade, who was the director of the Galerie Rive Droite, the term "Neo-Dada" was not used in Paris; it referred only to the American artists (conversation with the author, April 29, 1992). In at least one article, several of the Nouveaux Réalistes were called Neo-Dadaists; see John Ashbery, *New York Tribune*, February 8, 1961 (Niki de Saint Phalle's archives). Klein's resistance to Restany's comparison with Dada is discussed in *Yves Klein: 1928–1962, A Retrospective*, Houston, Institute for the Arts, Rice University, 1982, p. 277. See also the author's interviews with Spoerri and Arman in this catalogue.

10 See Bonnie Clearwater, ed., *West Coast Duchamp*, Miami Beach, Grassfield Press, 1991, pp. 77, 121; and Irving Blum, interviewed by Joann Phillips and Laurence Weschler, 1976, 1978, and 1979, Oral History Program, University of California at Los Angeles, pp. 202, 215.

11 The German artists' group Zero, which included Otto Piene, Gunther Uecker, and Heinz Mack, is a notable omission from this study; artists such as Yves Klein, Jean Tinguely, Daniel Spoerri, and Piero Manzoni were briefly affiliated with them, and their performance and art activities of the late 1950s bear comparison to contemporaneous developments elsewhere. However, their paintings are less relevant.

12 Jack Flam, "Foreword," *The Dada Painters and Poets: An Anthology*, ed., Robert Motherwell, second edition, Cambridge, Mass., Belknap Press of Harvard University Press, 1989, p. xi. Regarding its popularity, see Barbara Rose, "Dada Then and Now," p. 28; Barbara Rose, *Claes Oldenburg*, New York, Museum of Modern Art, 1970, p. 33; Barbara Haskell, *Blam! The Explosion of Pop, Minimalism, and Performance 1958–1964*, New York, Whitney Museum of American Art, 1984, p. 32; Lucy Lippard, *Pop Art*, p. 20.

13 Thomas G. Morphis, "Connections: Kurt Schwitters and American Neo-Dada," Masters thesis, Cranbrook Academy of Art, Ann Arbor, Mich., University Microfilms International, 1984, p. 13.

14 According to Anne d'Harnoncourt and Kynaston McShine, *Marcel Duchamp*, New York and Philadelphia, Museum of Modern Art and Philadelphia Museum of Art, 1973, p. 28, the Arensberg Collection influenced Robert Rauschenberg, Jasper Johns, and Robert Morris in 1960.

15 Robert Lebel, *Sur Marcel Duchamp*, New York, Grove, 1959. This publication affected Jasper Johns, Robert Rauschenberg, and Robert Morris in 1960, according to d'Harnoncourt and McShine, *Marcel Duchamp*, p. 28. According to Calvin Tomkins, this book was largely ignored in Paris, whereas in New York, "it was read and reread with passionate interest." See Tomkins, *Off the Wall: Robert Rauschenberg and the Art World of Our Time*, New York, Penguin Books, 1980, p. 170. Contrary to this statement about European knowledge, Nan Rosenthal says that Europeans were quite aware of Duchamp, and cites articles and interviews published there, Rosenthal, in *Yves Klein: 1928–1962, A Retrospective*, p. 95. Allan Kaprow said that he owned the Lebel monograph, and that "Everyone read it" (conversation with the author, July 16, 1992).

16 The exhibition *Dada: Dokumente einer Bewegung* opened in Düsseldorf in September 1958 and subsequently traveled to Frankfurt and Amsterdam. The show was reportedly jammed with young people, who thought the art was "astoundingly, delightfully funny." John Anthony Thwaites, *Arts*, vol. 33, no. 2 (February 1959), p. 32. Nam June Paik told Wolf Vostell that "he was very shocked and influenced by this exhibition." See "An Interview with Wolf Vostell: Fluxus Reseen," *Umbrella*, vol. 4 (May 1981), p. 50.

17 Interview with the author, Long Island City, July 21, 1991.

18 Duchamp "was always an ardent supporter of Happenings and had . . . a prodigious patience in lending his time to them," according to William Copley, "The New Piece," *Art in America*, vol. 57 (July-August 1969), p. 36. He was "very much in sympathy with Happenings and was an assiduous spectator-participant from the very beginning. He favored them because they were 'diametrically opposed to easel painting' and because they recognized the participatory role of the onlooker in the work of art." See d'Harnoncourt and McShine, *Marcel Duchamp*, p. 171. Among the younger artists' works he saw were the Claes Oldenburg Happening *Store Days* in February 1962 (see d'Harnoncourt and McShine, *Marcel Duchamp*, p. 28); a show of Jean Tinguely's *métamatic* sculptures (see Pontus Hulten, *Tinguely*, Paris, Musée national d'art moderne, Centre Georges Pompidou, 1988, p. 60), and his later *Homage to New York* in 1960 (see d'Harnoncourt and McShine, *Marcel Duchamp*, p. 28); and a performance by Rauschenberg, Johns, Saint Phalle, and Tinguely (see Wulp, "Happening," p. 134). Duchamp said, "I like the young Pop artists a lot. I like them because they got rid of some of the retinal idea, which we

have talked about. With them I find something really new, something different . . . They borrow from things already made, ready-made drawings, posters, etc." d'Harnoncourt and McShine, *Marcel Duchamp*, p. 27. He also said he admired Arman, Tinguely, Daniel Spoerri, and Martial Raysse (Pierre Cabanne, *Dialogues with Marcel Duchamp*, New York, Da Capo, 1987, p. 93) and saw Kienholz's work in New York and liked it, according to Walter Hopps (see Clearwater, *West Coast Duchamp*, p. 88).

19 Letter from Duchamp to Hans Richter, 1962, in Motherwell, *Dada Painters and Poets*, p. xiii. The quote continues, "as a challenge and now they admire them for their aesthetic beauty." This statement refers to Neo-Dada artists deprecatingly and is a rare moment when Duchamp says something negative about the younger artists. In Cabanne, *Dialogues with Duchamp*, p. 95, Duchamp says there's no glaring resemblance between his art and Neo-Dada.

20 Cabanne, *Dialogues with Duchamp*, pp. 47–48.

21 Calvin Tomkins, *The Bride and the Bachelors*, New York, Viking, 1974, p. 26.

22 Interview with Harriet and Sidney Janis, in d'Harnoncourt and McShine, *Marcel Duchamp*, p. 275.

23 Marcel Duchamp, *The Blind Man*, Paris, 1917.

24 André Breton's oft-repeated 1934 description of readymades as "manufactured objects promoted to the dignity of objects of art through the choice of the artist" undoubtedly perpetuated such an interpretation. Calvin Tomkins, *The World of Marcel Duchamp*, New York, Time-Life Books, 1966, p. 36.

25 Francis Roberts, interview with Duchamp, "I Propose To Strain the Laws of Physics," *Art News* (December 1968), p. 63.

26 Cleve Gray, "The Great Spectator," *Art in America*, vol. 57 (July-August 1957), p. 27.

27 Roberts, "I Propose To Strain the Laws of Physics," p. 63.

28 Tomkins, *The Bride and the Bachelors*, p. 40.

29 Ibid., p. 51.

30 Ibid., pp. 67–68. Duchamp says that artists who are integrated into the "money society on its own terms" are "contaminated." After signing innumerable reproductions, replicas, and other editioned copies of his work in 1963, for instance, he said to a friend, "You know, I like signing all those things—it *devalues* them." It would seem that his signing may have added value to the actual reproductions, but of course it would devalue the supposed "originals" of which they were copies.

31 Ecke Bonk, *Marcel Duchamp: The Box in a Valise*, New York, Rizzoli, 1989, p. 184.

32 Rose, *Claes Oldenburg*, p. 33.

33 Irving Blum, interview with Phillips and Weschler, p. 201. Blum also recalled that Jasper Johns purchased a Schwitters work that he saw hanging on Johns's studio wall in 1960. According to Blum, it was "something he had bought with his own money and something he really adored enough to have secured." Johns purchased a copy of Duchamp's *Green Box* in 1959 and had it signed by the artist later. Tomkins, *Off the Wall*, p. 170. See also Arman interview regarding Schwitters's influence on Rauschenberg, in this catalogue. According to Morphis, "Connections: Kurt Schwitters and American Neo-Dada," p. 13, seventy of Schwitters's paintings and sculptures were exhibited at Janis in 1952, thirteen works were included in a Dada show in 1953, and seventy-five collages were shown there in 1956.

34 Richard Brown Baker, unpublished journals, entry for November 23, 1957, describes how Rose Fried is asking "as much as $1,000 for a Schwitters collage. Mine cost $250 only 3 1/2 years ago."

35 Morphis, "Connections: Kurt Schwitters and American Neo-Dada," p. 12.

36 Duchamp put things together in peculiar ways in order to avoid evidence of craft, according to his stepdaughter, Jacqueline Matisse Monnier, conversation with the author, Paris, April 28, 1992.

37 In Tomkins, *Off the Wall*, p. 96, Rauschenberg is quoted as saying, "Nobody believes it yet, but the whole idea just came from my wanting to know whether a drawing could be made out of erasing." Yet, completely contradicting this "whole idea," Rauschenberg explains that he couldn't do the erasing on just any drawing, that "I had to start with something that was a hundred per cent art, which mine might not be; but his work was definitely art, he was the clearest figure around so far as quality and appreciation were concerned." The Duchamp work, *L.H.O.O.Q.*, was widely reproduced. John Cage associated Duchamp's and Rauschenberg's ironic gestures when he wrote, "Duchamp showed the usefulness of addition (moustache). Rauschenberg showed the Function of subtraction (De Kooning)." See John Cage, "26 Statements Re Duchamp," reprinted in this catalogue. The reference to Breton's act is described in Motherwell's anthology, which Rauschenberg could have seen, on p. 109.

38 Rauschenberg says that in *Factum I* and *Factum II*, he "was interested in the role that accident played in my work . . . I wanted to see how different, and in what way, would be two paintings that looked that much alike." When asked how these works came to be considered a comment on action painting, Rauschenberg attributes this interpretation to Thomas Hess, one of the critics most closely associated with the Abstract Expressionists. See Joann Prosyniuk, ed., "Robert Rauschenberg," *Modern Arts Criticism*, vol. 1, Detroit, Gale Research, 1991, p. 499.

39 Allan Kozinn, "John Cage, 79, a Minimalist of Musical Prolificacy, Dies," *New

York Times, August 13, 1992, p. A17.

40 Morphis, "Connections: Kurt Schwitters and American Neo-Dada," p. 17, points out the simultaneous attendance at Black Mountain by Rauschenberg and Motherwell, although he says Cage was there then too, which I have not been able to verify. See Mary Emma Harris, *The Arts at Black Mountain College*, Cambridge, Mass., MIT Press, pp. 183, 217. Motherwell's preface to his anthology, presumably one of the last things he did for it, is dated June 14, 1951.

41 Tomkins, *Off the Wall*, p. 129; and Barbaralee Diamonstein, *Inside New York's Art World*, New York, Rizzoli, 1979, p. 307; and Choay, "Dada, Néo-Dada, et Rauschenberg," p. 84.

42 Tomkins, *The World of Marcel Duchamp*, p. 170.

43 Tomkins says that Rauschenberg was not influenced directly by Duchamp, but that his "discovery of the Duchampian attitude was nevertheless of crucial importance" (*Off the Wall*, p. 311); and Solomon says that Rauschenberg wasn't "particularly conscious of Duchamp until quite late, until his own position had for the most part been defined" (*Robert Rauschenberg*, n.p.). Solomon continues, "Consciously or unconsciously Rauschenberg reveals a true community of spirit with Duchamp, and he has found in him reinforcement and reassurance for his own position." When asked how heavily Duchamp has figured in his life and art, Rauschenberg answers, "I guess heavily but too late to be a direct influence" (Diamonstein, *Inside New York's Art World*, p. 307).

44 Conversation with Sarah Taggart, Jasper Johns's curator, November 11, 1992.

45 Tomkins, *Off the Wall*, p. 130.

46 Ibid., p. 170; and Tomkins, *World of Marcel Duchamp*, p. 170. Soon after meeting Duchamp in 1960, Rauschenberg made the large Combine *Trophy II (for Teeny and Marcel Duchamp)*.

47 Tomkins, *Off the Wall*, p. 192.

48 Tomkins, *The Bride and the Bachelors*, pp. 193, 194.

49 Solomon calls the following similarities between Rauschenberg's and Schwitters's art "superficial": a cubist feeling in the irregular disposition of geometric shapes, the use of bits of familiar paper, refuse, and nonsense fragments of words (Solomon, *Robert Rauschenberg*, n.p.). See also Tomkins, *Off the Wall*, p. 87.

50 Tomkins, *Off the Wall*, p. 182; and Motherwell, *Dada Painters and Poets*, p. 59.

51 Dorothee Gees Seckler, "The Artist Speaks: Robert Rauschenberg," *Art in America*, vol. 54, no. 3 (May-June 1966), p. 74. See also interview with Arman in this catalogue.

52 Jasper Johns, untitled text, *Scrap* (New York), no. 2 (December 23, 1960), p. 2.

53 Jasper Johns, "Marcel Duchamp [1887–1968], An Appreciation," *Artforum*, vol. 7 (November 1968), reprinted in Cabanne, *Dialogues with Duchamp*, pp. 109–10, and in this catalogue; and Jasper Johns, "Thoughts on Duchamp," *Art in America*, vol. 57 (July-August 1969), p. 31.

54 Cabanne, *Dialogues with Duchamp*, p. 109.

55 "His Heart Belongs to Dada," p. 58.

56 See Max Kozloff, "Johns and Duchamp," *Art International*, vol. 8, no. 2 (March 1962), pp. 42–45; and Tomkins, *Off the Wall*, pp. 272–73.

57 *Richard Stankiewicz, Robert Indiana*, Minneapolis, Walker Art Center, 1963, n.p.

58 See Allan Kaprow interview in this catalogue. Donna De Salvo mentioned Follett's importance to Dine and Rosenquist, based on her discussions with them (De Salvo, conversation with the author, March 24, 1992).

59 Phyllis Tuchman, "Interview with John Chamberlain," *Artforum*, vol. 10 (February 1972), p. 39.

60 George Hugnet, "The Dada Spirit in Painting," in Motherwell, *Dada Painters and Poets*, p. 124. Conversely, Benjamin Buchloh states that Johns and Rauschenberg could only achieve visibility by *conforming* to dominant painterly conventions. "Hence, they engaged in pictorializing the radically anticipatory legacy of Dadaism." Buchloh, "Andy Warhol's One-Dimensional Art: 1956–1966," in McShine, ed., *Andy Warhol*, p. 49.

61 Allan Kaprow, "The Legacy of Jackson Pollock," *Art News*, vol. 57, no. 6 (October 1958), pp. 24–26, 55–57.

62 Kaprow told Alan Solomon that this part of his essay was drawn from a recent visit to Rauschenberg's studio. Tomkins, *Off the Wall*, p. 151. Such lists of unconventional materials are legion, reinforcing over and over again a disavowal of precious or even appropriate materials as a prerequisite of art. See for instance, Umberto Boccioni's 1912 list of appropriate materials including "glass, wood, cardboard, iron, cement, horsehair, leather, cloth, mirrors, electric lights, etc., etc.," (Herschel B. Chipp, *Theories of Modern Art*, Berkeley and Los Angeles, University of California Press, 1968, p. 284), Kurt Schwitters's prescription for theater involving "the dentist's drill, a meat grinder, a car-truck scraper, take buses and pleasure cars, bicycles, tandems and their tires, also wartime ersatz tires and deform them," (Motherwell, *Dada Painters and Poets*, p. 63), Robert Rauschenberg's quote already mentioned, and Claes Oldenburg's "A refuse lot in the city is worth all the art stores in the world" (Rose, *Claes Oldenburg*, p. 191).

63 Kaprow apparently said that the sprawling quality of Pollock's paintings affected Happenings, as discussed in Lawrence Alloway, *Eleven from the Reuben Gallery*, brochure, New York, Reuben Gallery, January 1965, n.p. Quotations are drawn from Kaprow, "Notes on the Creation of a Total Art," brochure, New York, Hansa Gallery, November 25-December 13, 1958.

64 Adrian Henri, *Total Art: Environments, Happenings, and Performance*, New York, Oxford University Press, 1974, p. 86.

65 Michael Kirby, *Happenings*, New York, E.P. Dutton & Co., 1965, p. 27.

66 *Allan Kaprow*, Pasadena, Pasadena Art Museum, 1967, p. 8.

67 Rose, *Claes Oldenburg*, p. 33, says the essay was widely read. For Schwitters quote, see Motherwell, *Dada Painters and Poets*, pp. 62–63.

68 *Allan Kaprow*, Pasadena, p. 8.

69 Cage acknowledged that Duchamp was a strong influence on him in Richard Kostelanetz, ed., *John Cage*, New York, Praeger Publishers, 1970, p. 171.

70 Haskell, *Blam!*, p. 32, and unpublished transcript of "The Toronto Symposium," Toronto, 1967, p. 3.

71 Kaprow, *Assemblages, Environments & Happenings*, pp. 167, 188.

72 Rose, *Claes Oldenburg*, pp. 183, 184.

73 Oldenburg, "The Toronto Symposium," p. 1; and Haskell, *Blam!*, p. 46.

74 Rose, *Claes Oldenburg*, p. 193–94.

75 Oldenburg in Ibid., p. 193.

76 Oldenburg showed two versions of *The Store*; one during a group show at Martha Jackson Gallery entitled *Environments, Situations, Spaces*, from May to June 1961, in which he included reliefs hanging in the stairwell, but not pieces of food, which he was inspired to create when he was a dishwasher in Provincetown, Massachusetts, that summer. (Ibid., p. 41). During that summer and fall he could have learned about Spoerri's exhibition from two possible sources; from Billy Klüver, whom he formed a close friendship with, and who told him about Spoerri (Ibid., p. 201); or from the Museum of Modern Art's *The Art of Assemblage* catalogue, in which William Seitz wrote about "Spoerri's project for a combined grocery store and art gallery where each avocado, pear, yam, and bottle of olives would be labeled ATTENTION: WORK OF ART." It may be a mere coincidence, since Oldenburg was certainly heading in this direction when, in 1960, during the intermission of the "Ray Gun Spex," the audience was able to use the fake money they'd been given to buy junk in the lobby that had been picked up off the street. See also interview with Oldenburg in this catalogue.

77 Ibid., p. 64.

78 Ray Falk, "Japanese Innovators," *New York Times*, December 8, 1957, Section 2, p. 24ff. One source states that the Gutai journal could be found on Kaprow's book shelves in the fifties; see *Reconstructions*, p. 25. Kaprow has written that he did not know a lot about the Gutai performances until 1963 (Kaprow, *Assemblages,*

Environments & Happenings, pp. 211–12), but he did remember hearing about the *New York Times* article, in the author's interview with him in this catalogue. According to Bruce Altshuler, B. H. Friedman wrote in the October 1956 issue of the Gutai journal of Pollock's death, adding that two issues of the journal had been found among Pollock's books, and that Pollock had admired their work (*"Make it New!": Avant-Garde Exhibitions in the Twentieth Century*, New York, Abrams, 1994). Oldenburg read the 1957 article in the *New York Times* and discussed it with a friend, according to Rose, *Claes Oldenburg*, p. 25. In George Maciunas's school notes, taken when he was studying at New York University's Institute of Fine Arts from 1955 to 1960, there are several references to the Gutai artists, (Maciunas notes, Gilbert and Lila Silverman Fluxus Collection Foundation, New York and Southfield, Michigan). Ben Vautier says that Klein and Arman knew about the art of the Gutai Art Association by about 1956 or 1957, interview with the author, New York, October 20, 1991. Al Hansen says, "Throughout this period, 1958–1959–1960 in New York City, many of us were aware of parallel things . . . [for example,] the work of the Gutai Group" (*A Primer of Happenings & Time/Space Art*, New York, Something Else Press, 1965, p. 68). Arman also discussed the Gutai group in our interview.

At the Martha Jackson Gallery show, October 1958, Kanayama's works made from a remote-controlled car were exhibited, as was a film showing the Gutai group's stage actions, actions that Kaprow was later to term the first Happenings in his *Assemblages, Environments & Happenings* (Altshuler, *"Make It New!"* and *Reconstructions*, p. 56.) The latter source also mentions that the Jackson show toured the United States.

79 Ed Ruscha, conversation with the author, Los Angeles, August 13, 1992.

80 Barbara Bertozzi and Klaus Wolbert, eds., *Gutai: Japanische Avantgarde/Japanese Avant-Garde, 1954–1965*, Darmstadt, Mathildenhohe Darmstadt, 1991, p. 51. Altshuler notes possible precedents for Tinguely's *métamatic* machines and Saint Phalle's shooting of cannons and guns in the Gutai artists' work from 1956 and 1957 (Altshuler, *"Make It New!"*).

81 Altshuler, *"Make It New!"*

82 Bertozzi and Wolbert, eds., *Gutai*, p. 113.

83 Altshuler, *"Make It New!"* passim; and Hansen, *A Primer of Happenings*, p. 68.

84 George Brecht, "Chance Imagery," in Henry Martin, *An Introduction to George Brecht's Book of the Tumbler on Fire*, Milan, Multhipla Edizioni, 1978, p. 133–46. Brecht's experiments in the mid-fifties, shooting lit matches to create compositions,

correspond directly to Duchamp's methods of composition, which Brecht must have read about in Motherwell's anthology. See author's interview with Allan Kaprow, and Bruce Altshuler, "The Cage Class," in Cornelia Lauf and Susan Hapgood, eds., *FluxAttitudes*, Buffalo and New York, Hallwalls and New Museum of Contemporary Art, 1991, p. 18.

85 Martin, *An Introduction to George Brecht*, p. 117.

86 D'Harnoncourt and McShine, *Marcel Duchamp*, p. 37, and Jan van der Marck, "George Brecht: An Art of Multiple Implications," *Art in America*, vol. 62 (July-August 1974), p. 50.

87 Martin, *An Introduction to George Brecht*, p. 71.

88 Brecht, "Paragraphs, Quotations, and Lists," 1961, reprinted in Martin, *An Introduction to George Brecht*, p. 126. The Tzara reference was included in Motherwell, *Dada Painters and Poets*, p. 248.

89 Letter from George Brecht to Jill Johnston, Jean Brown Archive, Getty Center, Santa Monica.

90 George Brecht, exhibition flyer printed on paper bag, *Toward Events*, New York, Reuben Gallery, 1959.

91 George Maciunas, letter to George Brecht, late 1962, Jean Brown Archive, Getty Center, Santa Monica.

92 Emmett Williams, as reprinted in René Block, ed., *The Readymade Boomerang: Certain Relations in 20th Century Art*, Sydney, Art Gallery of New South Wales, 1990, p. 147. Second quote is of Robert Morris, in Maurice Berger, *Labyrinths: Robert Morris, Minimalism, and the 1960s*, New York, Harper and Row, 1989, p. 28.

93 Maciunas notes, Gilbert and Lila Silverman Fluxus Collection.

94 Haskell, *Blam!*, p. 53.

95 According to Jon Hendricks, Maciunas learned of the Japanese artists through La Monte Young, who may have come into contact with them earlier, while he was still in San Francisco (*Fluxus Codex*, New York, Harry N. Abrams, 1988, p. 22). Maciunas's notes from graduate school between 1955 and 1960, show awareness earlier. Maciunas notes, Gilbert and Lila Silverman Fluxus Collection.

96 Wolf Vostell, interview in *Umbrella*, "From History of Fluxus," *FlashArt*, no. 149 (November/December 1989), p. 100, discusses Paik and the Dada exhibition. Tomas Schmit, "If I Remember Rightly," *Art & Artists* (October 1972), p. 34, recalls an image of Paik turning over a piano on the back cover of the publication, *Kolnische Rundschau*, several years later, but perhaps it was this early performance.

97 Perhaps Ono was aware of Max Ernst's work from 1920, a hatchet attached to a piece of wood, inviting viewers to shatter it, which occurred. See *Stationen der Moderne*, Berlin, Berlinische Galerie, 1988, p. 157.

98 Vautier referred to the Dadaist Ribemont-Dessaigne, who may have been a great source of inspiration to him. For instance, Vautier's repetitive frantic yelling at the same time each day from his shop recalls Ribemont-Dessaigne's performances. Vautier interview.

99 Morris purchased Robert Lebel's monograph on Duchamp in 1959, the year of its publication. See Berger, *Labyrinths*, p. 28, for the former reference, and for further discussion of Morris's relationship to Duchamp. Morris wrote in a 1962 letter to his colleague, Henry Flynt, "those most admired are the ones with the biggest, most incisive ideas (e.g. Cage & Duchamp)." Reprinted in Henry Flynt, *Down With Art!*, New York, Fluxpress, 1968.

100 Restany, interview with the author, Paris, April, 27, 1992, pointed this out. His opinion was confirmed by Daniel Spoerri and Niki de Saint Phalle in interviews.

101 For extensive discussion of Pop art's emergence, see Haskell, *Blam!*, pp. 69–83, 113.

102 Tomkins, *Off the Wall*, p. 215.

103 Arman had a one-person show at Cordier Warren Gallery in November 1961, and Klein had a one-person show of monochrome paintings at Castelli in April of 1961. Benjamin Buchloh has discussed Arman and Klein as precedents for Warhol in McShine, ed., *Andy Warhol*, pp. 43–57. See also Arman interview in this catalogue, where he confirms that Martial Raysse wrote to Arman in 1962 to inform him that there is a blatant imitator of his accumulations active in New York (and that the French art looked small and insignificant in comparison to the big American paintings). The connection is obvious in an installation view of Sidney Janis's *New Realists* exhibition, showing an accumulation of faucets by Arman hanging beside a Warhol Campbell's Soup painting. See Haskell, *Blam!*, p. 88.

104 Andy Warhol, quoted in Suzi Gablik and John Russell, eds., *Pop Art Redefined*, London, Thames and Hudson, 1969, p. 118. Somewhat later, Duchamp said of Warhol's art, "If you take a Campbell's Soup can and repeat it fifty times, you are not interested in the retinal image." *Pop Art*, Paris, Galerie 1900–2000, 1988, p. 2.

105 Brian O'Doherty, "Art: Avant-Garde Revolt—'New Realists' Mock U.S. Mass Culture in Exhibition at Sidney Janis Gallery," *New York Times*, October 31, 1962, p. 41.

106 Choay, "Dada, Néo-Dada, et Rauschenberg," p. 84.

107 Tristan Tzara's quote is discussed in the section on George Brecht above. André Breton wrote, "For Marcel Duchamp the question of art and life, as well as any

other question capable of dividing us at the present moment, does not arise." Both were reprinted in Motherwell, *Dada Painters and Poets*, pp. 211, 248.

108 Edward Kienholz, quoted in Arthur Secunda, [review], *Artforum*, vol. 1, no 5 (November 1962), p. 31.

109 Hodges, "Junk Sculpture: What Does It Mean?" p. 34. For additional discussion of California assemblage's agenda of social protest, see John Coplans, in *Assemblage in California: Works from the late '50s and Early '60s*, Irvine, University of California, 1963, p. 7; and Gerald Nordland, "Pop Goes the West," *Arts Magazine*, vol. 37 (February 1963), p. 60. More recently, Peter Boswell pointed out California artists' use of junk was distinctly anti-materialist, anti material well-being, and notes that in the late fifties, consumerism was practically synonymous with patriotism. Boswell, "Beat and Beyond: The Rise of Assemblage Sculpture in California," *Forty Years of California Assemblage*, Los Angeles, Wight Art Gallery, UCLA, p. 66.

110 Hausmann, "Neorealismus, Dadaismus," pp. 13, 14.

111 Duchamp, letter to Hans Richter, 1962, reprinted in Hans Richter, *Dada—Art and Anti-Art*, London, Thames and Hudson, 1966, pp. 207–08.

112 See the author's interviews with Arman and Spoerri in this catalogue. Jean Larcade, interview with the author, Paris, April 29, 1992, said that he did not see Dadaist works of art until he first went to the Museum of Modern Art in 1952, where he saw work by Schwitters, Duchamp, and Man Ray. He said there "was no representation of them in Paris anywhere." Rosenthal argues that Dada was exhibited more widely than is generally acknowledged; she cites the discussion of Duchamp in Michel Tapié's book, *Un Art autre* (1952); Alain Jouffroy's interview with Duchamp for *Arts*, November 1954; and the frequent exhibition of works by Picabia in Paris during the postwar years. Rosenthal in *Yves Klein: 1928–1962*, p. 94 This information must have been erratic, however, since many artists claim no knowledge of it.

113 *Daniel Spoerri from A to Z*, Milan, Fondazione Mudima, 1991, p. 69.

114 As discussed in Benjamin Buchloh's article, for the catalogue *Décollage: Les Affichistes*, New York, Zabriskie Gallery, 1990, p. 4.

115 These performances were *Variations II*, June 20, 1961, at the Théatre de l'Ambassade des Etats-Unis, Paris, and *The Construction of Boston*, May 4, 1962, at the Maidman Playhouse, New York. For *Variations II*, Jasper Johns painted a sign that read "Entr'acte" (Intermission). This may have been a reference to the Dada performance of the same title, which was illustrated twice in Motherwell's anthology *Dada Painters and Poets*, pp. 206, 272.

116 Pierre Restany, "Le Baptême de l'objet," *Ring des Arts* (Autumn 1961), pp. vii–ix, 31–35.

117 On a photograph of a 1959 performance by Allan Kaprow, Dick Higgins wrote in 1978, "He saw himself as, among other things, rejecting abstract expressionism/tachisme. But look at that brushwork. Is that rejection?" Jean Brown Archive, Getty Center, Santa Monica. In an interview with Richard Brown Baker, Richard Stankiewicz offered this often-repeated observation about John Chamberlain's art: "He really seems to re-do the abstract expressionist painting style in three dimensions in metal." Interview, August 20, 1962, Archives of American Art, New York.

118 Rosenthal in *Yves Klein: 1928–1962*, p. 107. In an unpublished fictitious letter entitled "Dear Jean," dating probably from the early 1990s, Niki de Saint Phalle says that Klein and Tinguely saw Abstract Expressionism as the enemy to be defeated.

119 Rosenthal in *Yves Klein: 1928–1962*, p. 95, and Arman interview in this catalogue.

120 Ibid.

121 Jean Larcade and Loïc Malle, interviews with the author, April 29, 1992, Paris. For discussion of Hains possibly telling Klein about Dada, see Rosenthal, Ibid., p. 131.

122 Pierre Restany, second manifesto, *A 40° au-dessus de Dada*, Paris, Galerie J., May 1961, reprinted in Restany, *Les nouveaux réalistes*, Paris, Éditions Planète, 1968, pp. 205–07.

123 Rosenthal in *Yves Klein: 1928–1962*, p. 277.

124 Tomkins, *The Bride and the Bachelors*, p. 148. Already in 1957, a brochure text by Hulten invokes Duchamp: "Ces peintures expriment l'idée de Marcel Duchamp: utiliser intentionellement le hasard." Reprinted in Tinguely's catalogue raisonné, by Christina Bischofberger, Küsnacht/Zurich, Edition Galerie Bruno Bischofberger, 1982, p. 66.

 While Duchamp called Tinguely "very intelligent," in Cabanne, *Dialogues with Duchamp*, p. 95, elsewhere he was less kind: "When I left my old studio on 14th Street, I sold my ice-box to Tinguely . . . [Tinguely made a work of art from it.] It's the appeal my old 'ready-mades' have for young people. They love me as providing a kind of raison d'être for their own ejaculations." Francis Steegmuller, "Duchamp: Fifty Years Later," *Show*, vol. 3, no. 2 (February 1963), p. 29.

125 Although there is no evidence to suggest this, it is not impossible that Tinguely may have been inspired by hearing of the Gutai artist Kanayama, who in 1957 attached a can of spray-paint to a remote-controlled vehicle to create paintings in Japan, or perhaps Kanayama heard of Tinguely's 1955 experiments. The French critic Michel Tapié knew of Kanayama's painting machines, and the Gutai journal was supposedly widely distributed as well.

126 Pontus Hulten, *Tinguely*, Paris, Musée national d'art moderne, Centre Georges Pompidou, 1988, p. 55.

127 Arman's visit to an exhibition of Schwitters's art (and of Yves Klein's as well) in 1955 was supposedly a "turning point" for him; *Arman*, Milano, Galleria Schwarz, 1968. See also Jan van der Marck, *Arman: Selected Works, 1958–1974*, La Jolla Museum of Contemporary Art, 1974.

128 See Daniel Spoerri interview in this catalogue.

129 Vautier said he signed people six months before Manzoni, interview with the author, New York, 1991; Spoerri says the opposite, interview in this catalogue.

130 Spoerri interview.

131 *Daniel Spoerri from A to Z*, pp. 55, 86.

132 Niki de Saint Phalle, unpublished fictitious letter to Jean Tinguely, Paris, Niki de Saint Phalle archives.

133 *Niki de Saint Phalle*, Stockholm, Moderna Museet, 1981, p. 15.

134 Letter from Niki de Saint Phalle to her granddaughter, Bloum, in this catalogue. The action of shooting recalls Duchamp's paint-dipped matches fired from a cannon to locate the nine mallic molds of the large glass, as well as the Gutai Group's usage of a cannon to shoot paint (see footnote 80), and Picabia's notes for a performance to begin by firing a cannon (see Mel Gordon, ed., *Dada Performance*, New York, PAJ Publications, 1987, p. 164).

135 Ed Kienholz, telephone interview with the author, August 26, 1992.

136 According to numerous accounts, Klein came to New York staking out turf, presenting himself as *the* monochrome painter, which did not go over well. See Rosenthal in *Yves Klein: 1928–1962*, p. 73; Loïc Malle, *Virginia Dwan et les Nouveaux Réalistes*, Paris, Galerie Montaigne, 1990. Pierre Restany confirmed this as well in an interview with the author.

137 Malle, *Virginia Dwan*, n.p.

138 Edith Tonelli, "Preface," *Forty Years of California Assemblage*, p. 11. Shirley Berman recalls that people definitely knew about Dada in Southern California in the late fifties. Shirley Berman, interview with the author, Topanga Canyon, Calif., August 15, 1992.

139 *Forty Years of California Assemblage*, p. 15; and Calvin Tomkins, "Profiles: A Touch for the Now," *New Yorker*, July 29, 1991, pp. 35–36. Hopps visited the Arensbergs ten or twelve times during a two-year period.

140 When asked whether or not people knew about Duchamp prior to the Pasadena retrospective, Irving Blum answered, "Yes, yes, yes, Duchamp was a celebrated figure." Blum, interview with Phillips and Weschler, p. 215.

141 Jules Langsner, [review], *Art News*, April 1959, as reprinted in Betty Turnbull, *The Last Time I Saw Ferus, 1957–1966*, Newport Beach, Calif., Newport Harbor Art Museum, 1976, n.p.; Jules Langsner, "Art news from Los Angeles," *Art News*, vol. 60, no. 5 (September 1961), p. 20; Secunda, [review], pp. 30–34; Nordland, "Neo-Dada Goes West," pp. 102–03; Langsner, "Los Angeles Letter," pp. 49–52.

142 Ruscha, telephone interview with the author, August 13, 1992.

143 Kienholz, telephone interview. Schwitters information also discussed in *Forty Years of California Assemblage*, p. 63.

144 Kienholz, telephone interview. According to Irving Blum, Kienholz was "looking harder" at Rauschenberg than at Schwitters in around 1960 and 1961. Blum, interview with Phillips and Weschler, p. 203.

145 Edward Kienholz, interview by Laurence Weschler, Oral History Program, Los Angeles, UCLA, 1978, pp. 171–72.

146 Ibid.

147 Turnbull, *The Last Time I Saw Ferus*, n.p.

148 Kienholz, telephone interview.

149 Secunda, [review], p. 31, quotes Kienholz: "There is no dada need, it's just a thing of this time. The thing now is social protest." Hodges, "Junk Sculpture: What Does It Mean?," p. 34, says "New dadaoid constructions . . . are a reaction to growing up absurd in the affluent wasteland . . . Junk sculpture indirectly criticizes the cozened consumer consciousness and foolery of organized waste." See also Gerald Nordland, "Pop Goes the West," *Arts Magazine*, vol. 37 (February 1963), p. 60; John Coplans in *Assemblage in California*, p. 7; and Anne Ayres and Peter Boswell, in *Forty Years of California Assemblage*, pp. 60, 66.

150 Coplans, *Assemblage in California*.

151 Berman, interview with the author.

152 Roberts interview, "I Propose To Strain the Laws," p. 47.

153 Shirley Berman said he owned the anthology and maybe ten other books on Dada, Berman interview. George Herms generally recalls Berman as "a Duchamp on the West Coast." See Clearwater, *West Coast Duchamp*, p. 121.

154 William Copley recalled showing the "objects of my affection" by Man Ray at his gallery, and remembered Walter Hopps visiting shows (of which there were only six). Copley, telephone interview with the author, March 1, 1993. Timothy Baum recalls Andy Warhol telling him that Man Ray influenced him. Baum, telephone conversation with the author, February 22, 1994.

155 *Forty Years of California Assemblage*, p. 49. Also Berman discussed the environment at Hermosa Beach (Berman, interview with the author), as did the art patron Betty Asher, interview with the author, Los Angeles, August 14, 1992.

156 Rose, "Dada Then and Now," p. 4.

157 Oldenburg, quoted in Tomkins, *Off the Wall*, p. 154.

158 Duchamp, quoted in Tomkins, *The Bride and the Bachelors*, p. 67.

65

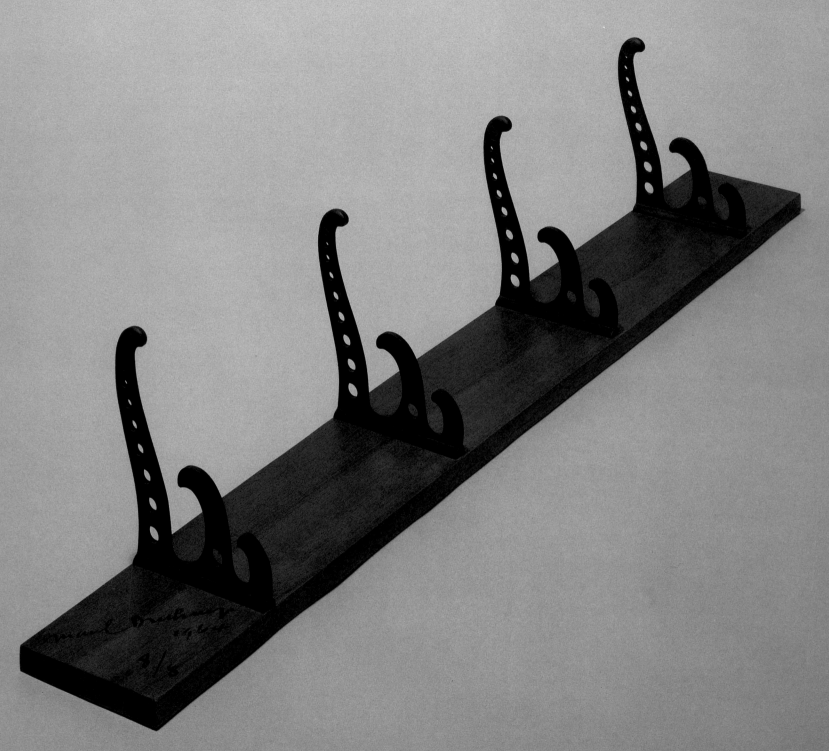

35 MARCEL DUCHAMP

Trébuchet (Trap), 1917/1964.

Forms of Violence

Neo-Dada Performance

Maurice Berger

Informed by the seemingly abstract notions of multiplicities, flows, arrangements, and connections, the analysis of the relationship of desire to reality and to the capitalist 'machine' yields answers to concrete questions. Questions that are less concerned with *why* this or that than with *how* to proceed. How does one introduce desire into thought, into discourse, into action? How can and must desire deploy its forces within the political domain and grow more intense in the process of overturning the established order? *Ars erotica, ars theoretica, ars politica.*

—MICHEL FOUCAULT (1983)

Like so many of Marcel Duchamp's readymades, *Trébuchet* (fig. 35), an ordinary four-pronged clothes rack nailed to the floor, rises to the level of myth by virtue of the simple story of its genesis. "[*Trébuchet* began] as a real coat hanger that I wanted sometime to put on the wall and hang my things on," Duchamp recalled in 1953. "It was on the floor and I would kick it every minute, every time I went out . . . I got crazy about it and I said the Hell with it, if it wants to stay there and bore me, I'll nail it down."[1] The innocence of Duchamp's recollection is deceptive, however; the work suggests far more than a mundane exchange between a household object and its bourgeois owner. For the word *trébuchet*, or trap, is a chess term for a pawn that is placed so as to "trip" an opponent's piece.[2] In other words, the term suggests a relationship between stalker and prey, and the coat rack that Duchamp continually kicked as it lay useless on the floor was also a snare that tripped his unsuspecting guests.[3]

Snatched from their everyday uses, such recontextualized objects are inevitably provocative, their newly skewed and

67

phalluses, an absurd game, or a whimsical trap, we must accept it as "art" in order to comprehend some of its deeper aesthetic and psychosexual meanings. As a "quintessentially collaborative act," the readymade is always engaged in a sort of performance, a series of temporal interactions that place artist, object, and viewer in a complex and rapidly shifting relationship.[5]

In its allusions to gouging, stumbling, and falling, *Trébuchet* is unmistakably sinister. The interchange between artist, object, and viewer even seems to hold some possibility of real injury. But the greater tension—or fear—is psychological. Like most of Duchamp's readymades, *Trébuchet* alludes to disturbing psychosexual paradoxes: domesticity and aggression, castration and penetration, sadism and masochism. These are the physical and emotional contradictions that charge desire. And *Trébuchet*, a seductive fetish, embodies them. It reminds the viewer that to act on one's sexuality is to stumble, to fall into a void where control is lost, where death is dared, where animal instincts flirt with violence. By exposing our vulnerabilities, our urges, and our aggression, Duchamp's readymades preclude complacency, they remind us of our split sense of self, the unease and confusion that we strive to mask and to disown.[6]

It was the readymade's potential to trap the viewer's psychological complexities that most influenced avant-garde artists in the late 1950s and early '60s. While the readymade's psychosexual dimension was important to the object-oriented art of this period (the enigmatic constructions of Robert Morris, the cast lightbulbs and flashlights of Jasper Johns, the fetish-sculptures of Arman, Joseph Beuys, and Piero Manzoni), what might be called its "performatory strategies" were essential to those Neo-Dada artists involved with performance, dance, installation art, and film.[7] Many of these Neo-Dada artists did not make objects at all and instead employed their own bodies as the ground for unsettling or even threatening performances. In 1966, in an issue of *Art and Artists* devoted to "violence in art,"

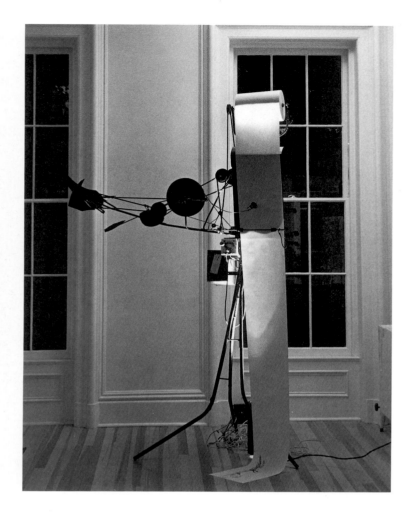

36 JEAN TINGUELY
Métamatic No. 12 ("Le grand Charles"), 1959.

fetishistic meanings dependent on knowledgeable readings by an informed, or at least engaged, observer. For Duchamp, the creative act was never limited to the artist alone: "The spectator brings the work in contact with the external world by deciphering and interpreting its inner qualifications and thus adds his contribution to the creative act."[4] More than most art objects, the readymade comes into being as art because of the duplicity of the viewer. While we might look at *Trébuchet* and see four

68

Neo-Dada

the magazine's editor wrote of the recent shift in art from passive object-making to the staging of aggressive events. He detected this tendency in the work of Yves Klein, Yoko Ono, Daniel Spoerri, Jean Tinguely, Niki de Saint Phalle, and many other artists associated with Neo-Dada, Fluxus, and the Nouveaux Réalistes:

> Aesthetic experience is now a matter of participation, a three way dialogic situation actually taking place in space and time between the artist, the spectator, and the object. It is something which *happens*, in which one is actively and psychologically involved rather than something you look at and take on subjectively. Thus, if we must have father figures, they should be Duchamp, not Picasso, Jarry, not Apollinaire.[8]

Intense psychological participation was required of visitors to the winding paths of *DYLABY: Dynamisch Labyrint*, an elaborate exhibition that opened at the Stedelijk Museum in Amsterdam in September 1962. This groundbreaking examination of the new, performative art called for six artists—Spoerri, Saint Phalle, Robert Rauschenberg, Martial Raysse, Tinguely, and Per Olof Ultvedt—to design individual units of a collective, rambling labyrinth. The aim of these artists, according to the catalogue's introduction, was to "let the public participate in their work, to let you see, feel, cooperate with them. They start from daily life, [provoking] the sensations you get feeling your way through a labyrinth."[9] The resultant maze was playful and sometimes also disturbing: a "beach" by Raysse; a shooting gallery by Saint Phalle; a scrim of clocks by Rauschenberg; and hissing, menacing machines by Tinguely.

Spoerri intensified the spectator/artist relationship by converting one chamber into a dark labyrinth where participants were exposed to sensory experiences, such as warm and damp surfaces and varied textures, sounds, and odors. The phenomenological

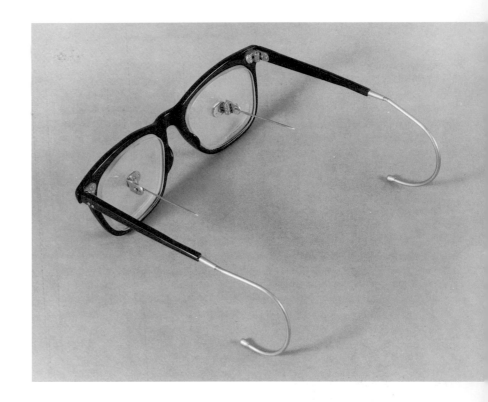

37 DANIEL SPOERRI
Les Lunettes noires (Black Eyeglasses), 1961 (recreated 1994).

aspect of the work was intensified by the fact that viewers were provided with dark glasses fitted with two needles that pointed directly at the wearer's eyeballs. Besides forcing participants to blindly feel their way through the darkness, these *Lunettes noires* (fig. 37), as the artist called them, were also intended—metaphorically or otherwise—to "poke out the eyes, [making] necessary and possible the recreation of objects through memory and imagination."[10]

In a second room, Spoerri applied his principle of the "snare picture"—in which arrangements of everyday objects were spatially reoriented by gluing them to a board and hanging it on the wall—to an entire room of *fin de siècle* painting and sculpture. Paintings were "hung" on the floor, while sculpture "stood" on

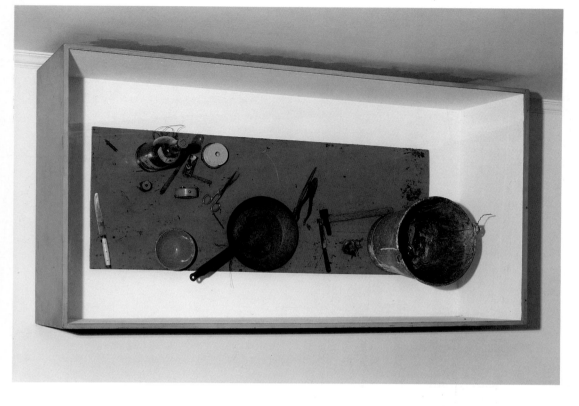

38 DANIEL SPOERRI

La Poubelle n'est pas d'Arman (The Trashbasket Is Not Arman's), 1961.

one of the walls. As a result, the spatial orientation of the room was rotated, creating a disorienting and tenuous passage for the viewer. Spoerri's installation deliberately affronted the comfortable regularity of perception, trapping the viewer into negotiating a world turned on its head. "Why should my snare pictures produce a malaise?" wrote Spoerri. "Because I detest immobility, I detest everything that is settled . . . I love contradictions because they create tension."[11] Or, as critic Alain Jouffroy observed in 1961, "Spoerri appears to assassinate reality and life; in fact, he awakens in the spectator the need for movement and change and an awareness of the beauty of movable disorder."[12]

Such dislocations and contradictions, of course, were already evident in the readymade's axial rotations—the urinal placed on its back (*Fountain*, 1917), the spiderlike appendages of a coat-stand suspended from the ceiling (*Hat Rack*, 1917), the snow shovel hung from a chord (*In Advance of a Broken Arm*, 1915). While it is clear that Duchamp undermined the logic of gravity in order to reeducate and hence liberate the senses,[13] Annette Michelson has argued that the artist's refusal to center himself or the viewer in the aesthetic field went even further, creating a kind of autistic economy designed to deny a stable sense of self. In fact, many of Duchamp's visual and linguistic exercises are strikingly similar to autistic obsessions: the fascination with revolving disks (*Rotary Demisphere [Precision Optics]*, 1925); the fantasy of being a machine (*The Chocolate Grinder*, 1914); and the withdrawal from coherent speech into a world of private

allusions and riddles (the convoluted puns of the film *Anémic Cinema*, 1920). As Michelson observes, Duchamp's pervasive interest in "the forms of rotation and motion, the insistence upon the usefulness of objects . . . the elaborate linguistic play, the recasting of natural laws into highly artificial and controlled codes, the subversion of measure, the constant movement between alternatives which supported his *esprit de contradiction*, the disdain of community, the extreme interest in scientific discovery, the enchantment with the pseudo-science of pataphysics, represents only a few strategies of the autistic economy so remarkably converted by him into uses of art and speculative thought."[14]

This aesthetic autism, a sensibility acknowledged by such early and widely read commentators on Duchamp as Robert Lebel, Jean Reboul, and Michel Carrouges,[15] inspired a generation of Neo-Dadist artists. Ono, for example, knelt on the stage and repeatedly hit her head against the floor in a 1962 Fluxus performance;[16] Klein tape-recorded human cries as a soundtrack for a 16mm color film on his *Blue Period* shows in 1957;[17] Tinguely constructed an assemblage, *Homage to New York* (1960), that shook, banged, and burned itself to the ground before an audience in the sculpture garden of the Museum of Modern Art; Arman hoarded hundreds of nearly identical, everyday objects, later organizing them into large-scale assemblages; Manzoni produced and packaged ninety cans of artist's shit (fig. 39); Warhol made films such as *Eat*, *Sleep*, and *Kiss* (all 1963) that fixated on monotonous, repetitive situations over extended periods of time; Saint Phalle obsessively fired a rifle at her paintings; Fluxus artist Ay-O severed the neck of a live chicken in a guillotine at the Gordon Gallery in New York in 1962.[18]

Many Neo-Dada performances recapitulated disturbing psychological conditions. In Morris's dance solo *Arizona* (1963), for example, ambient lights were darkened at one point while a small blue light rotated from a chord above the audience, pro-

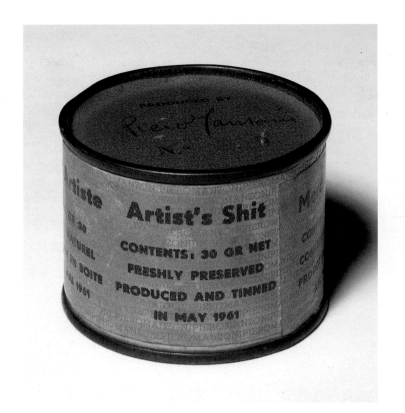

39 PIERO MANZONI

Merda d'artista (Artist's Shit), 1961.

ducing a vertiginous effect that nauseated many spectators.[19] In a 1962 Fluxus event by Ono, the audience sat for hours in darkness as sections of the stage or performer's bodies were sporadically illuminated by the glow of a match or flashlight. And Spoerri's Nouveau Réaliste manifesto on the "autotheater"—a concept of theatricality in art that grew out of the artist's longstanding involvement in ballet, pantomime, and theater direction—advocated the direct involvement and disorientation of the spectator. Among the points Spoerri advocated were these:

(4) the audience will consciously or unconsciously control the lights in these rooms. consciously, in that the lights should be worked and adjusted manually. unconsciously,

in that the audience would set off lights by tripping light contacts . . . (7) whether the audience ought to have masks, as in primitive theater, should be considered, in order to emphasize anonymity, which makes for a more objective event. (anything can be used as a mask: a cloth, a real gas mask, a bed pan.) . . . (8) the arrangement of rooms should be like a labyrinth, dead ends would ensure a repetition of experiences. thus, the length of the visit paid by each individual would be different. that means the possibility that not everyone would experience everything. Deceptive signs would increase confusion. [20]

In 1958, Spoerri and Claus Bremer translated into German *Le Coeur à gaz* (1922), a notoriously violent play by the Zurich Dadaist Tristan Tzara. During one performance at the Waag Hall in Zurich on the 14th of July 1916, for example, Tzara mischievously infiltrated the auditorium with demonstrators who shouted, fought, and broke windows until they were disbanded by the police. Spoerri was intrigued by the disconcerting, sometimes abusive tone of Tzara's work, a sensibility he found commensurate with his own ideas on the autotheater. He eventually staged the play in 1972, with a facsimile of a severed, disintegrating human head hanging upside down from the ceiling. Presaging Spoerri's spatial disjunctions in *Dylaby*, the head—which mouthed the words "ich töte mich" (I'm killing myself) over and over again—was situated in an empty room illuminated by a single lamp.

Spoerri has suggested that *Le Coeur à gaz* attracted him because it exemplified Dada's anti-bourgeois nihilism and emphasized the brutal decentering produced by an over-industrialized world.[21] But beyond any need to comment on collective cultural or social malaise—an understandable imperative given the threatening atmosphere of the Cold War—there was another reason for the Neo-Dadaist fascination with destabiliz-

ing the observer: a desire to explore the nexus between sexuality, repression, and violence. This relationship hinges on complex psychosexual connections between sexual pleasure and pain. Sigmund Freud, for example, analyzed the psychological conditions of masochism and sadism from the premise that sexual pleasure itself falls into a category of sensations that can only be felt after the body and mind have been pushed beyond a certain threshold of intensity. When they are powerful enough to momentarily shatter aspects of a person's emotional and physical equilibrium, pleasure and pain are both experienced as *sexual* pleasure. Thus the pleasurable excitement of sexuality occurs "when the body's normal range of sensation is exceeded and when the organization of the self is momentarily disturbed by sensations somehow 'beyond' those compatible with psychic organization."[22]

The Freudian analogy between sexuality and psychic disequilibrium can also be seen as an equation between sexual excitement and masochistic agitation. As psychoanalyst Jean Laplanche has pointed out, it was Freud himself who postulated that "sexual pleasure resides in the suffering position."[23] As such, human desire is aroused most intensely at the point when the object of satisfaction is absent; desire is "restless because it perhaps always includes, within itself, the disruptive effect on the *other's* equilibrium."[24] As theorists Leo Bersani and Ulysse Dutoit have observed:

Sexuality would be desire satisfied *as* a disruption or destabilization of the self. It would therefore not be originally an exchange of intensities between individuals, but rather a condition of broken negotiations with the world. The movement to satisfy a need (the "sadistic aim of inflicting pain," for example) becomes a desiring fantasy in which the structured self is more or less gravely "shaken" by an exceptional convergence between need and satisfaction.

Perhaps the "threshold of intensity" which Freud speaks of is passed whenever this kind of *dédoublement* takes place.[25]

Of course, repressed or unfulfilled desire can drive sexuality toward aggressive, self-defeating, or nonpleasurable behavior. In other words, autism—as a manifestation of desire turned deeply, psychotically inward—is a logical extreme of the very disruption of the self that promotes sexual pleasure. Thus the autistic economy of Duchamp's work and its physicalization in Neo-Dadaist practice promote two seemingly contradictory responses in the observer: sexual pleasure *and* some degree of disorientation. Coat racks nailed to the floor, performers abusing themselves, and rooms turned upside down initially decenter and sadistically tantalize the observer. But the hostile dislocations caused by experiencing these situations may eventually provoke feelings of anxiety, anger, and repulsion.

Forms of aesthetic aggression or violence—threatening actions or objects, autistic decentering, metaphoric allusion—gained significant artistic and critical currency in the early 1960s (culminating in the comprehensive *Violence in Contemporary Art* exhibition at the Institute of Contemporary Art, London, in 1964). The mechanisms of violence or hostility in art at the time were varied and complex. The first of many of Morris's labyrinths, *Passageway* (1961), for example, exchanged the autism of the artist's early Duchamp-inspired objects for a kind of Minimalist, abstract sadomasochism. The site-specific work compelled the viewer to negotiate a fifty-foot-long semicircular channel that graduated to a point so sharp that it was impossible to enter the last quarter of its length. The starkness of the dead end, coupled with the recorded sounds of a clock ticking and a heart beating, pushed the viewer to the edge of claustrophobia.[26] In a somewhat different way, Spoerri frequently pitched his work for shock value based on implied violence. At his *L'Epicerie* (fig. 64) at the Koepcke Gallery in Copenhagen in 1961, for example,

he exhibited bread rolls stuffed with razor blades, screws, nails, and rubber tubing. Ono also employed destructive or aggressive acts as part of her pseudo-therapeutic method for exploring individual and group dynamics. In a 1961 evening of Ono's performance events at Carnegie Hall in New York City, dancer Yvonne Rainer stood up and sat down in front of a table stacked with dishes. After ten minutes, and accompanied by a high-pitched, wailing aria by Ono and an aphasic soundtrack of repeated syllables, moans, and words spoken backwards, Rainer smashed the dishes. In another Carnegie Hall piece, Ono asked members of the audience to voluntarily come up on stage one at a time and cut away parts of her clothing with a large pair of tailor's shears. For nearly an hour, she sat motionless in complete silence as the audience stripped her nearly naked.

The performances and events of Yves Klein constituted an ongoing spiritual meditation on the human potential for destruction—what the artist referred to as our "Discord Spirit." A student and teacher of Judo, who even published a book on the fundamentals of the martial art, Klein developed a particularly muscular aesthetic that continually found the artist at its center, often abusing his spectators, his surrogates, and himself. At the 1958 opening of his now infamous exhibition *Le Vide* at the Galerie Iris Clert in Paris, for example, Klein served a cocktail of gin, Cointreau, and methylene blue prepared by La Coupole. As Klein told his friend Tinguely, he used methylene blue, a potent biologist's stain, in order to impregnate his audience with his presence (that is, with a trace of International Klein Blue, the artist's signature color). Indeed, the blue dye tinted the drinkers' urine for more than a week, a period of discomfort and humiliation roughly equal to the run of the show. Klein's sadism also manifested itself in his "Anthropométries" performances. In one of these pieces, performed at the Galerie Internationale d'Art Contemporaine in Paris in 1960, Klein appeared before an audience in formal blue attire. A small

73

40 ANDY WARHOL

Dr. Scholl, 1960.

41 YVES KLEIN

Victoire de Samothrace (Victory
of Samothrace), 1962/1973.

orchestra played his *Monotone Symphony* as three naked woman smeared their bodies with blue paint and pressed themselves against sheets of paper. Throughout the performance Klein barked orders to the models, an effect that suggested a subjugating, master-slave relationship. (In two Anthropométries done in 1959, Klein first substituted human menses and then beef blood for paint—a process that panicked and nauseated at least one of his performers.)[27] Klein was aware of the voyeuristic and sadistic tone of such performances: "I could continue to maintain a precise distance from my creation and still dominate its execution. In this way, I stayed clean. I no longer dirtied myself with color, not even the tips of my fingers."[28]

Klein's aesthetic, marked as it was by numerous attempts at defying gravity, was also self-destructive. While some of his "leaps" were faked—such as the famous photomontage of Klein's birdlike dive from the roof of a Paris apartment building (published November 27, 1960, on the front page of the artist's four-page facsimile of the French newspaper *Dimanche)*—others were real. In one 1960 event, Klein jumped from the window of dealer Colette Allendy's house in Paris, injuring his ankle. (His magic was unimpressive: "For a *judoka* who knew how to fall," observed one witness, "it was not extraordinary."[29]) On another occasion, Arman watched as Klein threw himself over a stairway at the Rive Droite Gallery, severely injuring his shoulder. For Klein—an artist whose work continually negotiated the tense interstice between sexuality, death, and violence—the "leap into

the void" was the ultimate metaphor for his troubled existence: it was at once a cipher of spiritual freedom (an idea rooted in his own earlier fascination with the Rosicrucian teachings of Max Heindel), alchemical transformation (perhaps inspired by Duchamp's autistic alchemy),[30] and tragic pessimism (continually depressed and ailing, Klein died of a heart attack in 1962 at the age of thirty-four).

Like Klein and Duchamp before him, Andy Warhol also transformed his complex persona into a kind of psychosexually charged art object. Warhol's Factory in New York nurtured an environment of theatrical sex, a place that celebrated the libidinal and drug cultures of the late 1950s and early '60s.[31] Appearing everywhere in sadomasochistic drag—black leather jacket and high black boots—Warhol personified the phenomenon of S&M chic; he became the master of a band of artists, musicians, writers, actors, groupies, and cultural runaways hell-bent on playing the "nasty, snobbish, exploitative sexual games supposedly [enjoyed] by the bored decadent leisure class."[32] But the Factory's stylish affectations barely concealed the morose, disturbing tone of Warhol's paintings from the early 1960s— silk-screened, cinematic repetitions of newspaper photos of grisly car accidents, gangster funerals, suicides, and the grieving Jacqueline Kennedy.

Warhol's disquieting repetition of horrific images is paralleled by the uncompromising voyeurism of his equally obsessive films of the early '60s. Viewing films such as *Kiss* (an hour-long com-

pendium of couples kissing) and *Sleep* (a six-hour view of the poet John Giorno sleeping), the spectator becomes an accomplice in the filmmaker's invasive practices: our eyes, following the lead of Warhol's Bolex, penetrate, and in effect violate, the privacy of others. "Watching *Sleep* and *Kiss*," writes Stephen Koch, "remote from the sexualized quiescence of the sleeper, remote from the kiss, from the grinding of flesh on flesh, we find ourselves voyeurs at both a proximity and a distance no voyeur could ever know."[33] In *Blow Job* (1963), a film of a rugged young man submitting himself to a mostly unseen male partner, our access to the intimate object of desire—the fellated penis—is strangely frustrated. Fixed on the man's face as it registers excitement and pleasure, the camera provides only a glimpse of the leather-clad shoulder that occasionally skims the bottom of the frame. By eliding most of the substantive details of the sexual action, Warhol's seductive cropping (a variation on Duchamp's own obsession with synechedotal imagery and hidden or secreted forms of information) pushes the film's voyeurism towards outright sadism: the viewer, hopelessly aroused by the passion of the moment, is forever denied the kind of visual jouissance normally associated with the pornographic experience.[34]

Perhaps nowhere in the Neo-Dadaist ethos were the conceits of autism and violence more concrete and dramatic than in the work of the American-born Nouveau Réaliste Niki de Saint Phalle. In the early 1960s, Saint Phalle began making large-scale, plaster-coated assemblages of toys and junk embedded with tomatoes, eggs, and ink bottles filled with colored paints—works meant to be shot at by rifle-toting viewers. In the 1961 *Shooting Gallery* at the Iolas Gallery in New York, for example, viewers were handed .22-caliber rifles and encouraged to fire at a plaster-coated assemblage covered with toy locomotives, a telephone, dolls' limbs, and "other remains of civilization . . . under atomic attack."[35] To heighten the "painterly" effect of the gunfire, shooters were directed to take aim at small, ink-filled plastic bags that were tied to a "rotating machine" designed by Tinguely, Saint Phalle's friend and close associate.

In order to overcome the curious depression that gripped her following each of these viewer-participation events, Saint Phalle began to shoot at the constructions herself.[36] In a March 1962 event sponsored by the Everett Ellin Gallery in Los Angeles, a crowd gathered to watch the artist, dressed in a white bodysuit and highly polished boots, ascend a ladder and shoot at a huge assemblage of junk with a hunting rifle. Taking pot shots at the ink bottles hidden within the work, Saint Phalle "painted" the whitewashed construction with bright bursts of color. Several months later, she held a "shoot" on a narrow plateau high in the hills above Malibu Beach, California. Before a festive picnic of invited art critics, artists, models, and film and theater personalities, Saint Phalle shot at a huge assemblage embedded with ink bottles and dominated by a dinosaur skeleton and a bird cage containing a live bird. Taking aim with a small cannon built by Tinguely and with rifles lent by artist Edward Kienholz, the

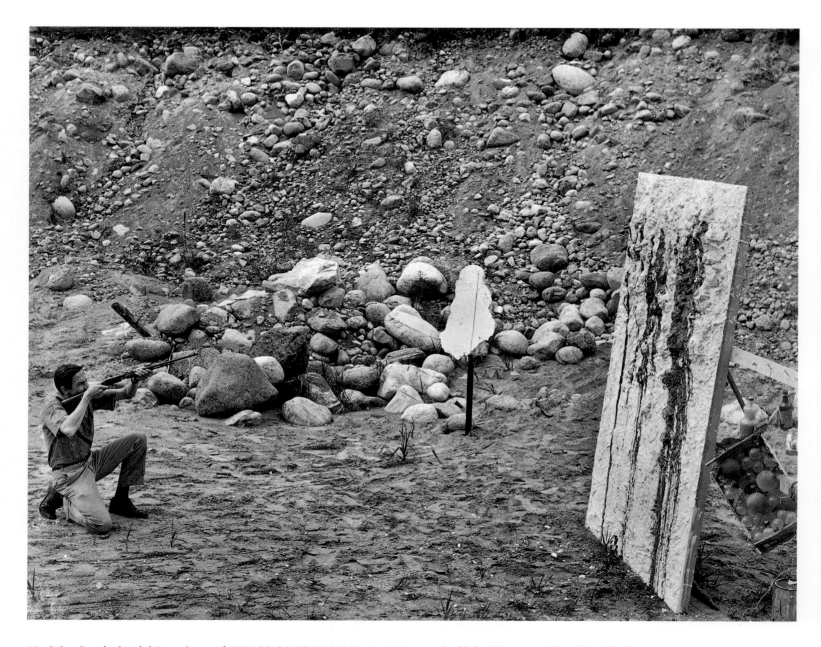

42 Robert Rauschenberg helping make one of **NIKI DE SAINT PHALLE**'s *tir* paintings, near Stockholm, May 23, 1961. Photo Harry Shunk.

artist shot each bottle in a fixed order. Fearing that they might be hit by stray bullets (or at the very least stray paint), nearly all of the spectators fled for cover.[37]

The destructive impulse in these works suggests several levels of meaning. First, Saint Phalle was clearly commenting on the machismo and militaristic aggression that shapes the dynamics of masculine power. But her shooting galleries also introduced an element of anarchistic fun into the experience of art. On the most intense level, however, Saint Phalle's decision to take the gun into her own hands was therapeutic, a means to exorcise demons that had haunted her since adolescence. In an imaginary letter to her granddaughter, she revealed her true target:

Things turned sour when I started growing breasts.
The dark side of my idealistic father manifested itself.

My father got more involved watching my breasts grow and my hips widen than discussing politics or life with me. I had turned into quite an attractive young girl. I became an object of his desire for total power over me. Something happened between us, something that turned me away forever from my father. All that love turned to hate. I felt I had been assassinated.

I couldn't bear being in the same room with him.

In 1961, daddy, I would revenge myself by shooting at my paintings with a REAL GUN. Embedded in the plastic were bags of paint. I shot you green and red and blue and yellow.

YOU BASTARD YOU!

When you saw me do this did you ever guess
I was shooting at you?[38]

By repeatedly returning the artist to the primal site of her pain, the gesture of shooting with a "REAL GUN" had also become an act of emotional liberation. Referring in 1962 to these bullet-riddled assemblages, Saint Phalle could very well have been talking of her own personal journey out of the darkness of incest, "Their attitude is a joyful one. The result of a destructive act becomes positive."[39]

Duchamp himself had fancied his work as therapeutic: he spoke of his roto-demispheres as healing devices that could help restore vision to those blinded by complacency and self-delusion. His autistic economy helped bring to the surface the primitive anxieties that underlie our collective psychosis. The obsessive repetitions, revolutions, and convolutions of his work function as a kind of desiring machine that forces us to confront the complex, shattering divisions that comprise the self. "Sickness, for Duchamp, is one of those third terms which come between a binary opposition and provide a way out: sickness is salutary," writes art historian Carol James. "Somewhat like Blanchot's Negative, a principle of impurity, subversion, and sickness, Duchamp's 'sick picture' is a way to circumscribe the idea of health, which is a 'pure' idea, and emphasize the need for the unending cure which confers the 'power to speak.'"[40]

This curative or "cathartic" function, as Lebel called it,[41] permeated Neo-Dadaist practice. Klein, for example, saw the artistic process as a means for achieving personal "health," as the last chance to triumph over the inner "discord" that was destroying him.[42] A student of Zen, like many of her Neo-Dadaist colleagues, Ono often spoke of the transformative nature of her art and of its potential to direct "the audience's attention inward so as to highlight the stillness of the self."[43] Morris wrote of the need to perpetually reenter the labyrinth in order to transcend his own crippling claustrophobia—a metaphor for what he felt was the subjugating, oppressiveness of postindustrial society. Warhol directed vivacious, sexually liberating films that ignited "that nerve of fear that fascinated and awakened a shock response, that felt like a presentment of things to come."[44] No wonder

79

then, that Martial Raysse built an indoor playland for his *Dylaby* installation—a light-filled "beach" replete with neon sign, wading pool, beach balls, water toys, and juke box.

The aesthetic recreation of violence, psychosis, and desire as tonics for emotional healing was at least superficially related to contemporaneous methodological shifts in the treatment and understanding of psychosis. In the late 1950s and early '60s, the writings of the new psychiatry, exemplified by the humanism of Herbert Marcuse and R. D. Laing, advocated a radical shift in our understanding of insanity. Laing, in such popular works as *The Divided Self* (1959), *Self and Others* (1961), and *Reason and Violence* (1964), argued that the societal impulse to incarcerate and tranquilize the schizophrenic or to silence the mumblings of disaffection and confusion that characterize psychotic speech parallels a greater need to establish order in a society conditioned by violence and repression. "What we call normal," wrote Laing, "is a product of repression, denial, splitting, projection, introjection, and other forms of destructive action on experience."[45] Laing reasoned that Western society's repression of "the instincts," sexuality, and transcendence precipitates a "pervasive madness, [a] normality, sanity, [and] freedom, [that makes] all our frames of reference . . . ambiguous and equivocal."[46]

Taking their cue from this politics of desublimation, a number of avant-garde artists began to question the tyranny of the normal and the convoluted frames of reference that determine our reality.[47] The editor's introduction to the "Art and Violence" special issue also pointed to the overarching influence of Laing and the new psychiatry on artists of this period:

We have, as . . . Laing has pointed out, "largely lost touch with our inner world in gaining control of our outer world. We have become strangers to our own experience, we are alienated from ourselves." Laing's . . . thinking as a psychiatrist is centered around a process of what he calls "mystification" whereby the human individual is "socialized" at childhood out of his own true spontaneous personality. This act of conditioning people's behavior patterns by imposing masks and attitudes upon them results, he maintains, from an act of violence masquerading as love.[48]

Many artists, confronted with a reality that now included the Cold War, the Bomb, Vietnam, Freedom Marchers, and the struggle for sexual and political liberation, were interested in stripping away this mask. Departing radically from the angry, self-destructive machismo characteristic of the Abstract Expressionist generation, the forms of violence and psychosis that racked Neo-Dada performance were for the most part also forms of recovery—vehicles for the artist *and* spectator to transcend the brutality and oppressiveness of post-industrial institutions. As John Cage remarked, "the anarchistic situation frees people to be either noble *or* evil," to rediscover the self independent of the normalizing restraints of repression.[49] Artists promoted varying degrees of "ego loss" in order to guide the heretofore complacent spectator into new levels of self-awareness, into a liberation of the mind and the senses that went far, to quote Michel Foucault, in "introduc[ing] *desire* into thought, into discourse, into action."[50]

Notes

1 Duchamp, unpublished interview with Harriet Janis, 1953; as quoted in Anne d'Harnoncourt and Kynaston McShine, eds., *Marcel Duchamp*, New York and Philadelphia, Museum of Modern Art and Philadelphia Museum of Art, 1973, pp. 283.

2 In French, the verb "to trip" is *trébucher*.

3 Gloria Moure writes: "The clothes rack, in fact, was on the floor of Duchamp's flat waiting to be set, and his visitors frequently stumbled over it." See Moure in *Duchamp*, Barcelona, Fundación Caja de Pensiones, 1984, p. 237.

4 Marcel Duchamp, "The Creative Act," in *The Essential Writings of Marcel Duchamp*, ed. Michel Sanouillet and Elmer Peterson, London, Thames and Hudson, 1975, pp. 138–39.

5 For more on the declarative and performative structure of Duchamp's readymades, see Benjamin H. D. Buchloh, "Ready Made, Objet Trouvé, Idée Reçue," in *Dissent: The Issue of Modern Art in Boston*, Boston, Institute of Contemporary Art, 1985, pp. 107–8.

6 Mason Klein, in an intelligent analysis of Duchamp's paradigm of the fractured self, writes: "The myth of a unified 'self'. . . was hardly endorsed by Marcel Duchamp, whose . . . [self-professed] female creativity was integrated into his alter ego, Rose Sélavy, if not completely resolved with his readymades. Unlike his surrealist colleagues, Duchamp's interrogation of the unity of the subject—its fictive coherence—ultimately addresses the discourse of sexuality itself as it parallels the internal and arbitrary division of language." See Klein, "Towards a Phenomenology of the Self: Marcel Duchamp's *Etant Donnés*. . . ," Ph.D. diss., City University of New York, forthcoming.

7 While this essay attempts to make specific structural, formal, and philosophical connections between Duchamp and the performatory works of Neo-Dadaist artists, the issue of direct influence—already made obvious by the well-documented bond between the Dadaist and the avant-garde in the United States and Europe during the period covered by this essay—will be left to other art historians to consider. However, much has been written on these artists' relationships to Duchamp and the channels through which his influence took form. For a representative example, see John Tancock, "The Influence of Marcel Duchamp," in d'Harnoncourt and McShine, *Marcel Duchamp*, pp. 159–78; Arman, Yoko Ono, Daniel Spoerri, Jean Tinguely, and Andy Warhol, et. al., "A Collective Portrait of Marcel Duchamp," in Ibid., 182–223; Maurice Berger, "Duchamp and I," in *Labyrinths: Robert Morris, Minimalism, and the 1960s*, New York, Harper & Row, 1989, pp. 19–46; Nan Rosenthal, "Assisted Levitation: The Art of Yves Klein," in *Yves Klein, 1928–1962: A Retrospective*, Houston, Institute for the Arts, Rice University, 1982, p. 95; Anthony Cox, "Instructive Auto-Destruction" (on Yoko Ono), *Art and Artists*, vol. 1, no. 5 (August 1966), p. 19; Stephen Koch, *Stargazer: Andy Warhol's World and His Films*

New York, Praeger, 1973, pp. 37–38 and 49; Benjamin H. D. Buchloh, "Andy Warhol's One-Dimensional Art," in *Andy Warhol: A Retrospective*, New York, Museum of Modern Art, 1989, pp. 39–44; Bazon Brock, "Daniel Spoerri Als Kulterheros," Innsbruck, Galerie Krinzinger, 1981, n.p.; and Daniel Spoerri, *An Anecdoted Typography of Chance*, New York, Something Else Press, 1966.

8 "Violence in Art," *Art and Artists*, vol. 1, no. 5 (August 1966), p. 5.

9 *Dylaby: Dynamisch Labyrint*, Amsterdam, Stedelijk Museum, 1962, n.p.

10 Daniel Spoerri, as quoted in Alexander Watt, "Daniel Spoerri," *Art and Artists*, vol. 1, no. 5 (August 1966), p. 47.

11 Daniel Spoerri, as quoted in Alain Jouffroy, "The Snare-Pictures of Daniel Spoerri," in *Daniel Spoerri*, Milan, Galeria Schwarz, 1961, n.p.

12 Ibid.

13 For more on Duchamp's strategy of spatial dislocation, see Herbert Molderings, "Objects of Modern Skepticism," in Thierry de Duve, ed., *The Definitively Unfinished Marcel Duchamp*, Cambridge, Mass., and London, MIT Press, 1991, p. 254.

14 Annette Michelson, "*Anémic Cinema*: Reflections on an Emblematic Work," *Artforum*, vol. 12, no. 2 (October 1973); rpt. in Amy Baker Sandback, ed., *Looking Critically: 21 Years of Artforum Magazine*, Ann Arbor, UMI Research Press, 1984, p. 148. Michelson's categories of autistic behavior are taken from Bruno Bettelheim's description of Joey (*The Empty Fortress: Infantile Autism and the Birth of the Self*, New York, 1967), a severely autistic child who lived for years at the Orthogenic School in Chicago.

15 Robert Lebel's groundbreaking *Marcel Duchamp* (French and English editions both 1959)—the first comprehensive monograph on the Dadaist master—gained wide popularity in the New York and European avant-garde communities of the early 1960s. The catalogue was almost singlehandedly responsible for introducing Duchamp to an entire generation of avant-garde artists. Discussing speculations by Jean Reboul and Michel Carrouges on Duchamp's personal "schizoid tendencies," Lebel concludes: "We shall leave to the specialists the problem of deciding whether the 'autist' resolution from which [*Bachelor Machine*] was born was originally due to the emergence of schizoid tendencies. But such considerations seem to us purely retrospective, the point of departure being of much less importance today than the result." Lebel, *Marcel Duchamp*, Paris, Trianon, 1959, p. 71.

16 The performance was described by Barbara Haskell in *Yoko Ono: Objects, Films*, New York, Whitney Museum of American Art, 1989, p. 2. Ono's notation for the work (in *Grapefruit*, Tokyo, Wunternaum Press, 1964, n.p.) suggests a somewhat different orientation for her action: "WALL PIECE FOR ORCHESTRA FOR YOKO ONO/Hit a wall with your head. 1962 winter."

17 For more on Klein's *Cris bleus*, see Rosenthal, "Assisted Levitation," pp. 114–15.

18 For an account of the incident, see Watt, "Daniel Spoerri," p. 47. Spoerri writes: I have accepted "chance as a collaborator after the initial result has been achieved, of transformations due to time, weather, corrosion, dirt, etc. Example: the rats who devoured the organic matter on two of my snare-pictures at Galleria Schwarz in Milan have been accepted [by me] as collaborators." See Spoerri, *An Anecdoted Topography of Chance*, p. 182.

19 Perhaps no artist embraced Duchamp's autistic strategies more directly than Robert Morris in his constructions, installations, and performances of the early 1960s. In *Three Rulers (Yardsticks)*, 1963, for example, standardized relations of scale were over-turned as three "yardsticks," each of a different length, "measured" thirty-six inch-es—a paraphrase of *Trois Stoppages Etalon* (1913–14), Duchamp's arbitrary, "pataphysical" measuring devices. (Duchamp created the "three standard stoppages" by dropping three-meter threads on pieces of canvas and cutting out the resultant shapes defined by the curves of the threads.) Morris's construction *Pharmacy* (1962) exemplified the kind of autistic repetition embodied by Duchamp's *Rotative Demisphere* (1925). The work interposed a glass plate between two circular mirrors. Two pharmacy bottles, one red, the other green, were depicted one on each side of the glass plate. (These bottles allude to the red and green marks added by Duchamp to the print of a winter landscape in the rectified readymade *Pharmacie* (1914), to suggest the bottles of colored liquid that were a common sight in pharmacy win-dows.) By juxtaposing the images on a transparent surface between the mirrors, Morris set up an endless repetition of red and green bottles—a whirling, decentering riddle that recalled the running around in circles of the autistic child who will never find his elusive center.

20 Spoerri, in Otto Piene and Heinz Mack, *Zero*, 1961; rpt. with English trans. by Howard Beckman, *Zero*, Cambridge, Mass., and London, MIT Press, 1973, p. 219.

21 Of his interest in Dada, Spoerri has said: "Dada was the loss of trust in the senses . . . at the beginning of our century . . . we knew that what we were seeing was no longer what we were seeing . . . Art, until the twentieth century, had to be as true as possible to reality. It had to create, like God. But in the twentieth century, everything could be something else . . . You can be sure of nothing." See interview with Daniel Spoerri in this catalogue.

22 This quotation is an extrapolation by Leo Bersani and Ulysse Dutoit of ideas expressed by Freud in his *Three Essays on the Theory of Sexuality*. For more on Freud's

analysis of the dynamics of sadomasochism, see Bersani and Dutoit, *The Forms of Violence: Narrative in Assyrian Art and Modern Culture*, New York, Schocken, 1985, pp. 24–39.

23 Jean Laplanche, as quoted in Ibid., p. 33.

24 Ibid.

25 Ibid.

26 *Passageway* was conceived as part of a concert series organized by La Monte Young and held at Ono's Chambers Street loft in Manhattan. Presented from January to June 1961, the "Chambers Street Series" offered the first collective forum for what would come to be known as Fluxus. Morris eventually grew disillusioned with the Fluxus sensibility and the movement's titular leader, George Maciunas. After with-drawing his contribution from the preeminent collection of Fluxus writing and graphics, *An Anthology* (1963), Morris wrote to Maciunas in 1964 demanding to be disassociated from a Fluxus movement he now saw as aesthetically irresponsible, con-descending, and unserious.

27 A year later, Ono suggested a similar idea, except her notion was autodestructive rather than sadistic: "Use your blood to paint. Keep painting till you faint. (a) Keep painting until you die. (b)." See Ono, *Grapefruit*, n.p. The use of blood also recalls Duchamp's *Allégorie de genre* (Genre Allegory [George Washington], 1943), a work that would have been known to both artists through Robert Lebel's writing on Duchamp (Klein was, in fact, a friend of Lebel's). Rejected by *Vogue* magazine as a commission for a special Washington cover, this collage of the stars and stripes con-flates the profile of the president with an outline of the United States. The iodine-tinted gauze used to fashion the central image alarmed the magazine editors because it resembled bloodstained bandages.

28 Yves Klein, "Truth Becomes Reality," in *Yves Klein, 1928–1962: A Retrospective*, p. 230.

29 Bernadette Allain, as quoted in Thomas McEvilley, "Yves Klein: Conquistador of the Void," in *Yves Klein, 1928–1962: A Retrospective*, p. 64. The publicity around Klein's jumps led to a tragic copycat attempt in Japan in 1961. A young Japanese artist, inspired by the leaps and Anthropométries, was reported to have jumped from a high building onto a canvas on the street below. The artist, who died on impact, willed his canvas to a reportedly uninterested Tokyo Museum of Modern Art.

30 On the transformatory quality of these artists' works, François Pluchard writes: "[For Klein, color] durably alters the spectator's consciousness so that no double meaning may distract from the ultimate aim of a work of art: the transformation of an indi-

vidual's behavior with respect to the society to which he belongs. This denial of aesthetic gratification on behalf of energy and disturbing violence appeals, in the end, to a notion of quality. Marcel Duchamp's readymade is diversely beautiful in its form, efficacious in its dialectic, and prompt to assure its place in the long monologue of creativity. In the same way, Klein's universal appropriation is capable of entrapping a more or less large share of energy, of reality, of creative fever." See Pluchart, "Fire Sermons," *Art and Artists*, vol. 1, no. 5 (August 1966), p. 26. The title of this essay refers in part to Klein's violent and transformatory "fire paintings," in which monochromatic paintings were set ablaze with flares. In the summer of 1961, Ono proposed a parallel aesthetic action: "Light a canvas or any finished painting with a cigarette at any time for any length of time. See the smoke movement. The painting ends when the whole canvas or painting is gone." See *Grapefruit*, n.p.

31 Stephen Koch writes, "One senses that, in those days, a thrilling complicity united the artistic and sexual and drug subcultures, that some kind of shared refusal threw together mute *seriosos* like the composer La Monte Young with hardened, quick-witted, druggy street performers with names like Rotten Rita, Narsissy, and Ondine, people living on drugs and their wits, doing their numbers in bars and apartments and lofts, of the existence of which the straight world had only the merest dreadful imitations. Men for whom the flamboyant pose and a tongue like lightening were the only life found themselves in a department of limbo adjacent to middle-class artists." See Koch, *Stargazer*, p. 5.

32 Ibid., pp. 8–9.

33 Ibid., p. 43. For more on Warhol's films, see *The Films of Andy Warhol: An Introduction*, New York, Whitney Museum of American Art, 1988.

34 Of Duchamp's use of the synecdoche, Koch writes: "The Duchampian context invariably involves a displacement of interest from what is being seen into a visually marginal, imagined concern created within us by the shadow-play of perception, by the activation of thoughts and alternative responses, even when the thing before us is truncated, uninteresting in itself, or absurd." See Ibid., p. 49.

35 For more on *Shooting Gallery*, see Dorothy Gees Seckler, "The Audience is His Medium," *Art in America*, vol. 4, no. 2 (October 1963), p. 67 and J[ill] J[ohnston], "Niki de Saint Phalle," *Art News*, vol. 61, no. 8 (December 1962), p. 16.

36 For more on Saint Phalle's depressive attitude towards her non-participation in the shooting assemblages, see Rosalind Wholden, "Puerealism: 'The End' with Innocence," *Artforum*, vol. 2, no. 3 (September 1963), p. 30.

37 For a description of the Malibu Beach event, see Lois Dickert, "Shooting at Malibu," Summer 1962, unpublished manuscript, courtesy Saint Phalle archives, Paris.

38 Saint Phalle, "A Letter to Bloum," in this catalogue.

39 Saint Phalle, "Closeup: Avant–Garde Artist," *New York Post*, December 5, 1962, p. 47.

40 Carol James, "Duchamp's Pharmacy," *Enclitic*, vol. 2, no. 1 (Spring 1978), p. 78.

41 Lebel, in *Marcel Duchamp*, writes (p. 71): "However burdened with affectivity it may have been in the beginning, Duchamp's work has, as it were, probably led him to a positive catharsis. That is to say that the metamorphosis of the subject has been achieved in a fashion exactly the reverse of the precedents established by Van Gogh and Kafka."

42 See McEvilley, "Conquistador of the Void," p. 36. Of his "leap into the void," Klein wrote: "For years I have been training for levitation, and I am intimately familiar with the best means of attaining it—the judo falls. On one side is the traditional legendary vampirism at night, combined with absolute physical immobility during the day (a sort of systole and diastole); and on the other is the actual liberation of every aspect of the individual personality by the aggravation of the Me, practiced to the point of an absolute purifying sublimation. I recently declared . . . that, once liberated from the psychological world, the artist of tomorrow will create himself anew in every work, through his power to levitate in total physical and spiritual freedom." Klein, "Du vertige au prestige, 1957–1959," in *Dimanche, le journal d'un seul jour*, November 27, 1960; rpt. and trans. by Thomas McEvilley in *Yves Klein, 1928–1962: A Retrospective*, p. 235.

43 Barbara Haskell, *Yoko Ono: Objects*, p. 2.

44 Koch, *Stargazer*, p. 9.

45 R. D. Laing, "The Schizophrenic Experience," in *The Politics of Experience*, New York, Ballantine, 1967, p. 27.

46 R. D. Laing, "Preface," in *The Divided Self: An Existential Study in Sanity and Madness*, Baltimore, Penguin Books, 1965, p. 11.

47 For more on the influence of the New Psychiatry on the avant-garde in the United States and Europe, see Berger, *Labyrinths*, pp. 47–79 and 154–62.

48 "Violence in Art," p. 5.

49 As quoted in Ibid.

50 Michel Foucault, "Preface," in Gilles Deleuze and Félix Guattari, *Anti-Oedipus: Capitalism and Schizophrenia*, New York, Viking, 1977, p. xii.

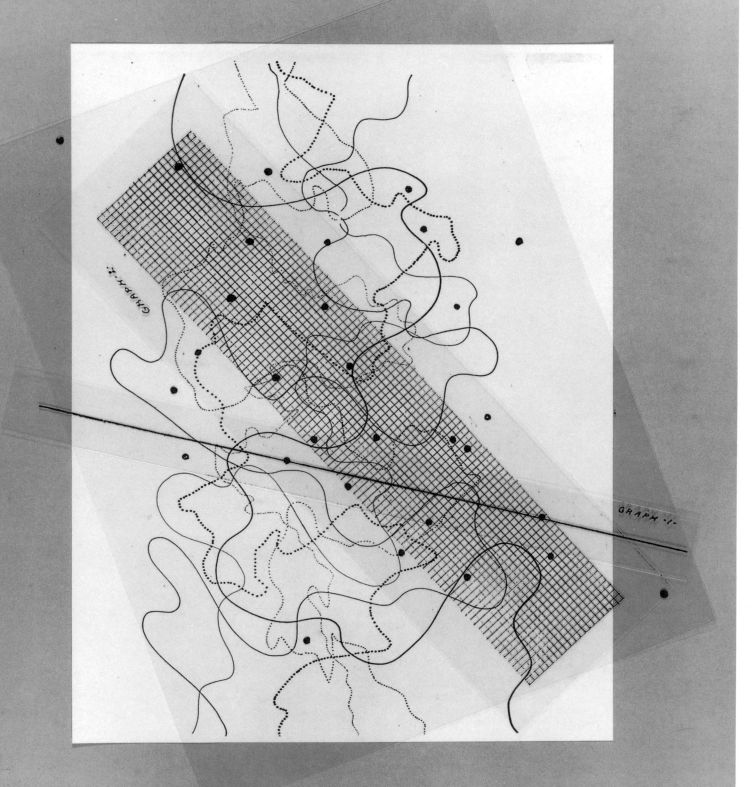

43a JOHN CAGE

Score for *Fontana Mix*, 1958.

Dada and Fluxus

Jill Johnston

I don't believe in art, I believe in artists.
—MARCEL DUCHAMP

Writing in 1936, Richard Huelsenbeck, a founder of the Dada movement, proclaimed, "Dada will experience a golden age, but in another form than the one imagined by the Paris Dadaist."[1] He was writing some fourteen years after the demise of Dada in Paris, its exit point in Europe. For Huelsenbeck the pure Dada of rebellion and destruction that had characterized the Berlin Dada movement had been frittered away under Tristan Tzara in Paris; he said, "Tzara transformed Dadaism into an artistic movement."

In 1962 Dada erupted once again on the European continent: the new "golden age" was called Fluxus. By then Huelsenbeck was a seventy-year-old New York psychoanalyst practicing under the name Charles Hulbeck. There had been plenty of proto-Fluxus activity in America and elsewhere, from the mid- to late 1950s, and I don't know if Hulbeck recognized in these Fluxus-type events the recovered golden age he had dreamed of in 1936. But fellow Dadaist Marcel Duchamp wrote in 1962 to Hans Richter, "This Neo-Dada, which they call New Realism, Pop Art, Assemblage, etc., is an easy way out, and lives on what Dada did."[2] He complained that the Neo-Dadaists had taken his ready-mades "and found aesthetic beauty in them." Indeed, nothing was thought to be more "beautiful" than Jasper Johns's transmogrified readymades—his handpainted Flags, Targets, Numbers, and Maps.

Johns was one of the artists sometimes called a Neo-Dadaist in the late 1950s and early '60s. One critic even claimed that the critical term "Neo-Dada" came into existence with Johns's first show at the Castelli Gallery in 1958. As recently as 1990, critic Hilton Kramer said, "I mean, my God, painting the American flag . . . it's sort of the ultimate Dada gesture."[3] But nobody really

85

Dada and Fluxus

10 TRANSPARENT SHEETS WITH POINTS. 10 DRAWINGS HAVING SIX DIFFERENTIATED CURVED LINES. A GRAPH (HAVING 100 UNITS HORIZONTALLY, 20 VERTICALLY) AND A STRAIGHT LINE, THE TWO LAST ON TRANSPARENT MATERIAL.

PLACE A SHEET WITH POINTS OVER A DRAWING WITH CURVES (IN ANY POSITION). OVER THESE PLACE THE GRAPH. USE THE STRAIGHT LINE TO CONNECT A POINT WITHIN THE GRAPH WITH ONE OUTSIDE.

MEASUREMENTS HORIZONTALLY ON THE TOP AND BOTTOM LINES OF THE GRAPH WITH RESPECT TO THE STRAIGHT LINE GIVE A 'TIME BRACKET' (TIME WITHIN WHICH THE EVENT MAY TAKE PLACE) (GRAPH UNITS = ANY TIME UNITS).

MEASUREMENTS VERTICALY ON THE GRAPH WITH RESPECT TO THE INTERSECTIONS OF THE CURVED LINES AND THE STRAIGHT LINE MAY SPECIFY ACTIONS TO BE MADE. THUS, IN THE CASE OF (FONTANA MIX) TAPE MUSIC, THE THICKEST CURVED LINE MAY GIVE SOUND SOURCE(S) WHERE THE LATTER HAVE BEEN CATEGORIZED AND RELATED QUANTITATIVELY TO 20. (IN THIS CASE, THE 2 POINTS CONNECTED BY THE STRAIGHT LINE MUST PERMIT THE LATTER TO INTERSECT THE THICKEST CURVED LINE.) INTERSECTIONS OF THE OTHER LINES MAY SPECIFY MACHINES (AMONG THOSE AVAILABLE) FOR THE ALTERATION OF ORIGINAL MATERIAL. AMPLITUDE, FREQUENCY, OVERTONE STRUCTURE MAYBE CHANGED, LOOPS AND SPECIFIC DURATIONS INTRODUCED.

MEASUREMENTS MADE MAY PROVIDE ONE OF A NUMBER OF PARTS TO BE PERFORMED ALONE OR TOGETHER. IN MAKING TAPE MUSIC, AVAILABLE TRACKS MAY BE LESS IN NUMBER THAN THE TIME BRACKETS GIVEN BY MEASUREMENTS. FRAGMENTATION IS THEN INDICATED.

THE USE OF THIS MATERIAL IS NOT LIMITED TO TAPE MUSIC BUT MAY BE USED FREELY FOR INSTRUMENTAL, VOCAL AND THEATRICAL PURPOSES. THUS, AFTER A PROGRAM OF ACTION HAS BEEN MADE FROM IT, IT MAY BE USED TO SPECIFY A PROGRAM FOR THE PERFORMANCE OF THE OTHERWISE UNCHANGING MATERIAL. WHERE POSSIBLE TECHNICALLY THIS CAN BE NOT ONLY SIMPLE CHANGES OF TIME (STARTING, STOPPING) BUT ALSO ALTERATIONS OF FREQUENCY, AMPLITUDE, USE OF FILTERS AND DISTRIBUTION OF THE SOUND IN SPACE.

43b JOHN CAGE

Score for *Fontana Mix*, 1958.

12 PIANO COMPOSITIONS FOR NAM JUNE PAIK, by George Maciunas, Jan.2,1962

Composition no.1	let piano movers carry piano into the stage
Composition no.2	tune the piano
Composition no.3	paint with orange paint patterns over piano
Composition no.4	with a straight stick the length of a keyboard sound all keys together
Composition no.5	place a dog or cat (or both) inside the piano and play Chopin
Composition no.6	stretch 3 highest strings with tuning key till they burst
Composition no.7	place one piano on top of another (one can be smaller)
Composition no.8	place piano upside down and put a vase with flowers over the sound box
Composition no.9	draw a picture of the piano so that the audience can see the picture
Composition no.10	write piano composition no.10' and show to audience the sign
Composition no.11	wash the piano, wax and polish it well
Composition no.12	let piano movers carry piano out of the stage

44 GEORGE MACIUNAS

Score for *12 Piano Compositions for Nam June Paik*, January 2, 1962.

was further from the original spirit of Dada than Johns, an artist's artist, who aspired from the start to enter the pantheon of Modernism. His confrere, Robert Rauschenberg, had a Dada edge to him and had even committed an indisputably Dada gesture (e.g., the de Kooning drawing he obtained and infamously erased). But, like Johns, Rauschenberg was ever an ambitious artist, working in the grand tradition of the innovative genius.

The reintroduction of real objects and all sorts of foreign materials into art apparently made many critics of the late 1950s feel that Dada was upon them again. But the true spirit of Dada was anti-art, whatever the objects or materials, and however absurdly or incongruously they were used. Rauschenberg's stuffed goat (in *Monogram*) was a kind of assisted readymade, and part of an art work that included many other objects and painted images. The new collage, assemblage, or Combine forms looked back to the advanced art of the 1910s and '20s—art that Dada disavowed along with abstraction and Expressionism once

it found its revolutionary voice. Duchamp said, "Dada was an extreme protest against the physical side of painting."[4] Jean Arp, the Alsatian cofounder of Zurich Dada, said, "Dada is for nature and against art." Huelsenbeck's claim that "Everyone can be a Dadaist" became "Everyone can be Fluxus" in the 1960s.

What became Fluxus was first called "Neo-Dada," the only truly accurate application of the name at the time. Everything else remained "art," however innovative or seemingly iconoclastic or reminiscent of Dada. Of course, anti-art is simply that which is outside the prevailing definition of art at the moment it arises, and Fluxus manifestations became art, too. But both Dada and Fluxus said that everything is art. At its extremity, the limit(lessness) that defined it, Dada said, "The Dadaist loves life because he can throw it away every day . . . The bartender in the Manhattan Bar who pours out Curaçao with one hand and gathers up his gonorrhea with the other, is a Dadaist. The gentleman in the raincoat who is about to start his seventh trip around the

IN MEMORIAM TO ADRIANO OLIVETTI By George Maciunas March 20,1962
revised: Nov. 8,1962

*

ny used tape from an Olivetti adding machine may be used as a score for this piece.

PERFORMANCE INSTRUCTIONS
Numbers (including zero) represent specific sounds or actions, each of which is
assigned to separate performer. When performed by fewer than 10 performers, the
unassigned excessive numbers represent silences. Same number can also be assigned
to more than one performer if the tape contains more than one of same number per row.
In such cases the second or third performer performs only when 2nd. or 3rd. of same
number appear on the row.
Each horizontal row is performed simultaneously at preferably fast tempo such as
2 regular beats per second. A conductor or metronome may direct the group if necessary
Blank row represents silence of one beat.

VERSION 1. (poem)
Each performer pronounces his assigned number in any language.

VERSION 2. (ballet) performers to be formally dressed (except no.9,in military uniform
Performers perform the following actions assigned to indicated numbers:
0 - lift bowler hat from head when first 0 is indicated,place on head when next 0 is
 indicated, repeat action for succeeding indications of 0's.
1 - point with finger at someone in the audience (arm outstreched) whenever 1 is
 indicated. Point at different member of audience for each separate indication of 1.
2 - point with finger at ceiling or floor
3 - sit down on a chair when first 3 is indicated, stand up on next indication, etc.
4 - squat down when first 4 is indicated, stand up when next is indicated, etc.
5 - strike floor with cane or umbrella on each indication of 5
6 - open umbrella over head on first indication of 6, close on next, etc.
7 - bow down (towards or away from audience) on first indication of of 7, raise on next
8 - stamp floor with foot on each indication of 8
9 - give military salute with hand on first indication of 9, lower hand on next, etc

VERSION 3. (ballet)
Each performer to use different kind of hat. Perform as in Version 2 (zero)

VERSION 4. (chorale)
0 - smack with lips smartly (sound like drop falling into water) on each indication of0
1 - smack with tongue (click like opening corcked bottle)
2 - lip-fart (through tight lips)
3 - lip-fart (with tongue between lips)
4 - draw air (upper teeth over lower lips)
5 - draw air, open mouth, vibrate deep throat (pig like sound)
6 - blow air between lips vibrating them
7 - dry spitting
8 - lunger
9 - sniff wet nose (wet nose with water if necessary)

VERSION 5 _(string quartet or ensemble)
0 - strike body with mallet or stick
1 - knock against floor (cello) or table (violin)
2 - shake body (have pellet or pellets placed inside beforehand)
3 - with stick scrape edge of sound hole (obtain squeek or screech)
4 - place instrument in playing position and in non-playing position on next called beat
5 - place bow over strings in playing position ,, ,, ,,
6 - (replace beforehand a string with electric heating coil) scrape coil
7 - pluck heating coil
8 - (replae beforehand a string with rubber band)- pluck rubber band smartly
9 - open etuis, close it on next called beat.

```
VERSION 6  (for string quartet only)
1 - pizzicato  C
2 -      ,,    C+½ (tone)
3 -      ,,    C-½
4 -      ,,    C #

Any sounds or actions of any versions may be combined in any way to form new
versions or new sounds and actions substituted.

EXAMPLE  (combined version 2 and 4)     9 performers (1,3,5,6,7,8,9,0)

16387 - point finger,open umbrella,sit on chair,lip-fart(8),bow down
0086  - lift bowler hat,list boater-hat,lip-fart,close umbrella
1057  - point finger elsewhere,place bowler hat on head,draw air(pig-like),raise-up
608   - open umbrella,lift bowler hat,lip-fart
300   - get up from chair,place bowler hat on head,place boater-hat on head.
3798  - sit down on chair,bow down, give military salute,lip fart

etc.
                                              ©FLUXUS 1963
```

45abc GEORGE MACIUNAS

Score for *In Memoriam to Adriano Olivetti, Revised,* March 20, 1962
(revised November 8, 1962).

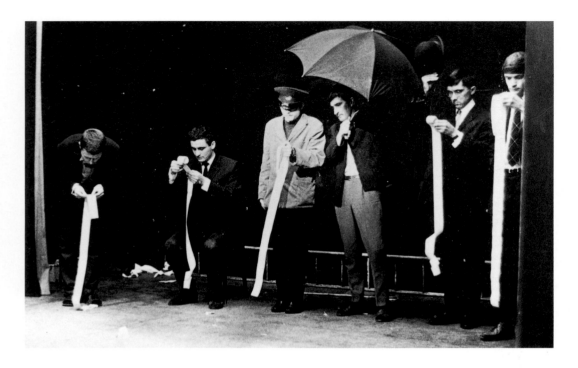

46 GEORGE MACIUNAS (second from right) and other Fluxus artists performing his *In Memoriam to Adriano Olivetti* during the "Fluxus Festival," Hypokriterion Theater, Amsterdam, June 23, 1963. Photo Oscar van Alphen, courtesy Gilbert and Lila Silverman Fluxus Collection.

world, is a Dadaist. The Dadaist . . . lives only through action . . . [and] is the man who rents a whole floor at the Hotel Bristol without knowing where the money is coming from to tip the chambermaid."[5]

The Dadaist, it's clear to see, was a man. This was understood. It was a limit that placed the Dadaists squarely inside the bourgeois society they hated and wanted to destroy, yet in which they were rooted. It was a condition of their freedom so utterly assumed that it seemed unrecognizable at that time. And, in 1962, the Fluxus artist was a man, too. During that year Alison Knowles, wife of proto-Fluxus artist Dick Higgins, entered the Fluxus core group as its token woman (comparable, say, to Emmy Hennings, the wife of Hugo Ball, who, with Hennings,

founded Dada in the Cabaret Voltaire in Zurich in 1916). During the 1960s, several Japanese women, including Yoko Ono, were sometimes listed as participants in Fluxus festivals.

In June 1962, a concert entitled "Neo-Dada in der Musik" took place in Düsseldorf, and included a number of composers who later became members of Fluxus. In August, George Maciunas, inventor of the word "Fluxus," wrote to Korean composer Nam June Paik, "I think Fluxus festivals . . . must lean more towards neo-dada . . . we should eliminate all non-action, non neo-dada, non-concrete pieces."[6] Maciunas, considered by many to be the founder of Fluxus, was well-acquainted with Dada history. A native of Lithuania, Maciunas came to the United States with his family after World War II. He attended Cooper Union and

Kammerspiele Düsseldorf NEO-DADA in der Musik

Drucksache HERRN JÄHRLING

GALERIE PARNASS

WUPPERTA-E.

MOLTKESTR. 67

NEO-DADA in der Musik Kammerspiele Düsseldorf

Kammerspiele Düsseldorf Samstag 16. Juni 1962 23 Uhr

NEO-DADA in der Musik

Vorspruch: Jean-Pierre Wilhelm

PROGRAMM:

1. One-for Violin Solo	Name June Paik
2. Wort-Event	George Brecht
3. Sonata quasi una fantasia	Name June Paik
4. read music „Do it yourself"	Name June Paik
— Antworten an	
La Monte Young —	
gelesen von C. Caspari	

5. Composition Anonyme

Komponisten	Parallele Aufführungen von	
	Titel	Interpreten
Sylvano Busotti	Paik piece 62	C. Caspari
Jed Curtis	Saint Anthony's Blues	Jed Curtis
Dick Higgins	Danger Music Structure	J. Flimm
Toshi Ischiyanagi	Violin Piece	J. G. Fritsch
Jackson Mac Low	poem	W. Kirchgässer
George Maciunas	piano piece for NO 8 for NO 12	George Maciunas H. v. Alemann
Name June Paik	aus „Bagatelles americaines"	Name June Paik Fr. Reddemann Tomas Schmit Batzing Bonk
Benjamin Patterson	Papier Musik	Alvermann Schneider Weselina Schröder u. a. etc.
	Disturbance from „Lemons"	A. Falkenstörfer Benjamin Patterson
Dieter Schnebel	Visible Composition for Conductor	H. Reddemann
Vostell	„KLEENEX" décoll/age	Vostell
La Monte Young	For Flynt 566" chant of death	Name June Paik u. a. etc. J. G. Fritsch

6. smile gently
————or etude platonique NO 5 Name June Paik

47 FLUXUS

Neo-Dada in der Musik (Neo-Dada in Music), June 16, 1962.

UNiversity of california
Berkeley campus

THe
ARchiTecTure
ArTs
FeSTiVAl

PReSEnTs

TO

By IaM⊙n·E younG
TeRRy RiIEy
walT de MariA

An occAsion

imPRovisATion

ElecTRoniC SoUNds
PiECES
OF indETERminACy
Court

ACTioNs

MAy 6 FRiday ARchiTecTure Court
MOnday MAY 2

NOON HOur

48 Poster for *TO*, a collabora-
tion event held at the University
of California, Berkeley, May 2,
1960, with works by La Monte
Young, Terry Riley, and Walter
De Maria. Poster design by David
Degener. Photo Ken Cohen.

the Carnegie Institute of Technology, and in 1955 studied art history (including Dada, Surrealism, and Futurism) at the Institute of Fine Arts at New York University. Through composer Richard Maxfield, Maciunas also met many of the artists who had studied in John Cage's famed and influential class at the New School for Social Research from 1957 to '59.

Cage, who idolized Marcel Duchamp, and had known him in New York since the '40s, was the clear link between Dada and Fluxus. Every current history of Fluxus makes a deep bow to Cage. His students included George Brecht, Al Hansen, Dick Higgins, Jackson Mac Low, and Maxfield, all key figures in the development of Fluxus-type activities. Of this group, only Kaprow was never associated with Fluxus. Instead, Kaprow allied himself with another loose cluster of artists—including Claes Oldenburg, Robert Whitman, Jim Dine, and Red Grooms—who made Happenings. Whereas Fluxus events were characteristically quite minimal, emphasizing a single everyday action like brushing teeth, cutting hair, or moving something from one place to the other, Happenings tended to be more theatrical, expressionistic, and "artistic." Roughly, these simple Fluxus actions derived from Cage's theory of music as "found" or "environmental" sound. With Fluxus, the readymade came to the stage. Dick Higgins summed up the Fluxus attitude when he asked, "Why does everything I see that's beautiful like cups and kisses and sloshing feet have to be made into just a part of something fancier and bigger, why can't I just use it for its own sake?"[7] And Maciunas, in a 1965 manifesto, said the artist "must demonstrate that anything can be art and anyone can do it. [It] must be simple, amusing, unpretentious, concerned with insignificances, require no skill or countless rehearsals, have no commodity or institutional value."[8]

Anyone can do it. During the 1960s, this idea swept through the art world like a brushfire. No special knowledge of John Cage or his thought or the Fluxus movement was necessary for artists to believe that anything was possible. The idea hung porously in the atmosphere. Artists made dances. Dancers made music. Composers made poetry. Poets made events. People at large performed in all these things, including critics, wives, and children. Dogs, turtles, and chickens made it, too. One result of the notion that anyone could do it was an orgy of Intermedia. Another was that "it" could be anything. As a critic then myself, I developed a form called "the lecture-event." I would tape a "lecture" consisting of various items, such as a newspaper listing of the objects found in the pockets of a vagrant who was picked up on a park bench by the police. Then I would run the tape while performing a series of actions, like stuffing paper into a cardboard box, mounting a chair, and jumping into the box.

The high point of my career as a performer came in 1962 when John Cage asked me to participate with him and composer David Tudor in a performance of Cage's 1958 *Music Walk* at the YM-YWHA in Manhattan. *Music Walk* is described as "a composition indeterminate of its performance." This meant that the performer was supplied by the composer with the makings of a "score"—on a transparent sheet of acetate was a rectangle with five parallel lines on it; this would be laid over nine additional sheets, each with various points plotted on them, to determine characteristics of sound and action. Cage and Tudor were already outfitted with their sound/action-making implements: a piano and radios. I had to invent or bring my own. I was billed as a "dancer." That is, on this occasion, *Music Walk* was called *Music Walk with Dancer*.[9] I did in fact do a slight dance action on stage, slow and vampy (wearing heels, a floppy hat, and red dress), but I went mainly as a Mother. I took the "life-art" equation seriously then. I was a critic moonlighting as a mother of two small children, or vice versa. I chose a number of sound/action implements that I moved around my apartment every day: a frying pan and bacon, a Savarin coffee can, a broom, a baby bottle with brush, a pull-toy, a vacuum cleaner, etc. Then

WORD EVENT

● EXIT

G.Brecht
Spring, 1961

49 GEORGE BRECHT

Word Event, 1961.

I laid the transparent rectangle with parallel lines on it over the sheets with points to determine how much time and in what order I would do something with each object in the overall time limit of ten minutes. At the Y, I put all this stuff around the stage, lined up in the order determined by my operation with the "score." But some time during the rehearsal, my stack of cards, each identifying the object and action to be performed and the time allotted to perform them, fell in a puddle of water, blurring the print and making the cards unsuitable for use. (I had noticed the lovely graphics of John's and David's cards.) So I decided to abandon them and just do what I felt like doing for however long I wanted within the ten minutes allotted for the performance. The audience was very pleased with the three of us, but afterwards Cage reprimanded me for not "giving up my ego," meaning acting on my own, by choice, according to my likes and preferences. But, of course, the carload of household equipment I brought with me, like his piano and radios, already indicated plenty about choices we had made in our lives, whether "preferences" or not. This whole event and its outcome made a big impression on me.

In this instance I probably acted much more like a Dadaist than a Fluxus artist, for Fluxus actions became as methodical as Cage in their means of production. Although there were significant differences between Dada and Fluxus, Dada was surely proto-Fluxus in its experiments with chance methods. Tristan Tzara once said, "To make a dadaist poem / Take a newspaper / Take a pair of scissors / Choose an article as long as you are planning to make your poem / Cut out the article / Then cut out each of the words that make up this article and put them in a bag / Shake it gently / Then take out the scraps one after the other in the order in which they left the bag / Copy it conscientiously / The poem will be like you / And here you are a writer, infinitely original and endowed with a sensibility that is charming though beyond the understanding of the vulgar."[10] Tzara also invented

Spec.Coll.
64
Sb(n)
no. 1

1-9-80

by Alison Knowles

#1 —

Shuffle (1961)

The performer or performers shuffle into the performance area and away from it, above, behind, around, or through the audience. They perform as a group or solo: but quietly.

Premiered August 1963 at National Association of Chemists and Perfumers in New York at the Advertisers' Club.

#2 —

Proposition (October, 1962)

Make a salad.

Premiered October 21st, 1962 at Institute for Contemporary Arts in London.

Copyright©, 1965 by Alison K. Higgins. All rights reserved, including performance rights, which are readily available through Something Else Press, Inc., 160 Fifth Avenue, New York, N. Y. 10010. No part of this book may be reproduced in any form without permission in writing from Alison K. Higgins, except by a reviewer who wishes to quote brief passages in connection with a review written for inclusion in a magazine or a newspaper or a radio broadcast. Manufactured in the United States of America.

2

The Museum of Modern Art Library

by Alison Knowles

#2a —

Variation #1 on Proposition (October, 1964)

Make a soup.

Premiered November 9th, 1964 at Cafe au Go Go in New York.

#3 —

Nivea Cream Piece (November, 1962) — for Oscar Williams

First performer comes on stage with a bottle of hand cream, labeled "Nivea Cream" if none is available. He pours the cream onto his hands, and massages them in front of the microphone. Other performers enter, one by one, and do the same thing. Then they join together in front of the microphone to make a mass of massaging hands. They leave in the reverse of the order they entered, on a signal from the first performer.

Premiered November 25th, 1962 at Alle Scenen Theater, Copenhagen, at Fluxus Festival.

#3a —

Variation #1 on Nivea Cream Piece (no date, evolved through many performances from the above)

Large quantities of Nivea Cream must be available, at least one large jar per person. The performers enter and each lathers up his arms and face, then his colleagues, in a fragrant pig-pile.

3

50 ALISON KNOWLES

by Alison Knowles, 1965.

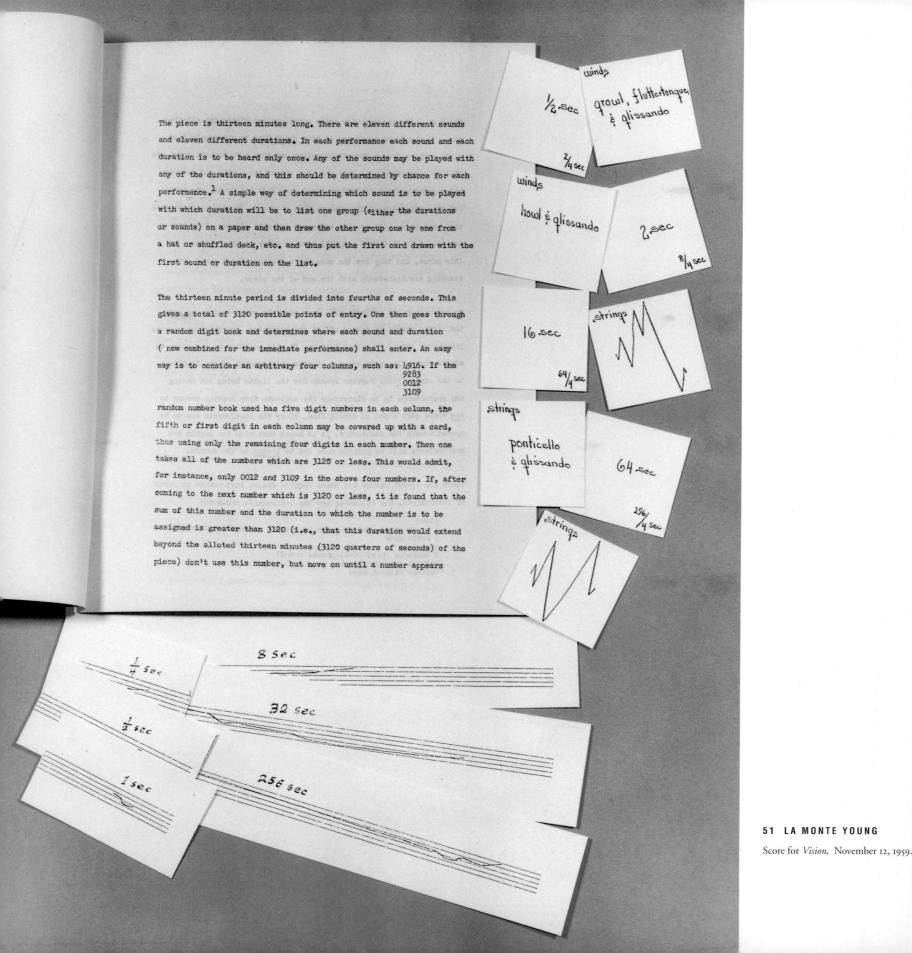

The piece is thirteen minutes long. There are eleven different sounds and eleven different durations. In each performance each sound and each duration is to be heard only once. Any of the sounds may be played with any of the durations, and this should be determined by chance for each performance.[1] A simple way of determining which sound is to be played with which duration will be to list one group (either the durations or sounds) on a paper and then draw the other group one by one from a hat or shuffled deck, etc. and thus put the first card drawn with the first sound or duration on the list.

The thirteen minute period is divided into fourths of seconds. This gives a total of 3120 possible points of entry. One then goes through a random digit book and determines where each sound and duration (now combined for the immediate performance) shall enter. An easy way is to consider an arbitrary four columns, such as: 4916. If the
9283
0012
3109
random number book used has five digit numbers in each column, the fifth or first digit in each column may be covered up with a card, thus using only the remaining four digits in each number. Then one takes all of the numbers which are 3120 or less. This would admit, for instance, only 0012 and 3109 in the above four numbers. If, after coming to the next number which is 3120 or less, it is found that the sum of this number and the duration to which the number is to be assigned is greater than 3120 (i.e., that this duration would extend beyond the alloted thirteen minutes (3120 quarters of seconds) of the piece) don't use this number, but move on until a number appears

51 LA MONTE YOUNG

Score for *Vision*, November 12, 1959.

something called the "static poem." Placards were placed on chairs, one word written on each, the sequence altered each time the curtain was lowered.[11] An alternative, the simultaneous poem, was a central feature in Dada performances. Different texts, or copies of the same text, were read simultaneously, with the expected chance results. Methods used by Duchamp and Arp for producing images by chance were well-known to Cage and his circle. George Brecht and Jackson Mac Low had experimented with making compositions by chance even before they attended Cage's class. In 1955, Brecht was using tables of random numbers to make paintings. He also obtained chance results by crumpling wet materials—like burlap or sheets—and pouring paint or ink over the lumps, then unfolding, stretching, and drying them. In the spirit of Tzara and Arp, Brecht created a collage by pasting down scraps of painted and inked paper drawn by chance from a paper bag.[12] His later *Motor Vehicle Sundown Event* (1960), dedicated to Cage, shows one of the classic chance-result forms developed by Fluxus in the so-called Event-Score (a form for which Brecht was much admired, and which became perhaps the most indexical of all Fluxus manifestations). The participants shuffle instruction cards to determine the order of their horn honkings, windshield-wiper startings, window openings, etc. Brecht has written, "Chance in the arts provides a means for escaping the biases engraved in our personality by our culture and personal past history."

Escaping culture and reclaiming nature were the common themes uniting Dada and Fluxus. Dadaists, however, were the much more disaffected group. Their brief burst in history began in 1916 in the middle of World War I on the European continent. There was lots of migration; artists were uprooted, fleeing their families, governments, or conscription. Huelsenbeck said, "We had all left our countries as a result of the war. Ball and I came [to Zurich] from Germany, Tzara and [Marcel] Janco from Rumania, Hans Arp from France. We were agreed that the war had been contrived by the various governments for the most autocratic, sordid and materialistic reasons . . . Politicans are the same everywhere, flatheaded and vile."[13] It's been said that the Dada movement was an organized insulting of European civilization by its middle-class young.[14] The Dadaists were certainly young. In 1916, they were all in their twenties, the traditional age of organized rebellion against elders. Dada was a fraternity of angry young men converging in several European cities (also in New York, but brought by Europeans) to separate themselves from a culture that disgusted them, to make war on their fathers, the bourgeoisie.

Middle-class bourgeois students in Zurich formed the perfect outraged audience at the Cabaret Voltaire. The typical Dada performance was impulsive and furious. Dadaists were short on method, long on spontaneity and chaos. Arthur Cravan punctuated a lecture at the Salle des Sociétés Savantes with random pistol shots. Jacques Vaché—a man admired by André Breton for having the "good fortune of producing nothing"—attended the premiere of an Apollinaire play dressed as an English officer and disrupted the intermission by threatening to "shoot up" the audience.[15] In a 1920 performance in Paris, people in masks read a disjointed poem by Breton, Tzara read a newspaper story that he called a poem, and the whole was accompanied by a cacophony of bells and rattles.[16] In Zurich, "Tin cans and keys were jangled as music . . . Walter Serner placed a bunch of flowers at the feet of a dressmaker's dummy. Arp's poems were recited by a voice hidden in an enormous hat shaped like a sugar loaf. Huelsenbeck roared his poems in a mighty crescendo, while Tzara beat time on a large packing case. Huelsenbeck and Tzara danced, yapping like bear cubs, or . . . they waddled about in a sack with their heads thrust in a pipe."[17] The public rage of the Zurich students and others, so often provoked, was sometimes identical to that of the Dadaists. Audiences threw eggs and tomatoes, and were even known to go out and buy veal cutlets

and hurl them, too. Brandishing weapons, they would chase the Dadaists off the stage and out of the building, smash their equipment or props, call the police, and so on. The Dadaists said, "True Dadaists are against Dada . . . Everyone is a leader of the Dada movement."[18]

Fluxus artists experienced similar outbreaks during their heyday in the 1960s. Alison Knowles remembers an audience walking out when they could not tolerate the amount of time it took her and her Fluxus coperformers to complete *Make a Salad*. Emmett Williams recalls the Fluxus group being ridiculed on TV and in the press, and having such rave notices as "FRAUD" or "THE LUNATICS ARE LOOSE" scrawled on festival posters all over town.[19] At the Fluxus concerts I saw in New York, the audiences laughed and loved it all. Maciunas put together exquisite evenings of minimal Flux events—very artful entertainments consisting of "anti-art" work. A grand piano on stage always signalled its unconventional use. The curtain would open, a performer would walk in and place a vase on flowers on it and walk off, the curtain would close. Or someone would sit at it, place their hands in playing position over the keys and play nothing. All traditional instruments were abused in such ways or simply destroyed. The destructive aspect of Fluxus was close to the heart of Dada.

The world was not at war in 1962, but there was tremendous unrest and discontent around the globe. There was a Cold War. And there was the Bomb, which hung over populations like fleets of lethally charged dirigibles threatening to fall when some man in a suit pushed a button. In America there were race riots, and politicians gathering momentum to start the very unpopular war in Vietnam. Drugs of ecstasy and oblivion were reaching deep into society, and the women's movement was taking root. And scarcely forgotten were the repressions of the 1950s, when the American government sponsored Communist witchhunts, homosexual purges, and demands for uniformity in general.

So the destructive urges in Fluxus—destroy art (a tool of the government), make way for life (a free commodity of the people)—were as powerful in their way as those that inspired Dada. Displaced persons of all sorts were the agents of the two movements. There's a clear parallel between the leaders Tzara from Rumania and Maciunas from Lithuania—both wartime exiles in strange urban settings, evidently hungry for community. The twin drives of destruction (of all art as commerce, as specialty) and for community (united against art, dedicated to life) guided both Dada and Fluxus. It's been said that Fluxus was first and foremost an occasion for the consolidation of an international art community.[20] Knowles has described Fluxus as a family: "We had our mothers and fathers aboard in some sense . . . Emmett as a story teller/Papa and George [Maciunas] an eccentric uncle."[21] Dada never cohered like Fluxus, possibly because it lacked the tyrannical expert entrepreneurship of a man like Maciunas. Dada didn't survive its "golden age," ceding to Surrealism after six years; Fluxus, with its structure and methods, its early dynamic leadership, its ability to change and grow and incorporate new members and let its members do their own work under different auspices, and to not care too much who is or isn't Fluxus or whether Fluxus does or doesn't exist any more, has survived way into old age.

Some people think Fluxus died around 1967, at the end of *its* golden age, when the coordinated activity of a tight-knit core group began to disperse and unravel, and Maciunas's attention was diverted by his co-oping ventures in SoHo in Manhattan. Others think Fluxus died when Maciunas did in 1978. Many think that Fluxus by now has been collected and bought and museumized and historicized and memorialized to death. Possibly this most recent phase of Fluxus, the worldwide celebration of its thirtieth anniversary in 1992–93, with exhibitions, catalogues, panels, lectures, and revivals of classic works, will indeed mean its end. Yet, of course, while they live, the original wide-flung

Score for *Composition 1960 #7*, July 1960.

```
Composition 1960 #13
to Richard Huelsenbeck

The performer should
prepare any composition
and then perform it as
well as he can.

          La Monte Young
          November 9, 1960
```

```
Composition 1960 #15
to Richard Huelsenbeck

This piece is little whirlpools
out in the middle of the ocean.

          La Monte Young
          9:05 A.M.
          December 25, 1960
```

53 LA MONTE YOUNG

Scores for *Composition 1960 #s 13,* and *15,* 1960.

Fluxus artists, now after all only in their fifties and sixties, will continue to congregate for anniversary or other concerts, including the kinds of Flux celebrations—collective events—that gave Fluxus new life after 1970. These events tend to bring in all sorts of Flux-minded people, reminding us that Fluxus, like Dada, is a state of mind that has always existed. Jean Arp said, "What interests us is the Dada spirit and we were all Dada before the existence of Dada."[22]

People not concretely a part of Fluxus can sense the power of this "ahistorical myth" when participating in such true community events as the *Flux-banquet* for Maciunas in 1976, the *Fluxdivorce* of Geoffrey and Bici Hendricks in 1971, *Fluxmass* at Rutgers University in 1970, the *Fluxlux* memorial in 1988 for Robert Watts in Pennsylvania, or the *Fluxwedding* of Maciunas and Billie Hutching in 1978 (a few months before Maciunas died). There have been Fluxsports, Fluxtours, and a number of New Year's Eve Fluxfests. It's interesting to note that Dada once had "tours," also. At some point, the Dadaists decided to give up exhibitions and performances and arranged "excursions and visits" through Paris. Invitations were sent out to meet Dada in the street.[23] Fluxtours of curbs, public restrooms, and other sites in SoHo were conducted in 1976. All such Flux events parodied or transformed their cultural counterparts: Fluxsports, a kind of Flux Olympics, consisted of such events as a "100 yard race while drinking vodka," a "100 yard candle carrying dash," a "crowd wrestling in confined space," and "soccer with ping pong ball pushed by blow tubes."[24] Everybody can feel part of such vivid nonsense. Everybody can enter into Fluxmind. It's a Zen and community feeling. On the other hand, entering a museum featuring a Fluxus exhibition turns us toward history. Who really is Fluxus?

I don't mean who really belonged or belongs to Fluxus, the historical group of performers; I'm thinking rather of the backgrounds of the members, and of what pulled them in. I believe that if we could find out who the Fluxus people really were, then we could understand more about the need for community and under what political conditions it arises in the modern world of isolated or sundered families. Why didn't other Flux-minded people enter the group? Why did some artists get marginalized? What made it possible for a number of artists to enter Fluxus late? What made some drop out?

Ray Johnson and Albert Fine, for instance, were pure Dada. Johnson must have known most of the Fluxus artists, the American ones at least; he never entered in. Robert Morris created a few Fluxus-type events or constructions; he never wanted to belong. Steve Paxton would've been perfect, but he was a dancer and did his Dada-like things in the context of another Cage-inspired movement: the Judson Dance Theater.[25] Charlotte Moorman, so often paired with Fluxus core member Nam June Paik, whose work she executed, was a Fluxus performer par excellence, but Maciunas barred her from Fluxus concerts and tried to inflame other Fluxus artists against participating in the annual international Avant-Garde Festivals that she organized in New York. Carolee Schneemann, famed creator of *Meat Joy* and other Happenings or events, is chagrined to this day to have been marginalized or left out of Fluxus. Ben Patterson, a gold-card Wiesbaden Fluxus artist, dropped out for a number of years, then was embraced upon his return. La Monte Young, a student of John Cage's in Darmstadt in 1959, organizer of the seminal 1960–61 series of proto-Fluxus events at the Chambers Street loft of Yoko Ono in New York, key Fluxus composer and participant, was working nearly exclusively on his own or with his wife Marian Zazeela as partner by 1964 or '65. George Brecht believes "Fluxus has Fluxed," and has not participated in Fluxconcerts for about a decade.

Most or all Fluxus artists balanced their own enterprises with their participation in Fluxus. Some became well known for "signature" work, like the skies of Geoff Hendricks, the sound

Audiotapes for *Hommage à John Cage: Music for Tape Recorder and Piano* and other works, 1959–62. Photo © 1982 by Peter Moore.

machines of Joe Jones, the beans of Alison Knowles, the chairs or cabinets of George Brecht—work often shown and sold in the traditional way.

Biographies or substantial profiles of Fluxus artists could make it possible to get some overall picture of the kind of "family" that Fluxus was or became. We should want to know where they came from, how they got there, what they decided to do when they did, what status they achieved, how they fared over the period of thirty or so years, how they got along with each other, what their liaisons were apart from the performing group (e.g., in marriage, and so forth). A bio-history of Dada would be equally helpful. Reincarnations would be discovered. Amazing family likenesses should come to light. (Emmett Williams has described Maciunas as looking just like Tristan Tzara at festival time, "complete with bowler hat, monocle, high collar and black tie.")[26] Feuds could be found to be reenacted. Schisms would sound familiar. But most important—Where did they come from?

Models of community made by disaffected, socially alienated people, Misfits,[27] united by (anti-)art, could emerge in graphic, intelligent detail. In the gap of forty years between Dada and Fluxus, we find a lone man (Duchamp) reputedly and ideally doing nothing—except playing chess. A spiritual inheritor of his (Cage), obtaining a vision at his feet it could be said (though Cage was assuredly influenced also by other sources), in the role of teacher touched the minds and hearts of many Dada descendants, apparently waiting to hear the word.

The word might be "Roar." At the end of a Flux-event in New York in the 1960s, performers and audience took up the yell of "Roar"—a poem of Tristan Tzara's consisting of that word repeated 147 times.

1 Richard Huelsenbeck in Robert Motherwell, *The Dada Painters and Poets: An Anthology*, New York, Wittenborn Art Books (1951), 1979, p. 281.
2 Marcel Duchamp in Ibid., p. xiii.
3 Hilton Kramer, interview for film by Rick Flores on Jasper Johns, 1988.
4 Marcel Duchamp in *Dadas on Art*, ed. Lucy Lippard, Englewood Cliffs, N.J., Prentice-Hall, 1971, p. 9.
5 Huelsenbeck in Motherwell, *The Dada Painters and Poets*, p. 28.
6 George Maciunas in Estera Milman, "Fluxus: A Conceptual Country," *Visible Language*, vol. 26, nos. 1/2, (Winter/Spring 1992), p. 31.
7 Dick Higgins in Ibid., p. 18.
8 George Maciunas in Elisabeth Armstrong and Joan Rothfuss, *In the Spirit of Fluxus*, Minneapolis, Walker Art Center, 1993, p. 28.
9 In 1960, *Music Walk* was called *Music Walk with Dancers* when performed on four occasions in Europe by Cage and Tudor along with dancers Merce Cunningham and Carolyn Brown.
10 Tristan Tzara in Motherwell, *The Dada Painters and Poets*, p. 92.
11 Georges Hugnet in Motherwell, *The Dada Painters and Poets*, p. 132.
12 Letter from George Brecht to Jill Johnston, circa 1961–63, the Getty Collection.
13 Huelsenbeck in Motherwell, *The Dada Painters and Poets*, p. 23.
14 Motherwell, "Introduction," *The Dada Painters and Poets*, p. xxiv.
15 William Rubin, *Dada, Surrealism and Their Heritage*, New York, Museum of Modern Art, 1968, p. 12.
16 Hugnet in Motherwell, *The Dada Painters and Poets*, p. 169.
17 Ibid., p. 131.
18 Ibid., p. 171.
19 Emmett Williams, *My Life in Flux- and Vice Versa*, London, Thames and Hudson, 1992, p. 28.
20 Estera Milman, "Fluxus: A Conceptual Country," *Visible Language*, p. 12.
21 Estera Milman, interview with Alison Knowles, "Fluxus: A Conceptual Country," *Visible Language*, p. 99.
22 Jean Arp in *Dadas on Art*, ed. Lucy Lippard, p. 22.
23 Hugnet in Motherwell, *The Dada Painters and Poets*, p. 184.
24 Kristine Stiles in *In the Spirit of Fluxus*, p. 65.
25 The Judson Dance Theater came directly out of a class taught in 1960–61 at the Merce Cunningham studio by composer Robert Dunn, (husband of Cunningham dancer Judith Dunn), utilizing chance operations as teaching techniques inspired by John Cage.
26 Emmett Williams, *My Life in Flux- and Vice Versa*, p. 32.
27 A reference to "The Festival of Misfits," a Fluxus festival that took place in London, 1962.

Artists' Interviews and Texts

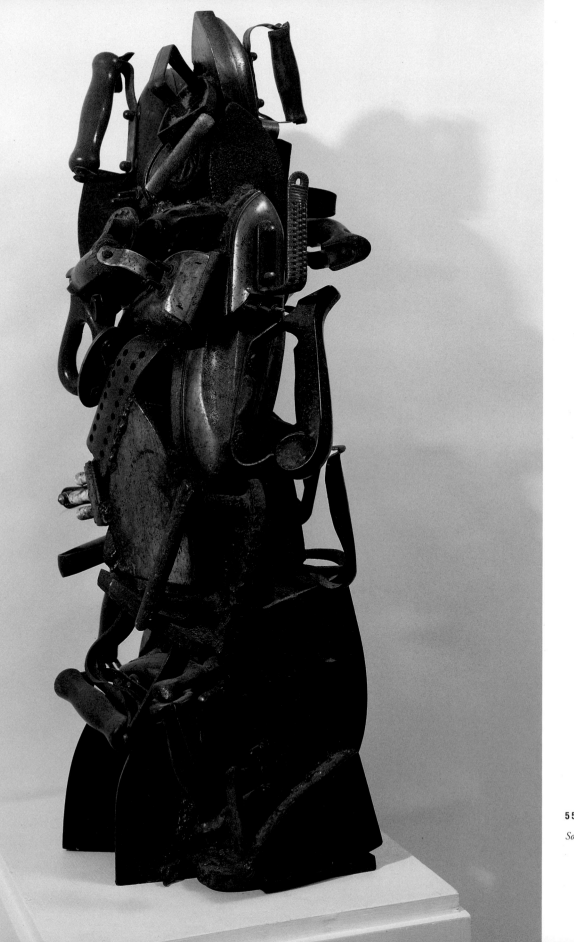

55 ARMAN

Sonny Liston, 1962–63.

Arman

Interview conducted by Susan Hapgood,
New York City, November 4, 1992

Susan Hapgood: How did you first learn about Marcel Duchamp?

Arman: In 1948, Yves Klein, who was my friend, gave me the catalogue of a Surrealist exhibition that had taken place at the Galerie Cordier in Paris. It's the catalogue that has on its cover the breast of a woman by Marcel Duchamp [*Prière de toucher* (Please Touch), 1947]. Through that catalogue I started to become aware of different ways of working as an artist. Before that, I had no documentation, nor any idea of what was going on. There were very few art magazines at that time, and no galleries. So it was very difficult to see anything.

SH: I understand that art by the Dadaists, like Duchamp and Schwitters, was not generally shown in Paris in the 1950s. But wasn't there a Kurt Schwitters show at the Galerie Berggruen in Paris in 1954?

A: Yes, I remember that. For me, it was a real eye-opener. But you have to keep in mind that the Berggruen show was fairly aesthetic material. It was nothing as shocking as Duchamp's bicycle wheel or the urinal. The collages were quite pretty, and there were two rubber-stamp pieces, too. The diehard Dadaists didn't care at all about aestheticism. At the time of the Café Voltaire or just after, Dada was more literary and political than aesthetic. But Schwitters inspired me to do something different in my own work. And I never refused to include aestheticism.

SH: Jan van der Marck claimed that by the mid-fifties you were very familiar with the works of Duchamp, Man Ray, Jean Arp, Tristan Tzara, and the whole group around André Breton. What was your knowledge of them at the time?

A: I knew their work through reproduction, but not in the flesh. I started to get some information through that 1948 Surrealist catalogue and, later, through Jacques Matarasso in Nice, who had a fantastic collection of Dada and Surrealist documentation and books. He showed me a lot of things—pamphlets, documents, books, photographs, reviews from the time. Through that rich documentation I had access to many interesting things. But I only saw Duchamp's work in the flesh when I first came to New York in 1961.

SH: You were actually introduced to Duchamp by William Copley in 1961, in New York. Do you remember the circumstances?

A: Oh, yes, very well, because it's quite specific. Bill Copley had collected my work. He bought some of my work at Iris Clert's gallery in 1958 or '59. And when I came to New York, he was one of the few people I knew. The first thing he asked me—which is a very American form of hospitality—was, "Who would you like to meet?" I said, "Marcel Duchamp." So Copley organized a dinner just for us to meet. It was Marcel Duchamp, Edgar Varèse, Teeny Duchamp, about ten people. I didn't speak English at all, maybe a few words. And Marcel was very nice always, very polite. He spoke to me in French, and asked, "From where are you? Are you from Paris?" I said, "No, I am not from Paris, I am in the fianchetto position." Fianchetto is chess jargon; it means diagonal from the bishop. "In Nice, in fianchetto." He says, "Ah, do you push wood?" Meaning I'm a chess player. "Yes." He says, "What is your rank?" I said, "I'm not too bad." He says, "What are you doing Thursday?" I said, "If it's to play chess, nothing." And we became very good friends. After, when I started living in New York, we played chess every week. Because among all the artists he knew at the time, I was one of the best chess players.

107

SH: How much did Yves Klein know about Duchamp in the mid- or late fifties?

A: Yves Klein knew a lot about Dada for a good reason: he was the son of two artists. His mother, Marie Raymond, was an abstract painter, quite well-known, and his father was a figurative painter, a little bit under the legacy of Gauguin. They had an apartment in the heart of Paris, within the intellectual crowd in Montparnasse, on rue d'Assas. Marie Raymond held a literary "salon" every Tuesday night; she received a lot of people and there were numerous discussions. It was there that Yves met the Lettristes in the early fifties, 1951 or '52. Living partially in Paris, having parents who were artists and being introduced into the milieu, he knew a lot. And he knew generally about Dada and Duchamp.

SH: But later, didn't Klein repudiate Pierre Restany's comparison of Duchamp and Dada with the New Realists?

A: That's something else. Part of Yves's big ego. He was always trying to manipulate people. I introduced Restany to Yves, and that really changed Pierre's life. Yves took Restany like Grant took Richmond. He changed overnight. Yves was so magnetic, there was such a sense of urgency in him, an immediacy, Restany was ready for that. In 1961, Restany was a poet and art historian, living with Jeanine Goldschmidt, whom he eventually married. She had a gallery called Galerie J., and she tried to include some of the Dada artists involved with the Nouveaux Réalistes. But she could not get all the artists because they were represented by other galleries, so she enlisted Pierre's help. As a good art historian, Restany organized a New Realist show and gave it the title *Forty Degrees Above Dada*—forty years after Dada. Yves didn't like it.

Remember, among the New Realists, Yves was quite different. He was more mystical than Neo-Dada. He was a kind of mystical spiritualistic artist, involved in different things like the Rosicrucians, astrology, and some particularity of Christianity, clouded ideas like that. He was not really a Dadaist; that movement was not mystical or religious at all. So when he saw the title *Forty Degrees Above Zero*, he got mad and naively (Yves was both shrewd and naive) decided to take over by replacing Restany with new art critics. He invited Gassiot Tallabot, Alain Jouffroy, and two or three other writers of the time. Klein excommunicated Restany in the same Surrealist manner experienced earlier by André Breton by his peers.

Now, remember, the New Realists was made up of three groups of artists: the Parisians, or poster artists; the Swiss, including Jean Tinguely, Daniel Spoerri, and by association to Tinguely, Niki de Saint Phalle; and the Niçois, to which Klein tacked on Martial Raysse. Raysse did not really fit in with the group at the beginning. There was a big brouhaha about him. The poster artists, especially Raymond Hains, did not want to accept Raysse because they were not familiar with his work. They went to the attic of the house where Martial lived to see his work and they shouted, "This is Surrealism not New Realism. We do not accept it!" This turned into a heated discussion and Klein struck Hains. The movement was dissolved twenty minutes later, after everyone had signed the manifest by Restany stating New Realism equals new perspectives and approaches to the real.

Yves Klein was such a bully. He was my best friend but intellectually I didn't like these things, and I sided with Restany. I was the only one. Yves was very angry with me, we didn't speak for several months. The price of reconciliation was that I was the first model for the experimentation of the blue figures. His reconciliation with Restany also came in a very strange way. In September, we had an exhibition called *L'Objet* at the Museum of Decorative Arts in Paris. Yves Klein showed a Sputnik satellite, and I had a bubble. Restany thought that bubble was fantastic. He was writing for a small magazine called *Planète*, and he told me, "I will reproduce a photo of the bubble because it's the most interesting object in the whole show." For me, it was incredible, because at that time, in 1960 or '61, I didn't have

much coverage. A photo in a magazine was fantastic. When the magazine appeared, three months later, it was the Sputnik of Yves Klein. I called Restany and said, "Why did you do that?" Restany said, "You know, I had to. Otherwise Yves wouldn't speak to me any more." I called Yves and said, "You're too much. You have all the coverage. I'm waiting. I live in Nice." He said, "You understand nothing. I have to succeed first, and after I will pull you along." He died one year later, in '62.

SH: Ben Vautier says that you first learned about the Gutai Group from Klein. Ben says that when Klein was in Japan in 1952, he saw Gutai performances and monochrome paintings, and that when he came back he started making them himself.

A: No, that's not true. Absolutely not, because the first time Yves spoke about monochromes or showed me something about monochromes was in '48. It was a design, a circle all in blue already, on a piece of cardboard. He told me that would be the future of painting. And when he was teaching judo in Spain in 1950 and '51 he had already prepared a show, a small show of monochromes, and a book. He didn't make much, but the idea was there already.

Before going to Japan, Yves had some idea about monochrome painting. When he was in Japan in 1952 and '53, he got some of the Gutai

catalogues and when he came back he gave me one, which I gave to Ben. In the catalogue were different performances: like going through paper, like little things of colored water hanging, like a can of food (it looked like a can from the American army), like walking on things, like crawling in the mud.

SH: Did Manzoni's cans of shit [fig. 39] come just after your invitation to *Le Plein* [fig. 65] [the invitation was printed on small tins of refuse] in 1960? Do you think that your cans influenced his?

A: Not the contents, but maybe. I don't know.

SH: According to Spoerri and Vautier, Manzoni was known for pinching ideas, but they both thought he used them well. Do you agree?

A: Yes, it was a little bit like that. But he had his own views—in the very few years that he was working, he had a certain direction like the long line or the base for the world. In my opinion, he was the first pre-Fluxus artist. He was more Fluxus than the New Realists. He's more in the direction of Ben, George Maciunas, George Brecht, all those Fluxus artists.

SH: Did you know about Rauschenberg and his Combines at that time?

A: Well, maybe as early as 1959 we had seen some of them. I met Rauschenberg in Paris in 1960.

SH: Do you remember seeing Rauschenberg's *Bed* in the *Exposition inteRnatiOnale du Surréalisme?*

A: Yes. I remember seeing it very well. We were walking on the sand, it was very special. I was very impressed by that work. But you know something about the Combine paintings? You remember I was influenced in 1953 or '54 by Schwitters. Someone else was, too. Rauchenberg had his white painting show at Betty Parsons on the same day of the opening at Sidney Janis of the first big Kurt Schwitters show. He told me that; he said that. It changed his life, too. The change is very clear. You see the dates of his work, the first Combine paintings are all '55. I really think it changed his life.

SH: In your accumulations, were you intentionally commenting on waste in our consumer society?

A: Well, it was just a sign of the times. I started that in Europe before coming to America. It was both pleasurable—as I've always been an accumulator myself—and a criticism. The first pieces I made with household garbage were in 1959. And I did some in 1960 and '61 [see fig. 57]. Then I made some special ones in '62, like the garbage of the Gallery Dwan. But I didn't make many pieces. Only thirteen still exist. At the time I was making them in small glass containers, and I would say the quantity of garbage of a French household for two days was enough to make a piece that was two feet by one-and-a-half feet by four inches, with dust, little pieces of glass, little bits of thread, a box from

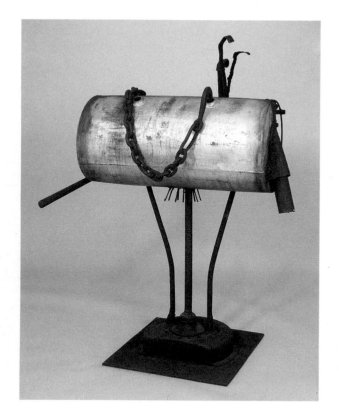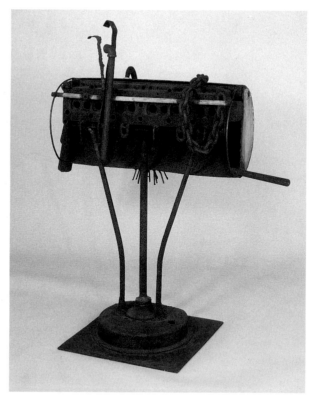

56 RICHARD STANKIEWICZ

Railroad Urchin (two views), 1959.

Camembert cheese, things like that. The quantity of garbage was very small. It took two days to fill up a case like that, from a normal three-person household. Ten years later, in 1969, when I was living in California, somebody showed me some mass-cast plastic. You could make a solid piece, that is, curing in mass. So I didn't have to do it in layers like before. In 1959, '60, and '61 when I was doing garbage, I had to remove the organic material because it would begin to rot and smell. By 1969, the garbage was totally different. It was about three or four times larger, and the colors, the contents, the containers, the plastic, and the packaging, and everything was so drastically different. What is more amazing, when I made similar pieces in Italy and France, they began to look exactly the same as the American garbage. Same color, same quantity, same material. Even the same products. That means that in those ten years the Americanization of consumption by supermarkets took place. It was quite incredible.

You know, a lot of people came to the opening of my first show in New York [at the Cordier and Warren Gallery, 1961]. I didn't even know Warhol, but he came to the opening. I saw him there, though I didn't meet him until a few months later. Everybody was there. Rauschenberg attacked me verbally, very violently stating—and I didn't understand, I had to have it translated—that random accumulation is not art. It's too random and too automatic to be art. He was really offended by my show.

SH: What was the situation surrounding Yves Klein's show in 1961 at Castelli in New York?

A: It was badly received for one reason: Yves's attitude was possible in Paris given the legacy of showmanship à la Dali, or Mathieu, but it certainly was no longer in fashion in New York.

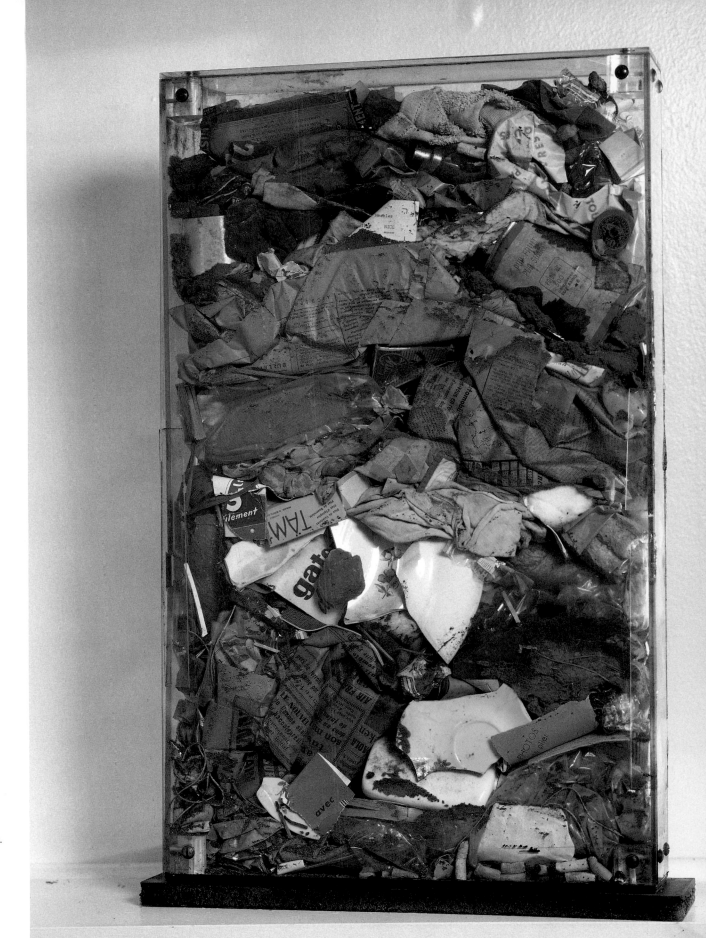

57 ARMAN

Grand Déchets bourgeois

(Large Bourgeois Trash), 1960.

Here in New York the situation was different, there were two new generations—the Pop artists and the assemblagists—flexing their muscles and understanding they were doing something important and different from the generation of the Abstract Expressionists. Everyone was talking about "serious" artists. To arrive with a cape and act like Dali didn't give the works an aura of seriousness and was certainly not well-received. The urge to create something, the complete and total work, was required as a mood in New York. Yves was certainly very serious in his work but to arrive dressed as the Knight of Saint Sebastian with cape and all was absolutely ridiculous! Everybody thought it was a joke, and he was very offended.

Once, after that, Yves was at an opening at Tibor de Nagy Gallery and John [Bernard] Myers, the director of the gallery—he was quite a big guy, very witty and gay—started to mock him. Yves spoke English very well. And Myers was taking advantage of that, being very witty. He said, "Aha, blue boy, how are you. Where did you leave your fan?" Yves had actually said he was going to buy a fan. So Myers began to get on Yves's nerves. And Yves, as you know, was a master of judo. He was quite physical and strong. And when he was close to John Myers, he gave him a punch in the stomach, and the guy collapsed on the ground. Nobody saw what happened exactly but everyone became extremely malevolent. They said Yves was a fascist and a

Nazi, and they started a campaign against him. It didn't help anything, you know.

SH: And wasn't Klein also negotiating with Ad Reinhardt and Barnett Newman, carving up the monochrome territory?

A: Yes, and that was very clumsy. It didn't look serious to say, "Okay, you take the lights in monochrome, I'll take the . . ." Oh, so what! It was maybe not the place and the way to do it. He did not leave a good impression. But in California, Yves had a lot of success. They were not phased by the pomp and circumstance.

SH: Now, in 1963 didn't Martial Raysse send you a letter after seeing the *New Realists* show, telling you that the French art looked small and insignificant in comparison to the big paintings of the new Pop artists? And he supposedly also told you that Warhol was ripping off your accumulations with his repetitions.

A: Ha! More than that! The letter from Martial Raysse—I still have that letter—has a sketch of the Warhol pieces, to give me an idea of what he was doing. And there was a note with it from Larry Rivers with a warning to Tinguely. Everybody put a note in the letter. Niki wrote, Klein wrote, all really short. You know, "Come see that. The gallery's taking your ideas of accumulation." But no, Warhol didn't really know about it. Maybe he saw the piece at Cordier in 1961; as I said, he was at the opening. But the character of his work was so completely different. Martial said, "You should do some big

silkscreens of French bread and red wine and Camembert and put a date of '58 or '59."

They were all offended that somebody took my idea. And I wrote back right away. I said, "Don't get upset. I understand what's going on. But I would never do it with silkscreen. And everybody sees things differently. I feel very secure about what I am doing." They were very offended about my response; we had a heated argument about it later. They were trying to help me, they felt. The central motif of accumulation, it's natural really.

SH: How did the *New Realists* show come to be organized? I've heard that Georges Marci enticed Sidney Janis into including the Nouveaux Réalistes. I've also heard that Pierre Restany suggested the exhibition of the Neo-Dadaists with the Nouveaux Réalistes, and felt thwarted when the younger American generation was inserted instead.

A: Well, you have to take one thing into account. Harriet Janis was very interested in two artists in Europe: Yves Klein and me. She is the one who got Sidney to see our works. He came to Paris in 1962 before the Venice Biennale in Italy. Georges Marci took him there. She's also the one who captured Virginia Dwan and introduced her to different dealers like Castelli, Sidney Janis, and others. At that time, nobody was selling anything. If you had a show and you sold one or two pieces, you were very happy. Virginia was the heiress of 3M and worth about $100 million

in 1960, so if she wanted a Rauschenberg, she bought it. She bought show after show after show, and put it all in a warehouse. Ten years later, after she lost a lot of money in the stock market, she made a lot of money selling all those works. She had amassed an enormous fortune!

Well, you have to realize that with regard to the *New Realists* exhibition, the Europeans were dealing with real objects because everybody was broke; we couldn't afford paints and canvases. We were buying at flea markets, it had a flea-market look. And the Pop artists like Lichtenstein, Wesselman, Warhol, all those artists were dealing with bright, strong color—big things. Right away, it's more attractive visually.

SH: Do you remember the term "Neo-Dada" being used much?

A: Not much, but a little bit here and there. Maybe when critics wrote it. But I don't remember which artists were called Neo-Dada exactly.

SH: Was there much tension between the United States and France during the early years of Nouveau Réalisme?

A: Oh, yes. I came here in 1961 when the assemblage show and my show were here. I remember there was something called the Nighttime Gallery on Mercer Street, where people discussed things. And I participated, so I became the focus of a violent attack against Parisian artists. I was not a Parisian! I had difficulties myself showing in Paris; it was very difficult for people from Provence. The people in the gallery were very resentful.

They felt there were good artists in the United States, but they had to show in Paris to have any stature. And they said, "Down with Paris, we're tired of that. Now we're as good as Paris at least and we don't need Paris any longer." It was a liability to be French. You could be Italian, Japanese, German, English, but not French, because Paris had been in the limelight for so long.

Despite all the friends I had, I was never invited to be in any of the shows. Except at my own gallery, Sidney Janis. When they organized the machine show, or art and technology, or group shows with a lot of artists, there was no place for me or other French artists. We were discriminated against and it's still the case today. Tinguely was very aware of that. He'd say, "Why are you staying in New York? They don't like you here. Me, I am not treated as equals with Rauschenberg and Johns. They were my friends before. I don't want to be in New York. I will never come back."

One of the first people I spent some time with in 1961 was an art critic, Donald Judd; we were quite friendly. He reviewed my show very well, very nicely in 1961. In 1963, he changed completely. After the Sidney Janis gallery show, Judd said something like, "Sidney left the peaches and took the lemons." It was no longer politically correct to support French artists.

SH: Were you aware of Stankiewicz's art by the early sixties?

A: Yes, and he was a great influence on Tinguely,

and on me with the chains and everything. We saw all these pieces in Paris.

SH: Do you think Tinguely's work really changed after he saw Stankiewicz's show in Paris?

A: His work changed after the collaboration show he did with Yves Klein entitled *Vitesse pure et stabilité monochrome.* I followed that show from the beginning. At the time, Tinguely was working on boxes in which there were little pieces of abstract shapes that were moving; it was a kind of post-Bauhaus style. They were at the Denise René gallery. And when Tinguely and Yves Klein planned that show together for Iris Clert gallery, their first plan was to make those boxes, in which those round plates had to turn very precisely. You could not see that they were moving, because a round plate that turns behind a white box . . . And Yves said, when he was working, before they put the wood box over it, "Oh, the motor is quite beautiful. You should show the motor."

SH: You heard him say this?

A: Yes. And after they discussed this, finally, you had the construction—all the gears of the motor—shown for the first time. And certainly, at the time, when Tinguely let himself show the mechanism, a vision of things he saw from Stankiewicz was embedded. Maybe. It's not sure, but, really, that show was the beginning of *Vitesse pure et stabilité monochrome.*

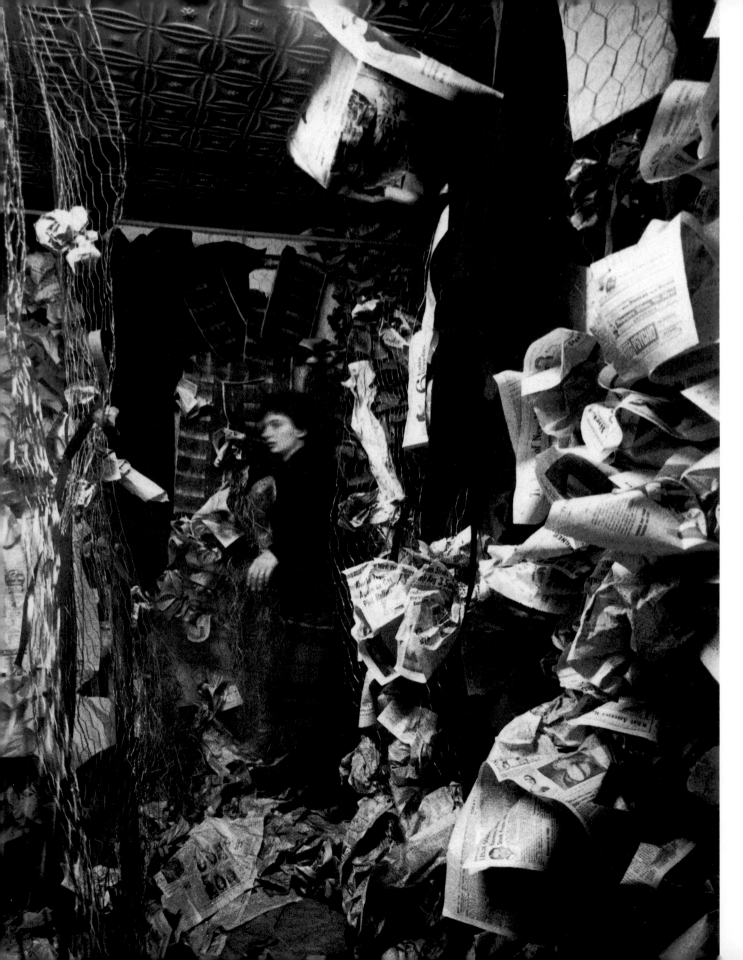

58 ALLAN KAPROW
Apple Shrine, 1960. Mixed-
media environment, Judson
Gallery, New York. Photo
Robert R. McElroy.

Allan Kaprow

*Interview conducted by Susan Hapgood,
Encinitas, California, August 12, 1992*

Susan Hapgood: Dore Ashton once called your work "Neo-Dada." Do you remember what the context was?

Allan Kaprow: She reviewed my last real exhibition, two environments that I had in succession at the Hansa Gallery in 1958. A number of the sculptures were assemblages made out of a variety of things—light bulbs flashing on and off, things that moved, paintings whose surfaces were broken up into literally separate planes in space. In other words, they were prototypes for the next step, the environmental. Her review called my work "Neo-Dada." I took exception to that because I really had none of the sociopolitical attitudes of the Dadaists. I remember one thing Ashton said in the review: "Me thinks he doth protest too much." But I wasn't protesting at all. I think that's what I objected to. I was really just having fun.

SH: You said in your essay for the *New Forms—New Media* catalogue that critics made erroneous references to Neo-Dada to describe objects, environments, and Happenings. Can you elaborate?

AK: Dada was a common reference point. To the extent that people would comment on what we were doing in that particular show or elsewhere, they would speak about Dada. It was mainly in conversation. Frequently, I thought, we were wrongly associated with Dada. Anti-art isn't something the Dadas invented. There's a whole thread of "life is better than art" dating at least to the time of Wordsworth, right through Emerson and Whitman, to John Dewey and beyond, emphasizing art as experience, trying to blend art back into life—this tradition influenced me very much. But anti-art is an old Western theme.

SH: What about the cynical side of Dada?

AK: The cynical side was not present. If you talk about freedoms—for example, the freedom to employ open processes or the freedom to use a variety of objects and materials from the everyday world—these were derived from the prototypes of Dada. But to ascribe to me protest and cynicism—not at all.

SH: How else was the term "Neo-Dada" used?

AK: Well, it was generally thrown around as a criticism. No one said, "Oh, isn't it wonderful that you're a Neo-Dadaist." It was a criticism, not a joyous utterance.

SH: Did the active role of the audience as participants in Happenings bear any comparison to Duchamp's insistence that the viewer creates the meaning of a work?

AK: Well, Duchamp gave that speech in Texas in 1957, I think. That's where he made the famous statement that the work of art is essentially a composite of meanings added to by posterity, whatever the artist may have put down first. I didn't read it until somewhat later. Then he gave a talk at the Museum of Modern Art where he also spoke more on the same lines, if I remember rightly. I did not attend, but it was recorded and published. But he also said something else about the rash of neo-Duchampian shows. He said, "When I selected my first objects, I did not have in mind whole shows of shovels and bottleracks, because that would have killed the point." And he implied that younger artists who were just buying out hardware stores were doing the wrong thing; they would overdo it. I think we all learned from those little hints from Duchamp. A key feature was discreetness, a timing and restraint that many of us didn't learn well enough.

Duchamp was personally very helpful to us,

Allan Kaprow

no question. He came to our Happenings, most of them. He certainly came to mine, and he brought his friends, Ernst and Richter and Huelsenbeck. And, in my case, Duchamp later acted as a referee in my getting a number of grants. So he was very helpful, both practically and intellectually.

SH: In a 1967 interview, you said that Schwitters conceived Happenings but never did them. Were you referring to his descriptions of Merz theater?

AK: What I learned about Schwitters was simply what was available to me through books: about his plans for theater, about his performances, about his wordplay. But I never heard or saw any of them. So, as far as I knew, most of them were cabaret-style performances, not Happenings. As much as they may have been capable of being Happenings, they never evolved to that point.

SH: Why do you believe artists used detritus and junk in their art?

AK: It was clearly part of transforming reality. It gave everyone a sense of instant involvement in a kind of crude everyday reality, which was quite a relief after the high-art attitude of exclusion from the real world. It also allowed us to give up a certain kind of seriousness that traditional art-making required. What's more, the materials were available everywhere on street corners at night. And if you didn't sell these environmental constructions, you'd just throw them back into the garbage can. Why not just throw them out? At once, the process in its fullest would be enacted. It was very liberating to think of oneself as part of an endlessly transforming real world.

SH: The element of getting away from tradition, couldn't that be called an anti-art gesture?

AK: Yes. *Now* I know it could be, but I didn't

then. At that time, I didn't like the idea of giving up a sense of art.

SH: In retrospect, there does seem to be some subtle protest.

AK: But the protest was not against society, it was against traditionalism in art. You might remember that this was during the Eisenhower years, and there was a powerful conservatism operating that began to repudiate Abstract Expressionist attitudes and anything attached to the European tradition of art. Even *Art News* and editor Tom Hess were going all out to celebrate a return to the figure and the "sanity-in-art" movement. "Sanity" meant reverting, not only to the figure, but to European prototypes of painting and sculpture; supposedly, this would reinstate humanitarianism and the great traditional values that had been forgotten. That was what we were implicitly protesting against. Under the aegis of de Kooning, even many of the Hofmann students who had been abstract artists were reverting. Matisse and German Expressionism were recalled again. To me, that seemed less interesting than experimental work. So you could say we were protesting, some of us.

SH: Did Rauschenberg's comment about working in the gap between art and life reflect a prevalent attitude at the time? Was it a prescription that artists followed?

AK: No, it became famous later on, but I would be very surprised if anybody even knew about it when it was first uttered. It was basically a prevalent attitude. I've tried to rephrase the attitude myself, not wishing to act in that gap, if there is one, but pushing it more toward the life side. I'm not too interested in gaps.

SH: One of the earliest Neo-Dada artists was Jean Follett, who was also one of the first artists

to make junk sculpture when she integrated gritty found objects into her works in the early 1950s. What do you remember about her?

AK: I met her in 1947 when I was a student at Hans Hofmann's School of Fine Arts in New York. She stood out from all the other students; her drawings looked like Picabia drawings and were unlike the very strong Hofmann style. Hofmann would often literally draw over our work, but he never touched Jean Follett's. He would get to Jean and he would just look at it, and almost invariably say, "Ja, das ist sehr gut, sehr gut" [Yes, that's very good, very good].

In 1949, two Hofmann students (Wolf Kahn and Felix Pasilis) organized a group show of certain graduates of the school at a kind of a semi-private gallery in their loft at 831 Broadway—I don't think there was a name. That's where I first saw Jean's sculptures. Shortly thereafter, this same group got together—and Richard Stankiewicz was very helpful—to form the Hansa Gallery, which was named partly to elicit the Hanseatic League, a loose federation of medieval North German states, and partly to honor Hans Hofmann. I joined Hansa in 1952.

Anyway, Jean Follett's works impressed *everybody*. But we also thought she was "crazy" because she put huge prices on them, prices that seemed astronomical! But we thought that she was absolutely a wonderful artist, very very powerful. Her show was one of the most widely attended. Even Leo Castelli came to the gallery, as did Clem Greenberg. I know that Dubuffet came to New York for a show at that time, and somehow or other she got him to come to her studio and he was mightily impressed.

SH: Do you remember when you first read Motherwell's Dada anthology?

AK: Yes. I was at Columbia in 1951 and '52, taking classes with Meyer Schapiro. I was most interested in Mondrian at the time; and we were just getting used to Abstract Expressionism, which had peaked by then. Dada wasn't particularly interesting to most artists. Motherwell's anthology, *The Dada Painters and Poets*, came out in 1951, but I didn't read it immediately. It was a little later before I was really very immersed in it. Probably within the year. And once I read it, of course, I found Dada, as presented by Motherwell, to be much more interesting than Surrealism. Then there followed a whole lot of publications and artists' revived interest in Dada.

I didn't meet Rauschenberg until 1952, but he was another important link to Dada. As was George Brecht, who was my neighbor in the early 1950s. I was teaching at Rutgers at that time, and George Brecht was working for the Personal Products Division of Johnson & Johnson, in New Brunswick [New Jersey]. And Bob Watts was part of the Art Department at Douglass College, the Women's College of Rutgers. George Segal was also a neighbor. All of us lived in the New Brunswick area.

SH: Did you talk to Brecht about Motherwell's anthology?

AK: Well, he had an earlier interest in Dada. He was doing work at that time—which I remember very vividly—that encouraged chance operations. For example, he once brought an eight-by-four-foot masonite panel and several boxes of wooden matches over to the farm where I was living. He laid out this panel on the driveway and casually threw matches over the surface. Then he tossed a lit match among them and they all burst into flame in some kind of random pattern. Then we lifted up the panel and the matchsticks fell off, leaving burn marks. This was his way, one of many, of trying to produce paintings that dealt concretely with what he felt Pollock was all about. He even wrote an essay on chance, which dealt with his interpretation of Pollock, essentially saying that Pollock was interested in giving up organizational techniques. But Brecht was more interested in a kind of randomized dispersion principle. I remember him showing me tables of random numbers. For him, Dada was a celebration of chance, or the appearance of chance.

SH: This is before John Cage's class.

AK: Right. He joined Cage's class just a bit before I did. In fact, we used to drive into New York City together. But I had known Cage earlier. Not well, but over the years I'd met him here and there and was part of the periphery of his circle, because I was familiar with Jasper [Johns] and Bob [Rauschenberg] and a lot of the musicians that Cage knew, like composer Morton Feldman. It was a very small group of people in those days. I attended Cage concerts as early as 1948, when he was diddling around with the prepared piano, and all kinds of toys and gadgets to make noise. I made a decision then to concretize my work by having a real action or activity take place. For example, hammering a nail or blowing your nose would be self-evident. It wouldn't just be the isolated feature of one sense being recorded.

Cage's teaching was sophisticated philosophically. From his own sensibility and from Zen Buddhist readings, he learned that the experience of the present is a combination of receptivity and action. For Cage, concreteness wasn't the isolation of one feature of a situation, framed out of context; it was actually an experience, like that [hits table]. That sense of the experiential moment was a clarifier for me. Once I realized how simple the whole thing was, it was only a matter of taking off as fast as I could in the direction of Happenings. (I did my earliest ones in his classes in 1957-58.)

SH: Did Cage talk directly about Dada in the class?

AK: He mentioned it now and again. I know that he was familiar with all of those people and certainly he knew Duchamp.

SH: Is it fair to say that by the latter half of the 1950s there was a major shift of interest among artists from Surrealism to Dada?

AK: Surrealism was interesting to the previous generation of New York School painters, and we sort of "got it" through over-saturation. But it was their thing, and very European. When Dada came along, there were few objects to see, it all seemed really very far-out, although we didn't necessarily understand its sociopolitical programs. We did not think, as the Dadaists did in 1916, that the world had gone crazy and there was no redemption in sight—its current of cynicism. Rather, we felt that here was freedom to put the real world together in weird ways. It was a discovery, a heady kind of appetite for debris, for cheap throwaways, for a new kind of involvement in everyday life without the judgments about it, either social or personal.

SH: Did John Cage's ideas about chance develop directly out of his knowledge of Dada and Marcel Duchamp?

AK: No. He claimed that his interest in chance derived from his study of Zen Buddhism, even though Zen Buddhism has no tradition of chance whatsoever. I think for Cage it was the open sense of an unwilled grander design in the

117

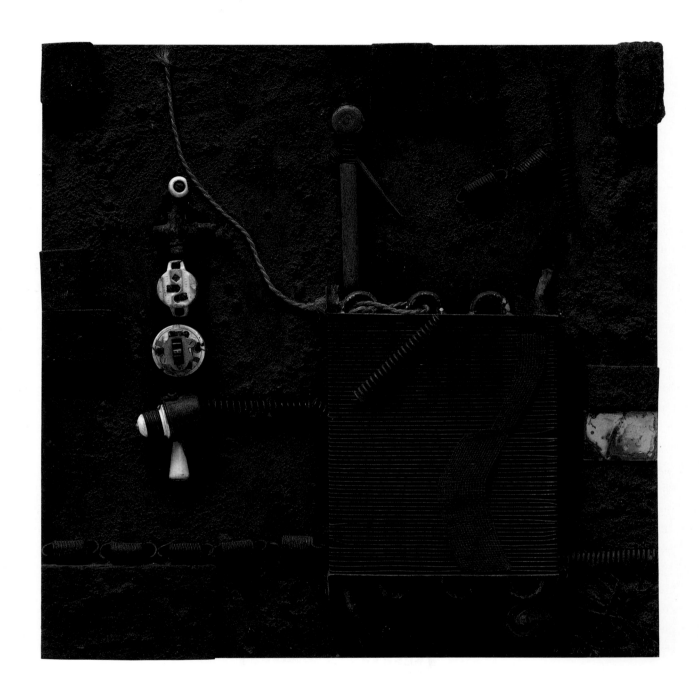

59 JEAN FOLLETT

Many-Headed Creature, 1958.

universe, one in which an experience is more important than knowledge of the grand design. For me, Cage's teaching was a real gift, an opening-up rather than a prejudice or a gimmick. But it was threatening to a lot of people because it meant losing control.

SH: Did everyone read books on Zen? And which books were the most widely read?

AK: The grand message-bearer of Asiatic philosophy and religion to the Western world was Daisetzu Suzuki, a transcendentalist and former student of John Dewey. He was an admirer of Ralph Waldo Emerson and all the American philosophers, and he felt their work represented a kind of analogy to the Japanese view of the world. Suzuki was really the bridge, more than anybody else. Cage attended Suzuki's lectures on Zen Buddhism in the Philosophy Department at Columbia University. Those lectures and readings certainly helped Cage clarify his own point of view. Now I didn't attend those lectures. In Cage's case, the whole notion of chance was a result of putting together a lot of readings: Thoreau, Emerson, anarchism, as well as Asiatic philosophy, and the *I Ching*.

So the answer to your question about how the chance operations evolved is: through Cage, as well as an awareness of Dada. He was very informed about Dada, a real intellectual. I'm sure he was aware of Duchamp's use, and Arp's use, of chance operations. I remember reading in Motherwell's Dada anthology, and also in the Lebel book, how Duchamp made part of the *Large Glass* by shooting paint-dipped matches out of a toy cannon: where they landed was where their marks went. In any case, the question is a complex one that, to my knowledge, has never been asked—how did the system of

chance operations evolve? All I know is that by the time I met Cage, I mean when I was going to the class, it had already been worked into a system.

SH: Wasn't your interest in the Gutai Group related to this idea of chance? Do you remember how you heard about the Gutai activities?

AK: Alfred Leslie told me about an article he had read in the *New York Times* [Ray Falk, "Japanese Innovators," *New York Times*, Dec. 8, 1957, p. 24ff.]. It was in the Sunday paper, but I hadn't read the *Times* that particular Sunday. Leslie saw I was moving into a kind of wild spatialized collage/assemblage mode, and he said, "Hey, did you read about this?"

SH: So the article was sort of a passing curiosity, then?

AK: Oh, it was a prominent article! Brecht must have heard about it, because the work he was doing paralleled the various Gutai environmental and action-type pieces. He must have read the article in the *Times*, and I would guess that Bob Watts would have, too.

SH: Your own article, "The Legacy of Jackson Pollock" [*Art News*, Oct. 1958], was published the following year and also created something of a stir, didn't it?

AK: Well, I got some feedback from people in my circle, like my editor, Tom Hess, who took a rather dim view of my very eccentric interpretation of Jackson Pollock as someone whose work led to conventional repetition or to what many felt was a kind of Dada junk.

It was written in its entirety after Pollock died in 1956, but then I reworked it slightly later. I gave it to Hess in 1958, within a month of finishing the rewrite. But he held on to it for reasons of caution before he published it. Then he

finally made up his mind to publish it, and I asked for it back to correct a few errors.

SH: I think the part about art employing any materials necessary is very impressive considering that it was written in 1956. Were you familiar with Schwitters's work by this point?

AK: Yes. What was unusual was the jump that I made from quasi-painting work, like Schwitters's, in which the common metaphor of art and the world was closure, to a kind of environmental phenomenon, open to everything because it was so big. That was a really extreme leap. Painting seemed unnecessary to anyone who wanted to experiment. I didn't, of course, say that it was over; it certainly wasn't. So in the Pollock article, I proposed that artists could go in one of two directions: to further develop action painting, or to work environmentally in lifelike situations.

SH: Oldenburg was supposedly especially struck by that article.

AK: Yes, he told me that later, but I didn't know him then. The first time I met Claes was at a party at George Segal's farm. He didn't say anything about the article, but did tell me how interested he was in what I was doing. There were some performances at the farm that day, and he was definitely very curious. That probably had something to do with his decision to become a Happener.

SH: In the Pollock article, you use the term "concrete art." And in a brochure for a Hansa Gallery show the same year [1958], you juxtapose the words "abstract" and "concrete." How were you using those terms?

AK: I borrowed them from music. *Musique concrète* was a postwar phenomenon, partly inspired by John Cage, but more well-known in France

and Germany. There was simultaneously an interest in Europe in the non-abstract aspects of music and in the specific, identifiable sounds of somebody hammering or a flushing toilet. Tape recordings were new in those days, a product of the war. With tape, you could make a recording of your footsteps and then manipulate it as much as you wanted. The French were not interested in making these sounds into abstract music but in retaining their very specific concrete identity. So that's what I had in mind: that *musique concrète* would then suggest a parallel in art—*art concrète.*

SH: Dick Higgins has said that the general nature of the performances at the Reuben Gallery were different from those at the E-pit-o-me Coffee shop, and that the latter were more allusive. Is that true? Was there a significant difference?

AK: What I do remember from the few times that I went to the E-pit-o-me was that the performances tended to be more like cabaret performances than Happenings. They were prototypes of what we would call "performance" today, where you get the *auteur* or *auteuse*, the singular actor or actress, doing a number. But the Happeners—at least Claes, myself, Red Grooms, and Whitman, Vostell, and later Knížák, I think—were much more involved in the physical materiality of things, pushing furniture around, hiding things, moving people in and amongst environmentally filled areas; like a literalization of, say, the clottedness of an Abstract Expressionist painting.

SH: Supposedly in 1961 you had a disagreement with Oldenburg about Happenings. Is that worth talking about?

AK: It wasn't all that terrible. One day, after some wonderful performances at one of our storefronts, in the days when we were still in a group, Claes and I were walking down the street. He said to me that he had heard from Jim Dine or Bob Whitman that I didn't think his work was a Happening. And I said, "Yes, I don't think it's a Happening, I think it's expressionist theater. But don't get me wrong, I think it's wonderful theater!" So we had what amounted to a real parting of the ways right there, not necessarily cordial. Then, weeks later we were in a show at Martha Jackson Gallery [in May 1961] called *Environments, Situations, Spaces.* That's where I did my tire environment *Yard* in the back yard. Well, the gallery organized a little supper for us on the evening of the opening. And each of us delivered a little speech, probably inspired by the old Dadaists. In any event, Claes said something that cast a pall over what we were doing. And I got the impression—though it might have been my sensitivity—that it was criticism directed at me. So I wrote him a somewhat angry letter and said, "Okay, I'll take you on anytime"—something foolish like that—"and we'll see where it goes from there." The next few years we went different ways: Claes became famous and I withdrew more and more from the art-exhibiting world, although I was hardly suffering.

I suspect our disagreement was more over

theoretical interests. I wanted to define what I thought were the experimental possibilities in art at that time. For example, he rehearsed people well after I gave that up. He had specific time slots for the pieces, at a time when I was seeing that as a dead end. He confined the performance area while I dispersed it. He definitely had audiences, when I was trying to integrate everything. Really, it was like two guys talking two different languages who, I believe, had admiration for one another.

SH: Do you agree that by 1961 there was a shift toward a cleaner, slicker look in art, especially in the work of emerging Pop artists?

AK: Sure. One of the things that happened was that the Abstract Expressionists were finally beginning to make a sizable impact on the market. Nothing like today, but for artists in those days to sell something for three or four thousand dollars was a bonanza. But the idea that an artist could in fact make a living off art had never been even remotely thinkable before, certainly not for experimental artists. Now there was a different idea. I remember one particular article in *Fortune* magazine that advised collectors how to make more money buying modern art than they could in the stock market. And they actually gave tables of appreciation over a five-year period. Like, buy Larry Rivers because it was no longer affordable to buy Pollock or Newman or de Kooning. And the art market began to pick up everywhere, including a market for work by younger artists.

Symbolically, Pop art developed when Andy Warhol discovered he could move from the commercial world, in which he was quite a figure, to the fine art world and not suffer a disruption of identity. He just had a more sophisticated audience at that point. And, therefore, it was probably no accident that my friend Roy Lichtenstein gave up the Abstract Expressionist paintings he was doing at the time for something that was always present in his work but latent: the investigation of popular imagery and methodology. And as it turned out, it was very marketable.

SH: Do you recall why Yves Klein's 1961 show of blue monochromes at Castelli was boycotted?

AK: Well, I know that he was not well-received, but that is largely through hearsay. I gather this not from the show, because I didn't see it, but from the reviews. He was repudiated for two reasons: one was his showmanship, and the other was his reputed association with a conservative political group, the Chevalier de la Croix [in 1956 he was made a chevalier, or knight, of the Order of Saint Sebastian], or something like that. He was both star and impresario, a dual role that has a great tradition in Europe, but which in America was associated with Broadway, razzle-dazzle, and the lowest common denominator.

SH: When did you become aware of the Nouveaux Réalistes?

AK: I became aware of the New Realists when Pierre Restany organized the show in New York in 1962. It was at two different places. One was a rented storefront on 57th Street, and the other

was Sidney Janis's gallery nearby. I became very interested, and in fact went to Paris the next year; there was a whole new set of people I wanted to meet. I did, in fact, and they were all very helpful. I met Spoerri right away. And Emmett Williams, who was living there at the time, and Jean-Jacques Lebel, and Robert Filliou. I became part of what I thought was an international association of artists. A number of the Japanese artists were in Paris then, so it was very international.

SH: Did you feel that there was a strong American chauvinism against Europeans between 1958 and 1962?

AK: To be as fair as I can, I would have to say that there was simply a very grateful sense that, at last, American artists were not deriving from somebody else. It was nice to feel that one was coming out of something personal. But we did not repudiate others, because obviously and logically they had just as much right to their ethos as we did ours. As I said, for us, the international sense of community was far more interesting than isolation. Some of us, after all, had a historical sense of what isolation had done back in the 1930s and '40s, and we didn't want to repeat that kind of silliness. So I was aware of some jingoism in the art world, particularly the distinctly nationalistic way in which Rockefeller and others resuscitated modern art, taking it from being the bad boy of American culture to being the exemplar of freedom. It was packaged for all over the world as a repudiation of Communism. Now this kind of turnaround was offensive to a

lot of us, although we weren't taking positions of ideology either.

I think I shared the common attitude that some of the European work seemed tame, and precious. However, much New Realism was a breakthrough for the Europeans. Yves Klein, Vostell, Vautier, Spoerri, Tinguely, Filliou . . . hold up very well today.

SH: In retrospect, what effects and influences do you think Happenings had on immediately subsequent art?

AK: Well, the effect must have been indirect, if at all, because very few people actually saw them. But if you can say things are in the air, that sometimes you don't have to read the book because you get the whole idea just from gossip, then in this case permission was in the air. It's possible to say with some caution that the Happenings allowed a good bit of Fluxus to take place, just as Gutai provided some justification for the early Happenings. You can also say that earthworks, particularly earthworks that were site-specific, were given their permission by the earlier example of Happenings, although they had nothing to do with each other directly. I think Happenings—especially things going on in multiple spaces at different times that were not physically connected—gave permission to conceptual art, the "live in your head" approach. Unfortunately, now there's a kind of new piety that's being brought to bear by critics and historians upon our work which was so irreverent at the time!

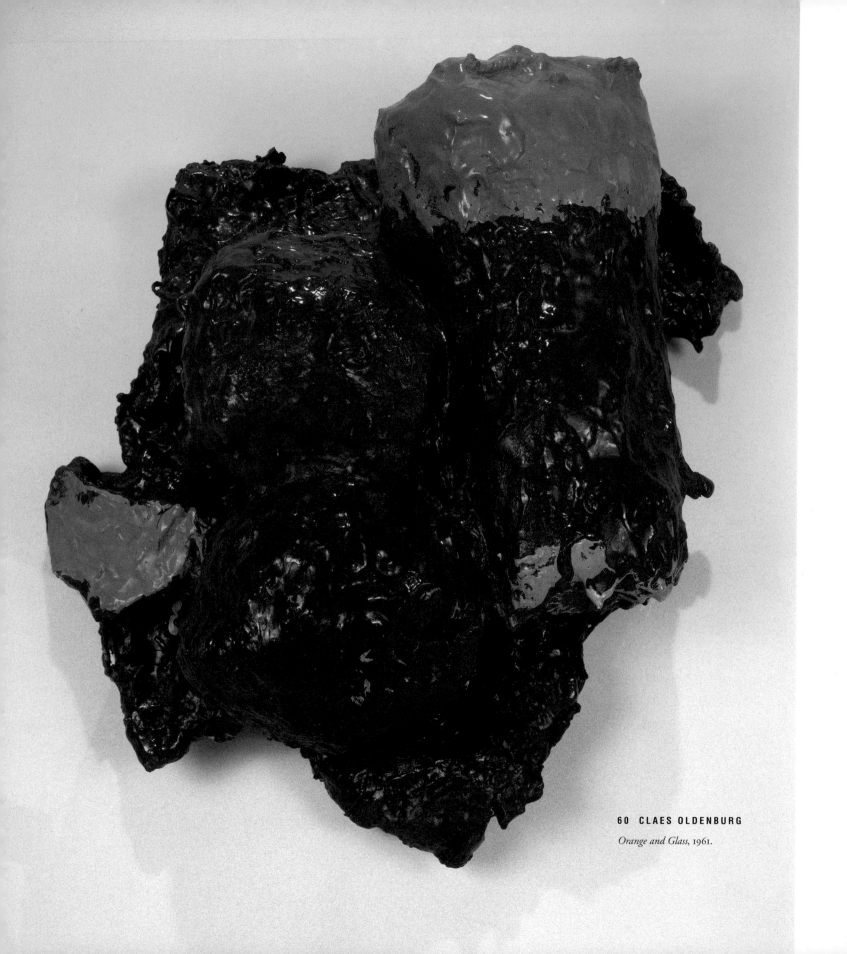

60 CLAES OLDENBURG

Orange and Glass, 1961.

Claes Oldenburg

Interview conducted by Susan Hapgood,
New York City, March 1, 1993

Susan Hapgood: Do you remember the term "Neo-Dada" being used by artists in the late 1950s and '60s, or was it primarily used by critics?

Claes Oldenburg: I don't remember the term "Neo-Dada" being used by anybody. I mean I've probably just forgotten or blocked it out, because I see that here in the Tillim article [Sydney Tillim, "New York Exhibitions: Month in Review," *Arts*, vol. 37, no. 2, November 1962, p. 36] it's used over and over again. I must have known about it, and I probably reacted against it. Any artist would react against an attempt to take a label from the past and put it on what they're doing.

SH: Kurt Schwitters's essay on "Merz" was widely circulated in the mid- to late 1950s. Do you remember reading it yourself? It was included in Robert Motherwell's *The Dada Painters and Poets*, published in 1951.

CO: No. I just read it recently for the first time in Elderfield's book on Schwitters. I didn't know very much about Schwitters. That particular text I don't remember reading, though of course it was thirty-five years ago. I remember people saying that Rauschenberg had something in common with Schwitters. I think Rauschenberg would make remarks like—just to paraphrase—art can be made out of anything. That was a very inspiring thought. But I think that idea came to my generation through Rauschenberg rather than Schwitters. There are two things that Rauschenberg said that affected me. One was the statement about working between art and life [first published in Alan Solomon, *Robert Rauschenberg*, Jewish Museum, New York, 1963]. The gist of the other statement was that you can go stand in an empty lot and make art out of what you find there. In retrospect, it looks to be what Schwitters did, but on a smaller scale and

more formally. But as I say, that would have come to me at that time more through Rauschenberg.

SH: Do you remember seeing the Schwitters shows at the Sidney Janis Gallery?

CO: No, I don't remember any contact with Schwitters at all.

SH: Barbara Rose has written that you were "especially struck" by Allan Kaprow's article "The Legacy of Jackson Pollock," [*Art News*, October 1958]. Do you remember reading this piece?

CO: Well, I don't remember it at this point. That's why I had David [Platzker, Oldenburg's assistant] bring it up. Well, I see here it says [reading the article], "Pollock . . . left us at the point where we must become preoccupied with and even dazzled by the space and objects of our everyday life, either our bodies, clothes, rooms, or, if need be, the vastness of Forty-Second Street. Not satisfied with the *suggestion* through paint of our other senses we shall utilise the specific substances of sight, sound, movements, people, odors, touch. Objects of every sort are materials for the new art: paint, chairs, food, electric and neon lights, smoke, water, old socks, a dog, movies, a thousand other things which will be discovered by the present generation of artists." Okay, that sounds familiar. ". . . Found in garbage cans, police files, hotel lobbies, seen in store windows and on the streets, and sensed in dreams and horrible accidents, etc." Okay, that I remember. I probably was more interested in that section than I was in his interpretation of Pollock.

When that came out, in October of 1958, I was mostly doing figure painting. My first group show was held at Red Grooms's City Gallery in

December of '58, just before Christmas. Red, I think, was a source of the same kind of thinking. Except he would put it into figurative compositions rather than abstract compositions. Of course, he also showed at the Hansa Gallery, and probably didn't have close connections with Kaprow. He was involved with another group of more expressionist artists. But I thought Kaprow at that point was rather expressionist, too. I met Kaprow for the first time in the summer of 1958. I saw him at an early event. I was taken to George Segal's farm, and I saw Kaprow there. He was trying to organize a performance in the course of a party, and he was very angry because nobody would cooperate, and they made fun of him. That was when I met Bob Whitman, too.

I continued to paint figuratively through '58 and my first show was at the Judson in May of 1959. I had initially planned the Judson exhibition as a figurative show but changed it to enigmatic objects that were quite transformed, though not really Dada objects. They didn't actually use street material; they were made of paper and wood, and whatever other materials were lying around. I had collected a lot of material from the street, but as a principle I never use collage. I never used found objects, either, except in performances, and that was later on. And I didn't keep them after the performances. I mean I never mounted found objects the way Schwitters did, or Rauschenberg did, or any number of other people did, because I didn't like

collage. I like to make my own work, I don't like to put things together. To me, that's not exactly creative. It's too easy to put things together. So I prefer to make things. Even if I use an object, I remake it. This is an important distinction.

SH: Dick Bellamy has said that in the late 1950s everyone studied Duchamp. But he also admits that he really didn't understand Duchamp's importance at the time. Do you remember how you felt about Duchamp and Dada generally in the late 1950s and early '60s?

CO: I only had a very peripheral awareness of Duchamp; and, again, it was coming through others. It was coming through Johns, maybe, though I'm not sure exactly. You know, it was permeating the scene. Duchamp himself did attend many of the Happenings, though. He attended the *Store* Happenings [see fig. 61]. And I saw him in Pasadena, when he had the show in '63. So he was seen, just like John Cage was seen. You could go to parties and see them, and they came to all the performances. So he was certainly on the scene. But I believe that the sort of thing I was into, which really was about the very gritty aspects of the Lower East Side, was very remote from Duchamp.

SH: You've said that you do not use the found object, but . . .

CO: Well, I shouldn't say I never used found objects, because there are many saved in the Mouse Museum. Of course, that was in '72. But the Mouse Museum had accumulated. When-

ever something interesting came into the house, it was placed in the Museum. But it wasn't treated as an art object, it was treated as an artifact of culture, like an archaeological find or something. It's a different concept.

I really believe in the artist's responsibility to make things, to transform things, so I could never have accepted the readymade.

SH: And you still feel that way?

CO: Oh, yes. I mean, for my own purposes.

SH: Between the first and second incarnation of your *Store*, Daniel Spoerri created his *L'Epicerie* [fig. 64], at the Addi Koepcke Gallery in Copenhagen. Spoerri's show had a front area with shelving that held grocery cans and packages that were stamped with a little round ink stamp that read, "Attention: Work of Art, Daniel Spoerri." He sold these objects for their actual prices as products, and they sold out during the opening.

CO: It's a whole different aesthetic that doesn't seem to have anything to do with my *Store*.

SH: Spoerri opened his in September '61. During that summer, you spoke with Billy Klüver about Spoerri's art, and early that fall, *The Art of Assemblage* catalogue had a text discussing Spoerri's plans for his grocery store. Do you remember knowing anything about Spoerri's store?

CO: No, and I didn't meet the Nouveaux Réalistes until later, in 1964, when I made a show in Paris and lived there. At that time, I saw Spoerri at parties and so on, and Restany as well. But Restany had come to see the *Store*; I remember I

took him around the Lower East Side in 1961. I don't remember knowing about Spoerri's store specifically, but that's the sort of thing you couldn't remember. I'd like to look it up.

SH: Did you disagree with Kaprow's definition of Happenings? I know that at one point you didn't even want to use the term to describe your performances. Also, I've heard that your performances were far more spontaneous and evocative of the contemporary urban environment than his performances, which have been described as controlled and detached. Is this true?

CO: There were a lot of people doing performances at that time, and they were borrowing from one another. You'd go to a performance, see something, and sort of transform it and use it yourself. But everybody had a very distinct approach to what they were doing. There were different emphases among the different people. I don't remember all of Kaprow's performances, but they had a certain character that you could recognize as Kaprowesque. The quarrel I had with Kaprow was that he attempted to put it all into one bag and give it a name that didn't necessarily even correspond. It seemed to me that it was a form that eluded definition—that was the whole point of it. And the name "Happening" seems to suggest something objective, something that is almost taking place by itself. Was that what we were doing? Or were we injecting ourselves into the performance and creating something closer to theater or mime?

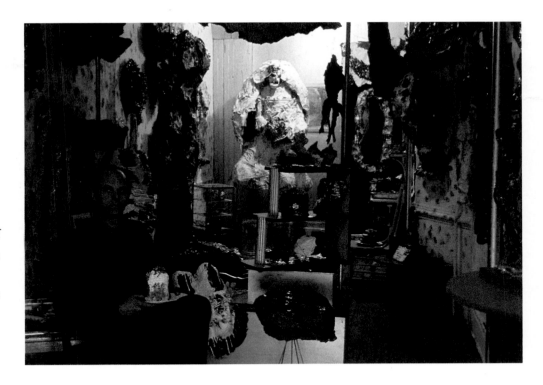

61 **CLAES OLDENBURG** in his *Store*, New York's Lower East Side, 1961–62. Photo Robert R. McElroy.

In his writing, Kaprow raised the question of whether a form existed that could do away with the subjectivity of the author. But even more extreme than that was Cage's view, or at least the view of some of the people who followed Cage, or thought they were following Cage, like George Brecht, for whom it was enough that the sun went up and the sun went down, or Yoko Ono. These people were much more inclined to accept things as they were and call them the equivalent of the readymades; hence the readymade event. But Kaprow actually put a lot of himself into these things. Many of his works were very expressionistic, and very sensational, and dramatic, and melodramatic, highly melodramatic. It seemed inconsistent with some of his remarks that they were just called Happenings. So some people preferred to call them performances, because that was more clearly what they were.

SH: Was that the term you preferred?

CO: Well, in the end, I used that. "Happening" was a great term and it set what we were doing apart from conventional theater, but after awhile everything was a Happening. I know that Bob Whitman was very precise about wanting to call them performances. That was one group of people. Then, simultaneously, Red was doing a completely different type of performance. It didn't have anything to do with Kaprow; maybe with Artaud, or maybe not even with Artaud, maybe just with the originality of Red Grooms. He was a born original. Not at all an intellectual

like Kaprow. Grooms was more like a great entertainer; he was a clown, he was an actor, he was very gifted. And then you had people like Richard Tyler, who is not very well known, but who went in the Artaudian direction, which also was the direction of the Living Theater. Judith Malina and Julian Beck ran the Living Theater and it was *the* avant-garde theater of the time. A lot of it was real theater, but theater edging over into events, particularly Artaudian events with the audience involved in suffering, violence, and emotion. But the Living Theater was never doing Happenings. This was more of a theatrical direction. My point is there was a great deal to choose from at the time. And that's why I think it's very difficult to classify the performances, to say that they were any one thing.

As a person doing a performance in 1962, I could choose from almost anything and use it for my own purposes. And I did that, because I made a kind of theater that didn't have a narrative, but was more like a poem. It had certain lines of association mixed together to produce a certain overall effect. It wasn't as direct as narration, but each particular performance concerned a certain area and a subject, so it had a unity to it. They all had specific titles. If you look at the photographs of them, you'll see that each one had a very special color and a very special set of costumes of period and identity, so there was a mixture of theater, mime, and

just pure invention with objects. It was a very wide-open, free medium.

I had another viewpoint on the art object. I was trying to think the other day where it all comes from. The idea is that the art object is a kind of corruption or perversion of a magical object. And that once upon a time in history the objects, everything, was endowed with a kind of mystical aura, and people lived in relation to that kind of perception. My feeling was that, if that really were true, there were no boundaries. It was a matter of where you found such objects, and you could find them in a dime store as well as in an art museum. So there was an idea of the art object (it's stated in *Store Days*) that transcended its use as a commercial counter, as a thing to sit in museums and so on. Now as far as I know, this idea was not shared by a lot of people. I certainly shared it with Tyler, who was very mystical, but very few other people I knew had a mystical direction at that time.

SH: You have said that Dick Tyler told you about the Gutai Group after he saw an article about them in the *New York Times* in 1957. Do you remember that?

CO: Yeah. Well, it was an interesting article, I know that everybody read it. I didn't realize it was as early as 1957. Because I remember that we talked about Gutai a lot in the mid-sixties. Kaprow included them in his book, he might have been in contact with them. But I was not in contact with them.

SH: Did you find any mystical affinities with people like Wallace Berman or George Herms when you went to California?

CO: Not really, because by the time I went to California it was 1963, and I'm talking about earlier than that. Perhaps the only person I had close contact with was Bruce Conner. I'm sure that Bruce felt that way; that was when he was doing that sort of thing. But by the time I arrived in California, the work I was doing was really edging into what you might call Pop art. And the people I met there were really different. I mean I met Wally, and I liked him very much, and I met Herms and people like that, but they were really not my main interest at that point. I thought the Los Angeles art had a stagey quality to it. I mean, you should be able to find a mystical quality in the most ordinary thing, without having it presented. It just sort of glows, it's just there, without having to arrange any special ceremony around it.

That's how I wanted my works to affect people: that they would have a certain power, that it would be irresistible, and that it would have nothing to do with commerce, or even with form or color. Essentially, I felt that if it was going to work as an object, it had to work on that very deep level. And I really don't know where that comes from.

SH: Maybe from your Nordic roots.

CO: It's probably Nordic. And maybe it's mixed

with Christian Science or with my mother's being in touch with the other world from time to time—she had a lot of friends who had seances. But then of course you have the Chicago school, people like George Cohen, Leon Golub, and June Leaf; all these people thought that way and were influenced more or less by Dubuffet. I was thinking a lot about Rouault for a time, and Céline, whose early writing is kind of incandescent. So I think all of that has very little to do with Dada.

SH: Were you aware of Beat poetry at the time?

CO: There were so many factors that coalesced around the beginning of the 1960s. You had the whole Beat aesthetic, which had nothing to do with Dada. But it was very influential on the look, the materials, the attitudes. It was about an attitude toward authority; it was anti-authority and anti-form. The drugs, the hallucinatory experiences, and all the other kinds of liberating things were contrary to the 1950s state of mind, which was very, very repressed. I was very much influenced by the Beat aesthetic, and read a lot of the literature.

Another factor, which was also anti-authoritarian, was the tremendous resurgence of comics, a different kind of comics. I'm talking about the original *Mad* magazine, that very anti-authoritarian, picturesque attitude. I grew up on the earliest *Mad* comics. They were part of the reaction to the 1950s, too. You know, there was a lot

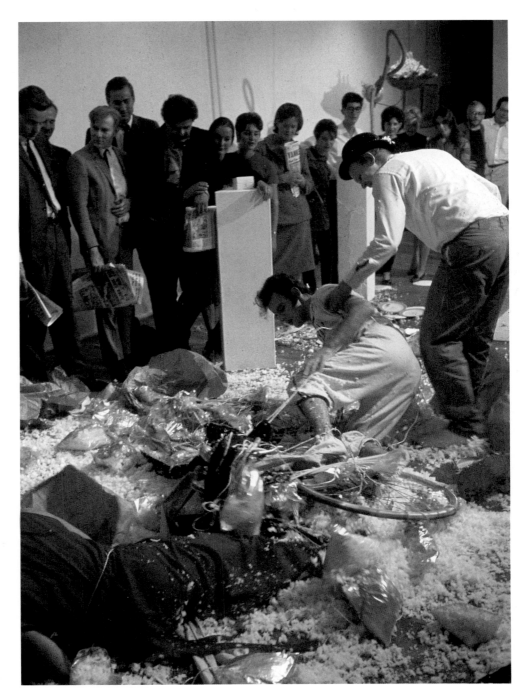

62 CLAES OLDENBURG (right foreground) at his Happening *Sports*, Green Gallery, New York, 1962. Also seen are Andy Warhol (third from left), Samuel Wagstaff, Jr. (fourth from left), John Chamberlain (fifth from left), Richard Bellamy (sixth from right), Lucas Samaras (center foreground), and Pat Oldenburg (left foreground). Photo Robert R. McElroy.

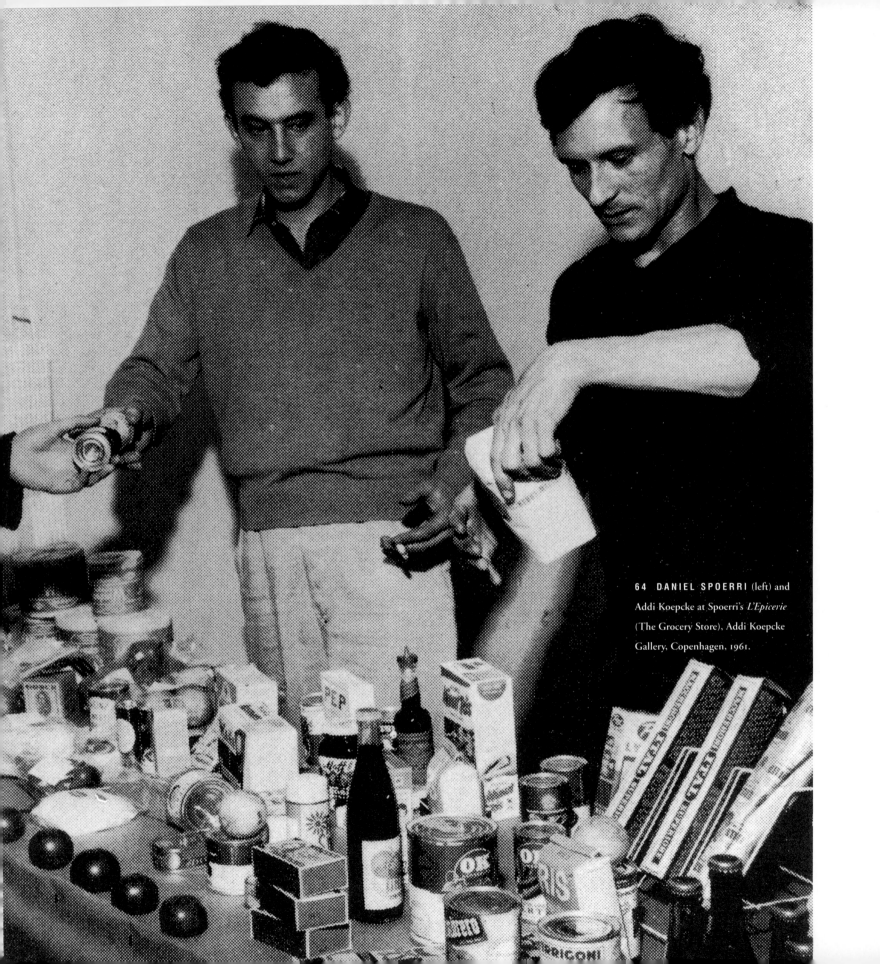

64 DANIEL SPOERRI (left) and
Addi Koepcke at Spoerri's *L'Epicerie*
(The Grocery Store), Addi Koepcke
Gallery, Copenhagen, 1961.

Daniel Spoerri

Interview conducted by Susan Hapgood,
Paris, April 26, 1992

Daniel Spoerri: We—the Nouveaux Réalistes—were not terribly pleased to be called Neo-Dada, which is understandable. There was a very deep difference between our work and the Dadaists. For one thing, provocation was very important to Dada. I would see it as a senseless network, working very precisely but with no final goal.

Susan Hapgood: Do you think that Dada inspired a lot of artists in the late 1950s?

DS: It certainly did in my case, and I can speak also for others like Tinguely, whom I knew very well. It certainly was the only movement that we really liked, that we were very much attracted to. I even translated Tzara's *Le Coeur à gaz* into German with the help of Claus Bremer. I produced it for the stage. *Le Coeur à gaz* is incredible, fantastic. From this whole period, it's probably the best piece that exists, the only truly valuable piece of automatic writing. I am very proud to know what it is about, because it is really very difficult.

Dada was the loss of trust in the senses that was also at the beginning of our century, when we lost it, when we knew that what we were seeing was no longer what we were seeing. Before, only sculpture and painting were copying reality, so to speak—false, artificial. That's why the sculptors and the artists were compared with God, because they could create artificial humans, like him. Even Shakespeare, when Hermione in *The Winter's Tale* says she was as beautiful as if she were alive, and then she is alive. That was what art should have been. Art, until the twentieth century, had to be as true as possible to reality. It had to create, like God. But in the twentieth century, everything could be something else. [Knocking on a piece of formica] That's not wood, it's plastic. You can be sure

of nothing. You can no longer trust existence.

I'm sure that Tzara would have loved our performance if he'd seen it. I knew him. I visited him in Paris when I was in my twenties, between 1950 and 1960. He was at rue de Lille. He gave me a little Dada manifesto. He said, "Here, you can have this."

SH: Did you know about Duchamp then?

DS: Naturally. When I was twenty-two, in '52, I learned about Duchamp. My neighbor in the house was a young man named Serge Stauffer, whom I met because we were in the couloir, and he already knew about Duchamp. But I remember that we didn't know if Duchamp was still alive.

SH: Do you remember discussing Duchamp with Tinguely?

DS: Tinguely was typing in my room in Zurich. He was typing a piece that was Dada-influenced, "Der Brazilianische Brataptelschlauch." That must have been around 1952. Then, Dada was just a word. I knew that Duchamp was the one who put the mustache on the Mona Lisa, and who put a toilet on a pedestal. Like everybody today. (We didn't even know that it was a urinal. In my mind, it was a toilet.) And that was Duchamp. These were the things that I knew. But already, that was so fantastic.

Then I saw my first Dada show in Frankfurt, in 1958, I think. [*Dada: Dokumente einer Bewegung* began in September 1958 in Düsseldorf and traveled to Frankfurt and Amsterdam.] It must have been the first one, it was in a museum. By then I already knew much more about it.

When I was a dancer, there was a Schwitters exhibition in Bern, probably the first Schwitters exhibition. By that time, I had already met Schwitters's son, who came from Norway to Bern, and Hans Bolliger, an archivist who made

catalogues and knew everything about Dada Zurich. He had every piece of Dada paper that existed. One day I was going down the street and I ran into Bolliger and he said, "I invite you for dinner. Now." I asked why, and it was because he had just found the last number of *Cabaret Voltaire*, which was missing in his archives, and he bought it for one franc. That was great for him. He is now eighty, still living in Zurich. I had access to his collection.

SH: Do you remember anyone talking about Schwitters and his *Merzbau*?

DS: Naturally we knew about Schwitters. I had heard of all these things through Bolliger. He knew everything about Dada, and Surrealism, too. And he lent me whatever I wanted. I had access to his entire library, and it was huge. So I knew a great deal about Schwitters. I knew his Merz theater and his manifestoes. I read everything of his. I really knew a lot about the art of the twentieth century. Remember, this was after the war and many things were still hidden, not yet worked on or not accessible. So, for that time, I knew a lot.

SH: So you were really an expert on Dada.

DS: Yes! I knew quite a lot about it. I even had original books of theirs. I had a little collection of books of Dada and Surrealist theater pieces. Here in Paris, I met all these people. I met Dr. Frankel, for instance. I met Max Ernst and I asked him about Tzara's *Monsieur Antipyrine*. And Breton, naturally, who didn't believe any-

more in Dada theater. I knew a lot about Dada; it was the thing I loved most, not Surrealism. We—I can say "we" because we agreed on that—we preferred the aggressivity and anarchistic revolutionary spirit of Dada more than the gooley-gooley of the Surrealists, who tried to find something deep underneath through Freud and Marx. But it is absolutely absurd; Freud and Marx, you can't marry them.

Duchamp I didn't meet until 1959, in Paris. I had already made my concrete poetry, and I had my newspaper, but I wanted to make multiples so I came to Paris. The word "multiple" was actually in my *Multiplication d'Art Transformable*, that was the Edition MAT. And I came for that, in the summer, in August '59. And Tinguely said to me, "I saw Duchamp yesterday, he is in town. And he's at Max Ernst's apartment, call him there. Rue Mathurin Regnier." So I called him there, and he said, "Okay, you can come and see me." I asked him to participate in my MAT edition and he said, "Naturally. You can have my rotoreliefs." He was very generous, and he liked me. Even in interviews he said that Tinguely, Arman, and Spoerri were the three young artists he was most interested in. He really liked us. So I met him every year.

Well, I agree that you can call certain things Neo-Dada. But then you also have Zero and Fluxus. Fluxus doesn't even exist. Maciunas was not an artist; he was an organizer, of something strange that he wanted to call Fluxus. He was a

sick and a strange person, eating pills all the time; he wanted to make his own dictatorial division of art. He made all these diagrams of how things went. He included me, by chance—he liked me. He also made the first book about me, *L'Optique moderne*. That was the only real book published by Fluxus. Outside of this, Fluxus didn't exist. Today, people think it was a movement. New Realism was a movement: people did work together and exhibit together, and have a gallery. But Fluxus was always only Maciunas, who decided who was in and who was not.

SH: Do you remember the term "Neo-Dada" being used much?

DS: Yes, I remember the term "Neo-Dada" because Restany, when he made his first catalogue about us, the Nouveaux Réalistes, in 1960, he called it *Forty Degrees Above Dada*. That means forty years after Dada, that's what he wanted to say. But we were very much against this title because we said we had nothing to do with Dada. Well, this wasn't actually true. We knew about Dada but we didn't want to be called Neo-Dada.

SH: Did European critics pick up on the word "Neo-Dada"?

DS: Yes, absolutely. Especially in a negative sense. Saying that Dada was originally a strong movement, and we were just a remake, reheated coffee. That's what they said. Neo-Dada was more or less an insult. I always thought that Dada was

one of the best names because it meant nothing.

SH: When did you first meet John Cage?

DS: I met John Cage for the first time in 1959. He gave a concert in Darmstadt in 1959, while I was still the assistant of Gustav Rudolf Sellner, the director of the Darmstadt theater. The whole concert was questions, just questions. Like, "Do you think, if Beethoven is played and the windows are open, and there is the noise of a car, do you think that belongs to Beethoven?" And so on. Instead of making a conference, he asked three hundred questions. And he was smoking. He had two or three dice, and every time he began to read, he would take a cigarette, smoke it, put it on the tray, and go on. He would read the number of words based on the roll of the dice and then light a cigarette, but he didn't smoke it. He would just light it and put it on the ashtray. Then he would read another group of words and light another one. At the end there were three packages of cigarettes smoking in the ashtray. That was the first performance I saw that was completely different. It changed my life.

When I was still in Darmstadt, I went to visit Tinguely and I told him about Cage. And I gave him my revue, *Material*. He later came to see me in Darmstadt. Then we met in Antwerp, and did the Hessenhuis thing. That was all in 1958 or '59. I made a speech for his first exhibition at Gallery Schmela in Düsseldorf in '58. But I had known him already since '50. So that was these first ten years, while he was still in Paris, getting known, and I was a dancer.

SH: What led you to do the MAT pieces? It seems like a break from everything you had done up to that point. You had done the concrete poetry for *Material,* and then suddenly you did this *Multiplication d'Art Transformable.*

DS: It's not so far from the concrete poetry, which is also an abstraction of words. You just choose two or three words and then you have a mathematical construction. The important thing is that you are refusing an individual selection. We were all very much against that.

SH: Would you say that concrete poetry had a strong influence on Nouveau Réalisme?

DS: No. For me, yes. But for Nouveau Réalisme, none at all. Even today they have no tradition of concrete poetry. They have Lettrism, like Dufrêne was a Lettriste, but not concrete poetry. For me, there is a direct link between concrete poetry. I did that, then there was the Edition MAT, then my *tableaux pièges*. It is all the refusal of handwriting, or of individual expression.

One of the principle strategies that we, the Nouveaux Réalistes, used was a sort of a ready-made one. One color with a roller is a ready-made, if you like, as was Niki shooting. My stuff was readymade, too. The only difference from Duchamp's readymades is that he takes one object and puts it on a pedestal; mine is the contamination of objects, between each other. It's a whole situation. There is a relationship among the objects on this table; it's a dramatic situation.

It tells something about what we did here, and that is something you would never find in Duchamp. That is a huge difference.

It was the most precise New Realist concept to say, "This is the table. That's reality. This square meter. It's a territory I'm taking. I'm showing a territory." The others, all these *affichistes,* that was just abstract painting as you can find it on the streets.

Edition MAT was also related to my friendship with Tinguely. For nearly two years, every day, Tinguely and I sat together and talked about movement. Since I was a dancer, I was always talking about movement and pantomime. Since I was sitting as a model for Madame Lurçat, we were allowed to use an atelier there. So in one of Lurçat's ateliers, we tried to invent "movement decors." That was an idea we had together. These were decors that he would do that would move around a body. That's how Tinguely's machine things began. It's true; I can tell you exactly the moment when he said, "I need motors." It was in 1952 or '53. We had tried to make a decor of colors for the ballet but it broke before the performance. It was just annihilated. It was this big flop. A few days later, he said, "I need little electric motors. I have to buy motors but I have no money. You have to give me your stipend." So I did.

SH: Do you remember Daniel Cordier gallery's 1959 exhibition, *Exposition inteRnatiOnal du Surréalisme?*

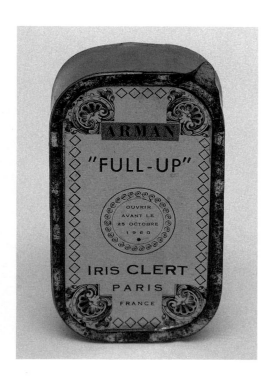

65 ARMAN

Invitation to *Le Plein* (Full Up), 1960.

DS: Yes, I saw it with Tinguely. We were a little bit disappointed, because the entrance was supposed to be a woman's vagina. Well there was a sort of abstract slit where you went in, but it was very abstract.

SH: Who conceived this?

DS: I think it goes back to a sentence of Duchamp's. This idea was later used by Niki when she made *Hon*, a whole woman's body that you entered through the sex, through "la porta." But the idea came from this situation. Inside the Cordier gallery, there was red velvet on the walls making it into a womb, and there were sounds of moaning. The dinner was by Meret Oppenheim, and they were eating on a naked woman.

SH: Do you remember seeing Rauschenberg's *Bed* in the show?

DS: No.

SH: When I first read about this, I thought it was impressive that Rauschenberg's *Bed* was shown in Europe at this time, but it doesn't seem to have had an effect.

DS: I don't think it was there.

SH: Yes it was.

DS: Then it was. It just didn't appear to anybody. I remember little paintings in gold frames on red velour, paintings by Dalí, Tanguy, and so on, and sculptures by Max Ernst. I also remember the bar where a naked woman was lying and people were eating oysters on her.

SH: Let me ask you about the store you made in 1961 called *L'Epicerie* [fig. 64], which I consider a major work.

DS: Yes, I'm very proud that you are asking about it because it's before the *Store* of Oldenburg [fig. 61], and it's not often connected. I don't think that he knew about it. But I'm very happy that no one can say to me, "Aha, you did the store after him." There are a lot of things that I did not do following others; I was too proud. *L'Epicerie* was just an idea I had all at once, on the spot. I was in Copenhagen in September 1961 as the organizer of a movement show, *Bewogen Beweging*.

SH: Can you talk about *Der Koffer*, the suitcase containing various works by others, which you made in 1961? How did Rauschenberg hear about it?

DS: He was there. He was living in Paris, he had Larry Rivers's studio, I think. I said, "I'm doing a piece with a suitcase. Would you like to participate?" So he put a padlock on the outside, and threw the key away. It was nice. Yves Klein refused

to participate. So I linked him by saying there was the non-participation of an immaterial painting of Yves Klein. It was such a mixture anyway that nobody understood what it was. Arman did a very beautiful piece; Martial Raysse did one; Tinguely; Niki; me, naturally; Hains; Dufrêne; Villeglé; so I really had everybody. The only one who didn't want to participate was Yves Klein.

SH: Why?

DS: Because we had a strange relationship. On the one hand we were very close and we had long discussions. For instance, this gold that he was throwing in the Seine. I told him that the Celts threw gold into the Seine as gifts for their water gods. I was very precise with him. I said, "If you get gold for immaterialized things, you can't keep it. You absolutely can't keep it. Because it's only immaterial if you do something else with this gold—if you hide it or you throw it away. But if you use this gold, then it's material. Then it's not true anymore."

He wanted to be the only and the last genius of the world. And he was a very good manager, with a fantastic, fresh, modern, advertising genius. Yes! He could advertise his ideas in a modern way! He said to me, "Look it's strange what you are doing because it's not necessary anymore. I did everything. That's it. The question of painting is resolved." Yves Klein was sure that he was a sort of a messiah. He was a dictator and a dangerous man. If he had been Hitler, he would have destroyed half of the world. It's really true! He would have decided what was right and what was not right. He wouldn't care. He was physically beautiful. Yves Klein, he was the best!

Now Manzoni, I knew him also. We were friends. He had something very important, because he turned it more into abstraction. He

was extremely well-informed about everything, and extremely quick. He certainly knew about Yves Klein, and then it occurred to him, "That's a fantastic idea!" He made it. Not in blue, not in color, but in white! Finished. He made it very quick. Then he also had the idea, for instance, to do it in fur, in white fur, and all these things. [This is a discussion of Klein's monochromes and Manzoni's A-chromes.] And Tinguely was making his machines at this time, the *métamatics* [see fig. 36], so Manzoni saw them or heard about them, or saw photographs or something, and he said, "Okay, I'm doing the longest line in the world." And then he'd sit at this thing, and vvvvvvvvvvv, and turn out 33 kilometers of line in one hour.

SH: Someone said to me that Manzoni made people angry with this copycat behavior, but they had to respect him because what he managed to produce was very good.

DS: It was not good. Technically, it was not good at all. He was just a very strange person. When Arman did the canned invitation to *Le Plein* [fig. 65], aesthetically made ordure, Manzoni said, "Okay, I'll do shit. Pure shit, in a can."

With Manzoni, it was always more extreme, more abstract, more definitive. For instance, he signed human sculptures. That was in Denmark, because it was not legal to show naked bodies in Italy or France—it would have been stopped by the police. He went to Galerie Koepcke in Denmark, at the time I showed there. It was just one evening and it was a lousy performance! He had a pedestal of one cubic meter and girls went up and he signed their behinds. But he had photographs made, and the photographs went around the world.

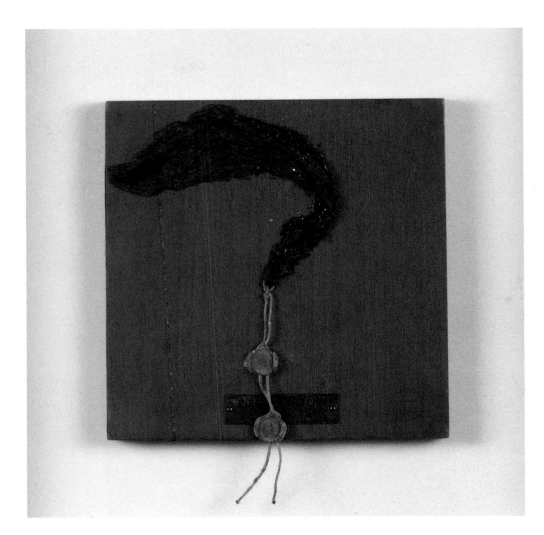

66 PIERO MANZONI

Fiato d'artista (Artist's Breath), 1959.

67 JOHN CAGE

Score for *Aria*, 1958.

History

The danger remains that he'll get out of the valise we put him in. So long as he remains locked up—

The rest of them were artists. Duchamp collects dust.

The check. The string he dropped. The Mona Lisa. The musical notes taken out of a hat. The glass. The toy shotgun painting. The things he found. Therefore, everything seen—every object, that is, plus the process of looking at it—is a Duchamp.

Duchamp Mallarmé

There are two versions of the ox-herding pictures. One concludes with the image of nothingness, the other with the image of a fat man, smiling, returning to the village bearing gifts. Nowadays we have only the second version. They call it neo-Dada. When I talked with M.D. two years ago he said he had been fifty years ahead of his time.

Duchamp showed the usefulness of addition (moustache). Rauschenberg showed the function of subtraction (De Kooning). Well, we look forward to multiplication and division. It is safe to assume that someone will learn trigonometry. Johns

Ichiyanagi Wolff

We have no further use for the functional, the beautiful, or for whether or not something is true. We have only time for conversation. The Lord help us to say something in reply that doesn't simply echo what our ears took in. Of course we can go off as we do in our corners and talk to ourselves.

There he is rocking away in that chair, smoking his pipe, waiting for me to stop weeping. I still can't hear what he said then. Years later I saw him on MacDougal Street in the Village. He made a gesture I took to mean O.K.

"Tools that are no good require more skill."

A Duchamp

Seems Pollock tried to do it—paint on glass. It was in a movie. There was an admission of failure. That wasn't the way to proceed. It's not a question of doing again what Duchamp already did. We must nowadays nevertheless be able to look through to what's beyond—as though we were in it looking out. What's more boring than Marcel Duchamp? I ask you. (I've books about his work but never bother to read them.) Busy as bees with nothing to do.
He requires that we know that being an artist isn't child's play: equivalent in difficulty—surely—to playing chess. Furthermore a work of our art is not ours alone but belongs also to the opponent who's there to the end.
Anarchy?
He simply found that object, gave it his name. What then did he do? He found that object, gave it his name. Identification. What then shall we do? Shall we call it by his name or by its name? It's not a question of names.

The Air

We hesitate to ask the question because we do not want to hear the answer. Going about in silence.

One way to write music: study Duchamp.

Say it's not a Duchamp. Turn it over and it is.
Now that there's nothing to do, he does whatever anyone requires him to do: a magazine cover, an exhibition, a movie sequence, etc., ad infinitum. What did she tell me about him? That he gave himself except for two days a week (always the same days, Thursdays, Sundays)? That he's emotional? That he formed three important art collections. The phonograph.

Theatre

2/50

TARGET 1970
and_____

Jasper Johns *Marcel Duchamp [1887–1968], An Appreciation*

The self attempts balance, descends. Perfume—the air was to stink of artists' egos. Himself, quickly torn to pieces. His tongue in his cheek.

Marcel Duchamp, one of this century's pioneer artists, moved his work through the retinal boundaries which had been established with Impressionism into a field where language, thought and vision act upon one another. There it changed form through a complex interplay of new mental and physical materials, heralding many of the technical, mental and visual details to be found in more recent art.

He said that he was ahead of his time. One guesses at a certain loneliness there. Wittgenstein said that "'time has only one direction' must be a piece of nonsense."

In the 1920s Duchamp gave up, quit painting. He allowed, perhaps encouraged, the attendant mythology. One thought of his decision, his willing this stopping. Yet on one occasion, he said it was not like that. He spoke of breaking a leg. "You don't mean to do it," he said.

The Large Glass. A greenhouse for his intuition. Erotic machinery, the Bride, held in a see-through cage—"a Hilarious picture." Its cross references of sight and thought, the changing focus of the eyes and mind, give fresh sense to the time and space we occupy, negate any concern with art as transportation. No end is in view in this fragment of a new perspective. "In the end you lose interest, so I didn't feel the necessity to finish it."

He declared that he wanted to kill art ("for myself") but his persistent attempts to destroy frames of reference altered our thinking, established new units of thought, "a new thought for that object."

The art community feels Duchamp's presence and his absence. He has changed the condition of being here.

139

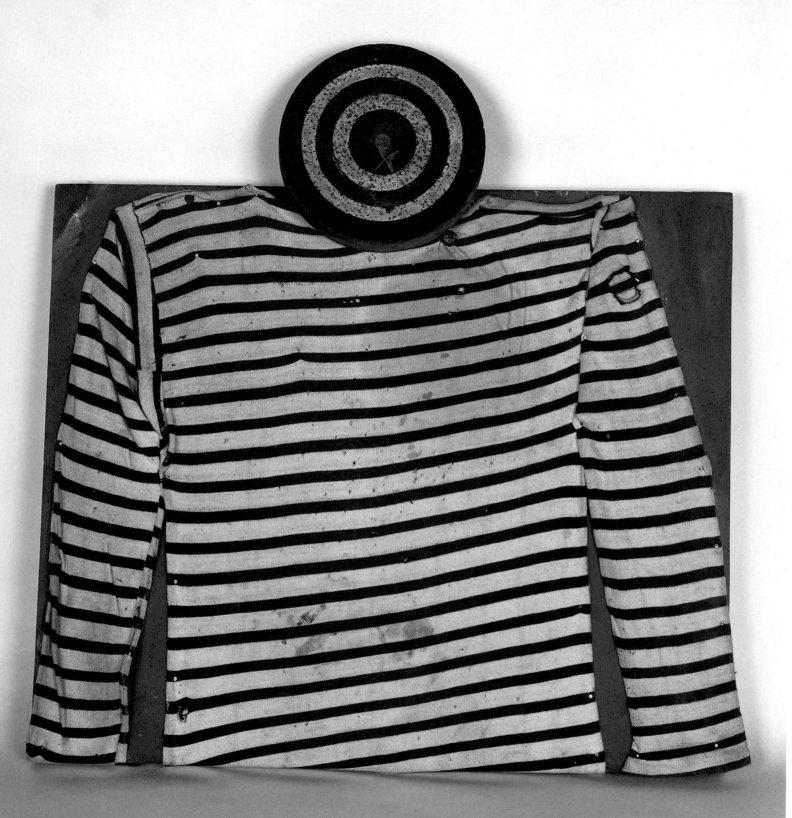

69 NIKI DE SAINT PHALLE

Dart Portrait, ca. 1961.

Niki de Saint Phalle *A Letter to Bloum*

Dear Bloum,

I was born in 1930. A DEPRESSION BABY. While my mother was expecting me they lost all their money. At the same time she discovered my father's INFIDELITY. She cried all through her pregnancy. I felt those TEARS.

The first three years of my life I was separated from my mother. As they were broke, my mother worked in N.Y.C. and I was shipped to my grandparents in France.

Mother, mother where are you? Nanas, the earth mothers, would come many years later.

As a child I could not identify with my mother or my grandmother, my aunts or my mother's friends. They seemed a pretty unhappy lot. Our home was not a home of love and joy. Home seemed like a very confining, narrow space to me with little liberty or privacy. I didn't want to become like them, guardians of the hearth, I wanted the world and the world then belonged to MEN. A woman could be queen bee in the home but that was it. The roles men and women were allotted to play were then subjected to very strict rules on either side.

As a young girl I not only refused my mother and father as models for future behavior, I also refused their social position. The only room in the house I found comfort and warmth in was the kitchen with the black cook. Later she would perhaps become *Black Venus* now in the Whitney museum.

After having rejected my parents and their social class, I would be FACED WITH THE ENORMOUS PROBLEM OF REINVENTING AND RECREATING MYSELF. To add to the problem, I had no defined national feelings. I felt half French, half American. Also half man and half woman.

I did not want to reject my mother entirely. I retained certain specific things from her that have given me a lot of pleasure—my love of clothes, fashion, hats, dressing up, mirrors. My mother had lots of mirrors in her house. Years later mirrors would become one of the main materials I would use in the *Tarot Garden* in Italy and *The Cyclops in the Forest of Fontainebleau* outside of Paris.

Until the age of eleven I had had an extraordinarily good rapport with my father. He was the link to that world outside the home I wanted to CONQUER AND MAKE MINE. We

141

Niki de Saint Phalle

had a repetitive game we played together throughout my childhood—blindman. Once a week we would take a walk alone together in Central Park, usually around the reservoir. He would shut his eyes and pretend to be blind (Tiresias) and I would be his eyes. I would lead him by the hand and describe to him the fabulous cities, treasures, flowers, storms, and dragons I was seeing.

At other times, by talking to me about his political opinions, my father gave me the impression that in his eyes I had the right to exist intellectually. My father was a Roosevelt admirer and I adhered to his liberal views.

Completely non-racist, he would tell me I could marry anyone I pleased, rich or poor, negro (that's what blacks were called in those days), white, or yellow.

It implied to me that women could also be equal. My mother, who had social ambitions for me would scream at my father for speaking this way to me. Her father came from Georgia and his grandfather had had slaves. There was also anti-Semitism. Her French grandfather, Mr. Blitz, was Jewish and a brilliant engineer. He built one of the bridges in New York City. I could never find out which one; my mother was so ashamed of him! She was an ardent Catholic and embarrassed to have an ancestor who belonged to a sect that supposedly had killed Christ.

ABSOLUTE RACIAL AND RELIGIOUS LIBERTY WAS MY FATHER'S CREED AND I HAVE MADE IT MINE ALL MY LIFE.

Things turned sour when I started growing breasts. The dark side of my idealistic father manifested itself.

My father got more involved watching my breasts grow and my hips widen than discussing politics or life with me. I had turned into quite an attractive young girl. I became an object of his desire for total power over me. Something happened between us, something that turned me away forever from my father. All that love turned to hate. I felt I had been assassinated.

I couldn't bear being in the same room with him.

In 1961, daddy, I would revenge myself by shooting at my paintings with a REAL GUN. Embedded in the plastic were bags of paint. I shot you green and red and blue and yellow.

YOU BASTARD YOU!

When you saw me do this did you ever guess I was shooting at you?

My childhood fears and anger caught up with me and at twenty-two I had a nervous breakdown, two years after your mother, Laura, was born.

My nervous breakdown, the descent into madness, was the most terrifying experience of my life.

I was hounded by countless conflicts. Everywhere CONFLICTS. I felt THREATENED. I stole KNIVES, RAZORS, anything sharp to protect myself from the DISGUSTING mass of HUGE HAIRY PURPLE SPIDERS, mountains of PUTRIFYING DECAYING BODIES, countless bloody heads filling up the room SCREAMING AT ME—yet out of this disintegration, out of all this darkness, OUT OF ALL THIS SHIT WOULD EMERGE GOLD. Out of chaos would come order.

I LEFT THE PSYCHIATRIC CLINIC AN ARTIST. It was there that my vocation became clear to me and possessed me as my madness had possessed me before. At the clinic I was free to be myself at last. I would be alone with my art and not be afraid to choose my own way. This was what I was meant to do. This was what I wanted to do. It was a magical alchemical process.

Out of the Darkness came light. I was reborn. Out of pain was born wild enthusiasm. My will emerged and took hold of all the fragmented parts of me and THROUGH MY ART I BECAME WELL. I had embarked on the real journey of my life.

On this happy note, Bloum, I will take leave of you as today October 29 is my birthday and in a couple of hours I will receive some old friends to toast the new year in.

A big kiss from Niki

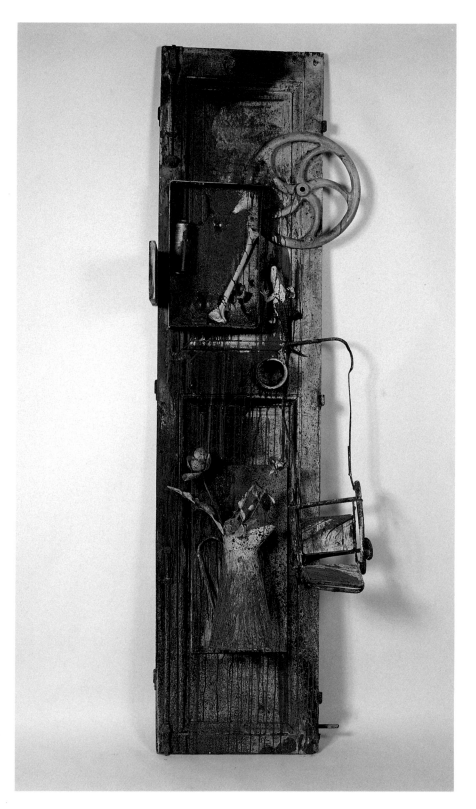

70 NIKI DE SAINT PHALLE

Tir avec roue et poussette (Shooting
Painting with Wheel and Cart), 1962.

Checklist of the Exhibition

Dada

MARCEL DUCHAMP
1887–1968

Roue de bicyclette (Bicycle Wheel), 1913/1964
Bicycle wheel mounted on painted wooden stool
49 ¾ × 25 ¼ × 12 ⅝"
Sixth version. Edition Schwarz, Milan
Edition number 8/8
Indiana University Art Museum; partial gift
of Mrs. William Conroy (71.37.1)
figure 1

Trébuchet (Trap), 1917/1964
Wood and metal coat rack
4 ⅝ × 39 ⅜ × 4 ¾"
Second version. Edition Schwarz, Milan
Edition number 8/8
Indiana University Art Museum; partial gift of Mrs.
William Conroy (71.37.9)
figure 35

KURT SCHWITTERS
1887–1948

White - Blue, 1946
Tempera, crayon, pencil, collage of paper
6 1/16 × 5 ¼"
Yale University Art Gallery (1953.6.75)
figure 3
(Scottsdale, New York, and Houston venues only)

Neo-Dada

ARMAN
born 1928

Invitation to *Le Plein* (Full Up), 1960
Refuse in sardine can
4 ⅛ × 2 ½ × 1 ⅛"
Edition number 438/500
Collection of the artist, New York
figure 65

Grand Déchets bourgeois (Large Bourgeois Trash), 1960
Accumulation of refuse in glass box
25 ¾ × 15 ¾ × 3 ⅛"
Jeanne-Claude and Christo, New York
figure 57

Sonny Liston, 1962–63
Irons
33 × 7 × 13"
Stephen S. Alpert, Boston
figure 55

WALLACE BERMAN
1926–1976

Semina 4, San Francisco, 1959/1992
Reprinted by George Herms, 1992 (original, ink on paper)
9 ½ × 8"
Original published by the artist on a handpress, reprint
by L.A. Louver Gallery Publications
Estate of the artist and L.A. Louver, Inc., Venice, California
figure 32

GEORGE BRECHT
born 1926

Chair Events, 1961 (recreated 1994–95)
Three chairs in differing contexts
Dimensions variable
Collection of the artist
(Recreated at each venue according to artist's instructions)
figure 11

Word Event, 1961
Photostat, 1994 (original, ink on paper)
2½ × 2¾"
The Gilbert and Lila Silverman Fluxus Collection
figure 49

JOHN CAGE
1912–1992

Score for *Fontana Mix*, 1958
Ink on paper and mylar sheets
11 × 8½"
© 1960 Henmar Press
figures 43ab

Score for *Aria*, 1958
Ink on paper
8⅞ × 12"
© 1960 Henmar Press
figure 67

JOHN CHAMBERLAIN
born 1927

Butternut, 1963
Welded auto metal
40¾ × 26 × 40"
Virginia Museum of Fine Arts, Richmond; The Sydney
and Frances Lewis Contemporary Art Fund (72.49)
figure 9

JIM DINE
born 1935

Double Red Bathroom, 1962
Glass, metal, paper, toothbrush, oil on canvas
50 × 80 × 7"
Rose Art Museum, Brandeis University, Waltham,
Massachusetts; Gevirtz-Mnuchin Purchase Fund
(1962.137)
figure 23

FLUXUS
most active 1962–78

Neo-Dada in der Musik (Neo-Dada in Music),
June 16, 1962
Ink on paper
7⅝ × 8⅛"
The Gilbert and Lila Silverman Fluxus Collection
figure 47

JEAN FOLLETT
born 1917

Many-Headed Creature, 1958
Light switch, cooling coils, window screen,
nails, faucet knob, mirror, twine, cinders, castor,
springs, rope, on wood panel
24 × 24"
The Museum of Modern Art, New York (296.61)
figure 59

RAYMOND HAINS
born 1926

Composition, 1959
Collage on zinc
39¾ × 41¾"
Stephen S. Alpert, Boston
figure 28

GEORGE HERMS
born 1935

Saturn Collage, 1960
Mixed media
72 × 48 × 10"
Paul Cornwall-Jones
figure 34

Nijinsky Running in the Snow, 1960
Wood shoetrees tied with metal wire and metal tag
16 × 10 × 4¼"
Arman, New York
figure 33

DICK HIGGINS
born 1938

Score for *Danger Music Number Seventeen*, ca. 1960
Color laser copy, 1994 (original, ink on paper)
3¹/₁₆ × 5⅛"
The Gilbert and Lila Silverman Fluxus Collection
figure 14

JASPER JOHNS
born 1930

Target (Do It Yourself), 1971 (based on a 1961 drawing)
Lithograph with stamp, watercolor discs, and paint brush
12¼ × 10"
Edition Gemini G.E.L.
Edition number 4/50
Collection of the artist
figure 68

ALLAN KAPROW
born 1927

Untitled, 1959 (recreated 1994–95)
Stepladder, chicken wire, newspaper, tape
Dimensions variable
Collection of the artist
(Recreated at each venue according to artist's instructions)
figure 10

EDWARD KIENHOLZ
born 1927

O'er the Ramparts We Watched, Fascinated, 1959
Painted wood, rope, radio parts, doll parts, other
mixed media, paint, on wood panel
25½ × 45½ × 5"
Stephen S. Alpert, Boston
figure 31

YVES KLEIN
1928–1962

Zone of Immaterial Pictorial Sensibility, June 14, 1961
Exists without dimension
Edward Kienholz
(not illustrated)

Victoire de Samothrace (Victory of Samothrace), 1962/1973
Dry blue pigment in synthetic resin on plaster, metal rod,
stone base
19 ⅞ × 10 × 14 ⅛"
Estate of the artist
figure 41

ALISON KNOWLES
born 1933

by Alison Knowles, 1965
Ink on paper
8½ × 5½"
Great Bear Pamphlet #1
Distributed by Something Else Press
The Museum of Modern Art Library
figure 50

GEORGE MACIUNAS
1931–1978

Score for *12 Piano Compositions for Nam June Paik*,
January 2, 1962
Color laser copy, 1994 (original, ink on paper)
3⅛ × 8"
The Gilbert and Lila Silverman Fluxus Collection
figure 44

Score for *In Memoriam to Adriano Olivetti, Revised*,
March 20, 1962 (revised November 8, 1962)
Color laser copy, 1994 (original, ink on paper)
Two sheets, 6½ × 8¾"; one sheet, 11½ × 8⅛"
The Gilbert and Lila Silverman Fluxus Collection
figure 45abc

PIERO MANZONI
1933–1963

Fiato d'artista (Artist's Breath), 1959
Mixed media with rubber, string, and sealing wax, on wood
7⅞ × 7⅞"
Hirschl & Adler Modern
figure 66

Merda d'artista (Artist's Shit), May 1961
Can of artist's excrement
2 × 2½"
Signed and numbered: Piero Manzoni 059
Galerie Karsten Greve, Cologne-Paris
figure 39

ROBERT MORRIS
born 1931

Box with the Sound of Its Own Making, 1961
(recreated 1993)
Wood box containing tape cassette player and audiotape
9 × 9 × 9"
Collection of the artist
(Recreated by the artist)
figure 21

CLAES OLDENBURG
born 1929

Liver Sausage with Slices, 1961
Enamel on plaster-covered burlap, on wood base
5 × 10 × 12"
Anderson Gallery, Buffalo, New York
figure 63

Orange and Glass, 1961
Papier-mâché and acrylic
16¼ × 14 × 14"
Anderson Gallery, Buffalo, New York
figure 60

YOKO ONO
born 1933

Painting to Hammer a Nail, 1961 (recreated 1994)
Wood panel, bucket containing nails, hammer, chain,
other media
10¼ × 5½ × 1¾"
Collection of the artist
(Recreated by the artist)
figure 17

NAM JUNE PAIK
born 1932

Audiotapes for *Hommage à John Cage: Music for
Tape Recorder and Piano*, 1959–62
Collection of the artist
figure 54 (audiotapes for other works also illustrated)

ROBERT RAUSCHENBERG
born 1925

This is a Portrait of Iris Clert If I Say So, 1961
Ink on paper
17⅝ × 13¾"
Ulla Ahrenberg, Vevey, Switzerland
figure 6

NIKI DE SAINT PHALLE
born 1930

Dart Portrait, ca. 1961
Target, dart, shirt, on painted wood panel
25⅜ × 21½ × 7"
Laura and Philip Mathews
figure 69

Tir avec roue et poussette (Shooting
Painting with Wheel and Cart), 1962
Pitcher, cart, wheel, artificial flowers,
paint, on wood panel
93⅝ × 28½ × 13⅝"
Private collection
figure 70

CAROLEE SCHNEEMANN
born 1939

Fur Wheel, 1962
Fur, cans, paint, on lampshade
20 × 20 × 28"
Collection of the artist
(Originally turned by hand, the work
has been motorized by the artist for the exhibition)
figure 20

DANIEL SPOERRI
born 1930

La Poubelle n'est pas d'Arman (The Trashbasket
Is Not Arman's), 1961
Household utensils on painted wood panel
17¼ × 41"
Stephen S. Alpert, Boston
figure 38

147

Les Lunettes noires (Black Eyeglasses), 1961 (recreated 1994)
Metal pins and eyeglass hinges glued to eyeglasses
1¾ × 4⅜ × 5½"
Collection of the artist
(Recreated by the American Federation of Arts according
to the artist's instructions)
figure 37

RICHARD STANKIEWICZ
1922–1983

Railroad Urchin, 1959
Steel and found objects
51 × 41 × 20"
Zabriskie Gallery
figure 56

JEAN TINGUELY
1925–1991

Métamatic No. 12 ("Le grand Charles"), 1959
Iron rods, wood pulleys, rubber belts, pen,
paper, electric motor, paint
85 × 57 × 24"
Phyllis Lambert, Montreal
figure 36

BEN VAUTIER
born 1935

Absolument n'importe quoi est art
(Absolutely Anything Is Art), 1962
Ink on paper
9⅛ × 12⅝"
Jon and Joanne Hendricks
figure 71

Ben dieu (Ben God), 1962–63
Portfolio of printed paper with 1964 appendix
12¼ × 8½"
Collection of the artist
figure 19

ANDY WARHOL
1930–1987

Dr. Scholl, 1960
Oil on canvas
48 × 40"
The Metropolitan Museum of Art; gift of Halston
(1982.505)
figure 40

A Boy for Meg, 1961
Synthetic polymer on canvas
72 × 52"
National Gallery of Art, Washington, D.C.;
gift of Mr. and Mrs. Burton Tremaine (1971.87.11)
figure 24
(Scottsdale, New York, and Houston venues only)

Do It Yourself (Flowers), 1962
Crayon and graphite on paper
25 × 18"
Sonnabend Collection
figure 25
(Scottsdale and New York venues only)

ROBERT WATTS
1923–1988

Dollar Bill, 1961–62
One example: drypoint on paper, 10 × 7½"
Five examples: offset on paper (from an edition
of unknown size),
2⁹⁄₁₆ × 6¹⁄₁₆"
Larry Miller and Sara Seagull
figure 15

Safe Post/K.U.K. Feldpost/Jockpost, 1962
Two sheets of fifteen stamps, offset (one blue, one
green) on gummed, perforated paper
4½ × 5½" each
Larry Miller and Sara Seagull
figure 16

LA MONTE YOUNG
born 1935

Score for *Vision*, November 12, 1959
Nine sheets of mimeographed paper (from first edition of
approximately thirty) thirty-one printed cards (from a
later, 1986, set of copies)
Sheets, 11 × 8½"; cards of varying dimensions
Collection of the artist and Marian Zazeela
Copyright © La Monte Young. All rights reserved.
figure 51

Score for *Composition 1960 #5*, 1960
Photostat, 1993 (original, ink on paper)
3½ × 8½"
Collection of the artist and Marian Zazeela
Copyright © La Monte Young. All rights reserved.
figure 12

Score for *Composition 1960 #7*, July 1960
Ink on paper
3 × 5"
Collection of the artist and Marian Zazeela
Copyright © La Monte Young. All rights reserved.
figure 52

Score for *Composition 1960 #9*, October 1960
Ink on paper (from an edition of approximately one hun-
dred); card, 3 × 5"; envelope, 3⅝ × 6½"
Limited edition of overprints from first edition of *An
Anthology* (1963)
Collection of the artist and Marian Zazeela
Copyright © La Monte Young. All rights reserved.
(not illustrated)

Scores for *Composition 1960 #s 6, 10, 13, 15*, 1960; *Piano
Pieces for David Tudor #s 1, 2, and 3*, 1960; and *Piano Piece
for Terry Riley #1*, 1960
Five sheets of mimeographed paper (from an edition of
approximately sixty)
Three sheets, 11 × 8½"; one sheet, 3⁷⁄₁₆ × 8½"; one sheet
6¼ × 8½"
Mimeographed first printing of these scores ca. 1961/62
distributed privately by La Monte Young before publica-
tion in *An Anthology*
Collection of the artist and Marian Zazeela
Copyright © La Monte Young. All rights reserved.
figure 53 (only *Composition 1960 #s 13* and *15* illustrated)

Bibliography

Armstrong, Elizabeth, and Joan Rothfuss. *In the Spirit of Fluxus*, exhib. cat., Minneapolis, Walker Art Center, 1993.

Art & Artists, vol. 7, no. 7 (October 1972). Issue devoted to Fluxus.

"A Symposium on Pop Art," *Arts Magazine*, vol. 37, no. 7 (April 1963), pp. 36–45.

Ashbery, John, and Sidney Janis. *New Realists*, exhib. cat., New York, Sidney Janis Gallery, November 1962.

Assemblage in California: Works from the Late 50's and Early 60's, exhib. cat., Irvine, Calif., Art Gallery, University of California, Irvine, 1968.

Battcock, Gregory, and Robert Nickas, eds. *The Art of Performance: A Critical Anthology*, New York, E.P. Dutton & Co., 1984.

Becker, Jürgen, and Wolf Vostell. *Happenings: Fluxus, Pop Art, Nouveau Réalisme: Eine Dokumentation*, Hamburg, Rowohlt, 1965.

Berger, Maurice. *Labyrinths: Robert Morris, Minimalism, and the 1960s*, New York, Harper and Row, 1989.

Block, René, ed. *The Readymade Boomerang: Certain Relations in 20th Century Art*, exhib. cat., Sydney, Art Gallery of New South Wales, 1990.

Blum, Irving. Interview by Joann Phillips and Laurence Weschler, 1976, 1978, and 1979, Oral History Program, University of California at Los Angeles.

Bonk, Ecke. *Marcel Duchamp: The Box in a Valise*, New York, Rizzoli, 1989.

Brecht, George. *Chance Imagery*, New York, Something Else Press, 1966. (Text written in 1957.)

Buchloh, Benjamin H.D. "Ready Made, Objet Trouvé, Idée Reçu," *Dissent: The Issue of Modern Art in Boston*, Boston, Institute of Contemporary Art, 1985.

Cabanne, Pierre. *Dialogues with Marcel Duchamp*, New York, Da Capo, 1987.

Cage, John. *Silence*, Middletown, Conn., Wesleyan University Press, 1961.

Choay, Françoise. "Dada, Néo-Dada, et Rauschenberg," *Art International*, vol. 5, no. 8 (October 20, 1961), pp. 82–84, 88.

Clearwater, Bonnie, ed. *West Coast Duchamp*, Miami Beach, Fla., Grassfield Press, 1991.

Décollage: Les Affichistes, exhib. cat., New York, Zabriskie Gallery, 1990.

de Duve, Thierry, ed. *The Definitively Unfinished Duchamp*, Cambridge, Mass., MIT Press, 1991.

De Salvo, Donna, and Paul Schimmel. *Hand-Painted Pop: American Art in Transition 1955–1962*, exhib. cat., Los Angeles, Museum of Contemporary Art, 1993.

Duchamp, Marcel. *Marchand du Sel: Ecrits de Marcel Duchamp*, ed. Michel Sanouillet, Paris, Le Terrain Vague, 1958.

Forty Years of California Assemblage, exhib. cat., Los Angeles, Wight Art Gallery, University of California, Los Angeles, 1989.

Gablik, Suzi, and John Russell, eds. *Pop Art Redefined*, London, Thames and Hudson, 1969.

Goldberg, RoseLee. *Performance Art: From Futurism to the Present*, 2nd ed., rev., New York, Harry N. Abrams, 1988.

Hansen, Al. *A Primer of Happenings & Time/Space Art*, New York, Something Else Press, 1965.

Hapgood, Susan. *Aspects of Collage, Assemblage and the Found Object in Twentieth-Century Art*, exhib. broch., New York, Solomon R. Guggenheim Museum, 1988.

d'Harnoncourt, Anne, and Kynaston McShine, eds. *Marcel Duchamp*, exhib. cat., New York, Museum of Modern Art, and Philadelphia, Philadelphia Museum of Art, 1973.

Haskell, Barbara. *Blam! The Explosion of Pop, Minimalism and Performance 1958–1964*, exhib. cat., New York, Whitney Museum of American Art, 1984.

Hendricks, Jon. *Fluxus Codex*, New York, Harry N. Abrams, 1988.

Hulten, Pontus. *Tinguely*, exhib. cat., Paris, Musée national d'art moderne, 1988.

Johns, Jasper. "Thoughts on Duchamp," *Art in America*, vol. 57 (July-August 1969), p. 31.

———. "Marcel Duchamp [1887–1968], An Appreciation," *Artforum*, vol. 7 (November 1968).

Johnston, Jill. "The Artist in a Coca-Cola World," *Village Voice*, January 31, 1963, p. 24.

———. "Niki de Saint Phalle," *Art News*, vol. 61, no. 8 (December 1962), p. 16.

149

Kaprow, Allan. "Some Observations on Contemporary Art," in *New Forms—New Media 1*, exhib. cat., New York, Martha Jackson Gallery, 1960.

——."The Legacy of Jackson Pollock," *Art News*, vol. 57, no. 6 (October 1958), pp. 24–26, 55–57.

Allan Kaprow, exhib. cat., Pasadena, Calif., Pasadena Art Museum, 1969.

Kienholz, Edward. Interview by Laurence Weschler, 1977, Oral History Program, University of California, Los Angeles.

Kirby, Michael. *Happenings*, New York, E.P. Dutton & Co., 1965.

Yves Klein: 1928–1962, A Retrospective, exhib. cat., Houston, Institute for the Arts, Rice University, 1982.

Kostelanetz, Richard, ed. *John Cage*, New York, Praeger Publishers, 1970.

Kostelanetz, Richard. *The Theatre of Mixed Means: An Introduction to Happenings, Kinetic Environments, and Other Mixed-Means Performances*, New York, Dial Press, 1968.

Kozloff, Max. "Johns and Duchamp," *Art International*, vol. 8, no. 2 (March 1964), pp. 42–45.

——."'Pop' Culture, Metaphysical Disgust, and the New Vulgarians," *Art International*, vol. 6, no. 2 (March 1962), pp. 34–36.

Lauf, Cornelia, and Susan Hapgood, eds. *FluxAttitudes*, exhib. cat., Ghent, Imschoot Uitgevers, 1991.

Lebel, Robert. *Marcel Duchamp*, New York, Grove Press, 1959, 2nd ed., New York, Paragraphic Books, 1967.

Lippard, Lucy, ed. *Dadas on Art*, Englewood Cliffs, N.J., Prentice-Hall, 1971.

——. *Pop Art*, London, Thames and Hudson, 1966 (2nd ed. 1988), p. 20.

Mahsun, Carole Anne, ed. *Pop Art: The Critical Dialogue*, Ann Arbor, Mich., UMI Research Press, 1989.

Malle, Loïc. *Virginia Dwan et les Nouveaux Réalistes*, exhib. cat., Paris, Galerie Montaigne, 1990.

Marcus, Greil. *Lipstick Traces: A Secret History of the Twentieth Century*, Cambridge, Mass., Harvard University Press, 1989.

Martin, Henry. *An Introduction to George Brecht's Book of the Tumbler on Fire*, Milan, Multhipla Edizioni, 1978.

McShine, Kynaston, ed. *Andy Warhol: A Retrospective*, exhib. cat., New York, Museum of Modern Art, 1989.

Morphis, Thomas G. "Connections: Kurt Schwitters and American Neo-Dada," Masters thesis, Cranbrook Academy of Art, 1981, Ann Arbor, Mich., University Microfilms International, 1984.

Motherwell, Robert, ed. *The Dada Painters and Poets: An Anthology*, (1951), 2nd ed., Cambridge, Mass., Belknap Press of Harvard University Press, 1989.

Müller, Maria. *Aspekte der Dada-Rezeption 1950–1966*, Essen, Verlag Die Blaue Eule, 1987.

Naumann, Francis, and Rudolf Kuenzli, eds. *Marcel Duchamp: Artist of the Century*, Cambridge, Mass., MIT Press, 1990.

New Forms—New Media I, exhib. cat., New York, Martha Jackson Gallery, 1960.

New Realists, exhib. cat., New York, Sidney Janis Gallery, 1962.

Nouveaux Réalistes, exhib. cat., New York, Zabriskie Gallery, 1988.

Oldenburg, Claes, and Emmett Williams. *Store Days*, New York, Something Else Press, 1967.

Paris-New York, exhib. cat., Paris, Musée national d'art moderne, 1977.

Phillpot, Clive, and John Hendricks. *Fluxus: Selections from the Gilbert and Lila Silverman Collection*, exhib. cat., New York, Museum of Modern Art, 1988.

Piene, Otto, and Heinz Mack. *Zero* (1961), repr., Cambridge, Mass., MIT Press, 1973.

The Prometheus Archives, exhib. cat., Newport Beach, Calif., Newport Harbor Art Museum, 1979.

Restany, Pierre. *Les nouveaux réalistes*, Paris, Editions Planète, 1968.

Richter, Hans. *Dada—Art and Anti-Art*, London, Thames and Hudson, New York, 1966.

Rose, Barbara. *Claes Oldenburg*, exhib. cat., New York, Museum of Modern Art, 1970.

——."Dada Then and Now," *Art International*, vol. 7, no. 1 (January 1963), pp. 22-28.

Rubin, William. *Dada, Surrealism and Their Heritage*, exhib. cat., New York, Museum of Modern Art, 1968.

Niki de Saint Phalle, exhib. cat., Stockholm, Moderna Museet, 1981.

Sandler, Irving. "Ash Can Revisited, A New York Letter," *Art International*, vol. 4, no. 8 (October 25, 1960), pp. 28–30.

Sanouillet, Michel, and Elmer Peterson, eds. *The Essential Writings of Marcel Duchamp*, London, Thames and Hudson, 1975.

Seitz, William. *The Art of Assemblage*, exhib. cat., New York, Museum of Modern Art, 1961.

Solomon, Alan. *Jasper Johns*, exhib. cat., New York, Jewish Museum, 1964.

——. *Robert Rauschenberg*, exhib. cat., New York, Jewish Museum, 1963.

Spoerri, Daniel. *An Anecdoted Typography of Chance*, New York, Something Else Press, 1966.

Steegmuller, Francis. "Duchamp: Fifty Years Later," *Show*, vol. 3, no. 2 (February 1963), p. 29.

Stich, Sidra. *Made in the U.S.A.: An Americanization in Modern Art, the '50s and '60s*, exhib. cat., Berkeley, University Art Museum, and Berkeley, University of California Press, 1987.

Taylor, Paul, ed. *Post-Pop Art*, Cambridge, Mass., MIT Press, 1989.

Tomkins, Calvin. "Profiles: A Touch for the Now," *New Yorker*, July 29, 1991, pp. 35–36.

——. *Off the Wall: Robert Rauschenberg and the Art World of Our Time*, New York, Penguin Books, 1980.

——. *The Bride and the Bachelors*, New York, Viking, 1974.

van der Marck, Jan. *Arman: Selected Works, 1958–1974*, exhib. cat., La Jolla, La Jolla Museum of Contemporary Art, 1974.

Wexner Center for the Arts. *Breakthroughs: Avant-Garde Artists in Europe and America, 1950–1990*, exhib. cat., New York, Rizzoli, 1991.

Young, La Monte, and Jackson Mac Low, eds. *An Anthology of Chance Operations* (1963), 2nd ed., New York, Heiner Friedrich, 1970.

Index

Photo Sources and Credits

Unless otherwise indicated, photographs of works in the exhibition are reproduced courtesy of the lenders.

Ken Cohen, figs. 12, 15, 16, 19, 20, 21, 33, 34, 37, 43ab, 51, 52, 53, 56, 67
Laurent Condominas, figs. 69, 70
Eeva-Inkeri, fig. 57
T. Stefan Gesek, figs. 60, 63
Michael Cavanagh, Kevin Montague, figs. 1, 35
Susan Hapgood, fig. 17
Ann Hutchison, fig. 9
Hermann E. Kiessling, fig. 47
Robert R. McElroy, fig. 11
David Reynolds, fig. 65
Oren Slor, figs. 10, 14, 44, 45abc, 49, 71
Dan Soper, figs. 28, 31, 38, 55

The American Federation of Arts *Board of Trustees*

Elizabeth Blake
Chairman

Robert M. Meltzer
President

Stephanie French
Vice President

Tom L. Freudenheim
Vice President

Margot Linton
Vice President

Jan Mayer
Vice President

John W. Straus
Vice President

Richard S. Lane
Secretary

David J. Supino
Treasurer

Maxwell L. Anderson
Ruth Bowman
J. Carter Brown
Robert T. Buck
Constance Caplan
George M. Cheston
Jan Cowles
Donald M. Cox
Catherine G. Curran
Philippe de Montebello
Linda Downs
David C. Driskell
Suzanne G. Elson
Arthur D. Emil
Donna M. Forbes
John A. Friede
Jay Gates
Marge Goldwater
John G. Hanhardt
Lee Hills
Theodore S. Hochstim
Janet Kardon
Elaine Kend *
Lyndel King
Gilbert H. Kinney
William S. Lieberman
Barbara Linhart *
Roger Mandle
Cheryl McClenney-Brooker
Leatrice B. McKissack
Barbara Babcock Millhouse
Charles S. Moffett
Marena Grant Morrisey

George W. Neubert
Sunny Norman
Nancy M. O'Boyle
Elizabeth Petrie
Earl A. Powell III
Frieda Rosenthal
Wilbur L. Ross, Jr.
Helen H. Scheidt
Hannelore Schulhof
Thomas K. Seligman
Alan Shestack
James S. Snyder
Myron Strober
Mary Ann Tighe
Evan H. Turner
Virginia Ullman
Nani Warren
Stephen E. Weil
Nancy Brown Wellin
Dave H. Williams
James N. Wood

Honorary Trustees

Mrs. Jacob M. Kaplan
President Emerita

Roy R. Neuberger
President Emeritus

John Walker

* *ex officio* (Co-Chairman of Membership
and Events Committee)

The American Federation of Arts *National Patrons*

Amy Cohen Arkin
Mr. and Mrs. Robert Baumgarten
Nancy Terner Behrman
Mr. and Mrs. Frank B. Bennett
Mr. and Mrs. Winslow W. Bennett
Mrs. Edwin A. Bergman
Mrs. George F. Berlinger
Mr. and Mrs. Leonard Block
Mr. and Mrs. Donald J. Blum
Mr. and Mrs. Duncan E. Boeckman
Mr. and Mrs. Selig S. Burrows
Mr. and Mrs. George M. Cheston
Mrs. Paul Cohen
Elaine Terner Cooper
Marina Couloucoundis
Catherine G. Curran
Mr. and Mrs. Hal David
Dr. and Mrs. David R. Davis
Dominique de Menil
Beth Rudin DeWoody
Mr. and Mrs. Charles M. Diker
Mr. and Mrs. C. Douglas Dillon
Mr. and Mrs. Herbert Doan
Mr. and Mrs. Robert Dootson
Mrs. Lester Eisner
Mr. and Mrs. Miles Fiterman
Mr. and Mrs. Robert F. Fogelman

Mr. and Mrs. David Fogelson
Bart Friedman and Wendy Stein
Barbara Goldsmith
Leo S. Guthman
Mrs. Wellington S. Henderson
Elaine Kend
Mr. and Mrs. Robert P. Kogod
Mr. and Mrs. Oscar Kolin
Mr. and Mrs. David Kruger
Mr. and Mrs. Anthony Lamport
Natalie Ann Lansburgh
Mr. and Mrs. Robert H. Levi
Mr. and Mrs. Sydney Lewis
Ellen Liman
Barbara Linhart
Mr. and Mrs. Richard Livingston
Mr. and Mrs. Lester B. Loo
Dennis H. Lyon
Mr. and Mrs. Melvin Mark, Jr.
Mr. and Mrs. Irving Mathews
Mr. and Mrs. Paul Mellon
Mr. and Mrs. Robert Menschel
Mr. and Mrs. Eugene Mercy, Jr.
Mr. and Mrs. Toby S. Meyerson
Mr. and Mrs. Peter Norton
Mr. and Mrs. George O'Leary
Patricia M. Patterson
Mr. and Mrs. Nicholas R. Petry
Mr. and Mrs. Charles I. Petschek
Mr. and Mrs. John W. Pitts
Mr. and Mrs. Harvey R. Plonsker
Mr. and Mrs. Lawrence S. Pollock, Jr.

Audrey S. Ratner
Edward R. Roberts
Mr. and Mrs. Edward W. Rose, III
Mr. and Mrs. Robert Jay Rosenberg
Walter S. Rosenberry, III
Mr. and Mrs. Milton F. Rosenthal
Mr. and Mrs. Richard L. Rosenthal
Mr. and Mrs. Douglas R. Scheumann
Marcia Schloss
Mr. and Mrs. Paul C. Schorr, III
Lowell M. Schulman and Dianne Wallace
Mr. and Mrs. Joseph Seviroli
Mr. and Mrs. Jan Shrem
Mr. and Mrs. Michael Steinhardt
Ann C. Stephens
Mr. and Mrs. James G. Stevens
Martha B. Stimpson
Rosalie Taubman
Mrs. Norman Tishman
Mr. and Mrs. William Troy
Mrs. George W. Ullman
Mr. and Mrs. Michael J. Waldman
Mr. and Mrs. Robert C. Warren
Mr. and Mrs. Alan Weeden
Mr. and Mrs. Guy A. Weill
Mr. and Mrs. T. Evans Wyckoff

71 BEN VAUTIER

Absolument n'importe quoi est art (Absolutely Anything Is Art), 1962.

THE COLLEGE OF SAINT ROSE LIBRARY

WITHDRAWN

3 3554 00051 4114

DATE DUE

MAY 0 9 1997		
NOV 6 1997		
APR 13 1998		
OCT 0 9 1998		
NOV 1 1998		
MAY 3 1 2000		
DEC 1 9 2003		
5/10/17		
WITHDRAWN		
GAYLORD		PRINTED IN U.S.A